GUIDE TO PHOTOGRAPHY

To Linda

GUIDE TO PHOTOGRAPHY

By John Morris

Bennett & McKnight Publishing Company
Peoria, Illinois

Bennett & McKnight Publishing Company
809 West Detweiller Drive
Peoria, Illinois 61615

85 86 87 88 89 RRD 5 4 3 2 1

ISBN 0-02-665400-8

Library of Congress Catalog Card Number 84-70519

Printed in the United States of America

Table of Contents

TABLE OF CONTENTS

Cover Design and Photograph by
David Slater & William Timmerman

A 4 × 5 studio camera and a special effects light table were used to make the photograph of the lens. An artist's rendering of the hang glider was reflected in the lens, and a set of exposures recorded that reflection. A second set of exposures recorded the barrel of the lens. The background effect and the colors in the aperture were created with a third group of exposures. All exposures were made using strobe lights fired in total darkness while the camera shutter remained open.

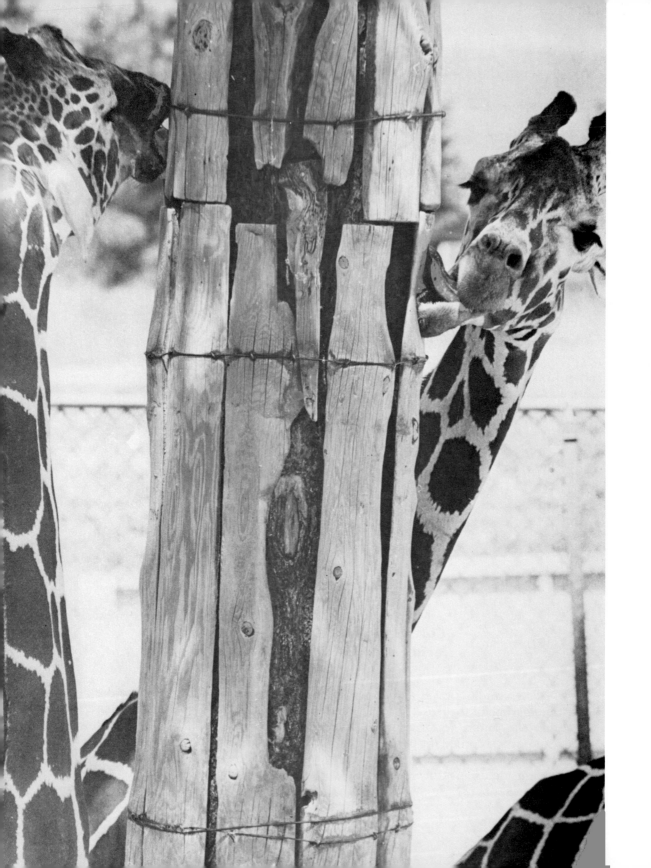

CHAPTER 1

Designing Pictures

When the experienced photographer walked through the gates of the zoo, he had one small camera and an extra lens. Many other visitors carried more equipment.

One of his shots that day was the picture on your left. It's well photographed, and it's interesting—partly because of the twisted mouth on one of the giraffes. Could the other visitors have found similar pictures?

"They could," said the photgrapher, "if they knew what to look for. The secret is partly in knowing how to look for good pictures.

"I approach the zoo just like any other assignment. I look for the most interesting things I can find—activity, expressions, things people would notice even when they don't have cameras. At the same time, I'm looking for ways to put these things in a picture."

The photographer was asked if the picture was a lucky shot.

"In a way, it was. I would have a hard time finding exactly the same image again. On the other hand, I went to the zoo *looking* for lucky shots. It takes only moments to find something eye-catching.

"It happened like this. Initially I went inside the giraffe house—just because that was the first place I came to. The light was bad—too dull. All the giraffes you could see were behind bars. I took a few shots of the animals feeding from baskets high on the wall. But I didn't like the angles or the light, and it wasn't long before I had sense enough to get out of there.

"At first, the outdoors wasn't any more inspiring, but I finally noticed the giraffes chewing on the tree. I knew that for the picture to have a pleasing arrangement, their heads had to be at specific points within the picture. I didn't need to show their bodies. I didn't need to show what was behind them. I did want them eating, because that strange mouth is interesting, and I absolutely had to be close enough to show the mouth in action. Besides that, the light had to be good and, at least in this case, the picture had to be sharp.

"I readjusted the camera. The light was right. I was close enough but not too close. I checked the background. It was clean, not cluttered. I aimed the camera in such a way as to put the heads and necks where I wanted them. I always make sure my pictures are well arranged. Then it was a matter of waiting for just the right action—and snap, I had the picture."

Terms to Learn

background
composition
frame
rule of thirds
subject
treatment

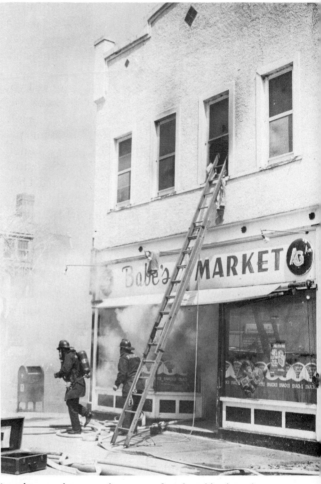

Local news photographers get a first-hand look at the next day's news.

WHAT MAKES A GOOD PICTURE?

From its very beginning, photography has been many things to many people. It can be an exciting way to make a living, a handy skill on many jobs, or a pleasant and challenging hobby. As a career, it can range from taking passport photos, portraits, wedding pictures, or advertising photos to responding to police calls for a local newspaper, photographing a royal wedding in Europe, or following mountain climbers over frozen crests in the Himalayas.

As a field, photography is incredibly complex. To know it all, a person would have to know physics, chemistry, business—and business *is* important to the photographer—art history, optics, computer technology, lasers, and often more exotic things, such as how to scuba dive to take pictures underwater.

However, you don't have to know a great deal about any of these things to get reasonably good pictures. What is important is an understanding of what makes good pictures and how to use your tools to get those pictures.

Photography really can be simple. In the hands of a professional, a simple camera—especially one with a good lens—can do wonders. In fact, many pictures fall into the narrow range of conditions that a simple camera is designed to handle. It is always an advantage to know how to do more with less.

If you add three special controls to a simple camera, you can go further. If you can change lenses, you can do still more. Practical

photography is partly a matter of mastering the controls. It's getting a feel for the camera, learning how the lenses work, and discovering how to use light. In short, it's making the most of your tools.

You also have to learn what to shoot. If you already know what kinds of pictures you want, good. Go after them. Too many beginners, though, forget why they're taking pictures. This is especially true when beginners get their first fancy camera. Their concentration turns from pictures to equipment. Their pictures begin to show a lack of purpose. *Good* pictures have a reason to exist. They try to show something specific—people, things, activities. In other words, they have a subject.

A subject is the first requirement for a good picture. Sometimes you need to show the subject at a specific time or place, but not always. Next, the subject has to be presented well. That means good composition, the right exposure, good lighting—all the technical things. A good picture is simply a worthy and well-presented subject in a frame.

When something goes wrong with a picture, a photographer must be able to separate subject problems from technical problems to make corrections.

Guide to Photography will show you how pictures work. It will guide you through the basic tools and techniques and show you how to get results.

It is written for people who want more than the occasional snapshot. Many cameras are designed strictly for the amateur. Except to illustrate basic principles, these cameras will not be covered in this text. Usually, the smallest (and least expensive) film size used by professionals is the 35 mm. Thus 35 mm photography will be emphasized.

When you finish this book, you should be able to assemble an attractive portfolio of

SAFETY REMINDERS

Generally speaking, photography appears to be a safe activity for anyone. The dangers certainly aren't as obvious as those in, say, a metal or woodworking shop. You don't need safety glasses to work with a camera, you don't often need protective clothing, and your camera is not likely to explode when you take it out of the case or cut off your fingers as you handle it.

As a matter of fact, that is one of the most dangerous things about photography: It doesn't look dangerous at all. But it *can* be dangerous. You're never quite so vulnerable as when you're looking through a viewfinder and moving around, finding the best camera angle for a picture. As often as not, you're up on a perch or on high ground, trying to get an overview—and falls are bad enough on level ground. If you happen to be shooting a traffic accident, you're vulnerable to smokers who fail to notice puddles of draining gasoline and drivers who pay more attention to the accident than where they are going.

In this and other chapters, you will see safety reminders. Take a moment or two to reflect on the points after you read them.
- Know where you're stepping. It's easy to trip when you're looking through a viewfinder.
- If you do happen to shoot zoo animals, don't go beyond barriers established for the general public.
- Scuba diving, mountain climbing, and other exotic activities all have their safety rules. Learn the rules before attempting to shoot the activities.
- If you're carrying camera bags, tripods, or other equipment, don't leave your equipment where you or others can trip on it.

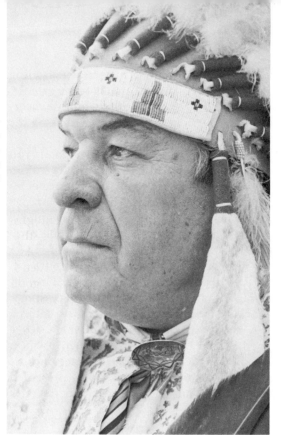

This portrait of the Indian was taken on an overcast day. The overcast gives a nice even light that is easy to work with. Notice how the selection of an interesting and moderately unusual subject—the Indian —contributes to the picture. Look for the photogenic in your own life.

your work. You should also be able to shoot pictures for a yearbook; illustrate the steps in a manufacturing process; shoot pictures for a slide show, for an advertising brochure, or for a trade-magazine layout. You will be able to make the pictures in your family album interesting to strangers. You will also have laid the groundwork for specializing in one of the many jobs photography has to offer.

DESIGNING PICTURES

Perhaps the easiest way to learn photography is to start with pictures. Pictures are what photography is all about. All the tools you work with—the camera, light, lighting equipment, film, backgrounds, filters, tripods, and so on—should be thought of in terms of what they mean to your pictures. When you think in terms of pictures, you've won half the battle.

As mentioned earlier, all pictures have two key elements. The first is the subject. The second is the treatment of the subject. Both elements, subject and treatment, are crucial to good pictures. Of the two, the subject is probably more important.

The subject is the star of the picture. It is what the photographer wants to show. In a wedding picture the subject may be the bride, the bride and groom, or the entire wedding party. In an industrial picture, the subject may be a whole manufacturing plant or a single screw.

The **treatment** is the way the subject is shown. Treatment begins with what sur-

rounds the subject, how the subject is placed, and the background. If the picture is in color, the treatment includes the selection and use of color. Treatment may also include the photographer's timing, lighting, exposure, focus, depth of field, and grain. These will be covered later in this chapter and throughout the book.

Subjects

The more interesting your subject, the simpler your treatment can be. Some of the world's most compelling pictures are powerful subjects treated in the simplest possible way. Usually, people look at pictures to see the subject. In the best pictures, the subject takes over. The subject is so interesting that the photographer's job is to *let* the subject take over. Whenever you have a choice, start with the most interesting subjects you can find.

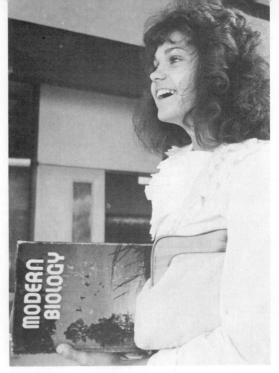

John Morris IV

When you finish this book, you should be able to take eye-pleasing pictures for your school yearbook. A student took this picture without flash.

Often, however, the professional photographer has to take a picture of a subject that isn't particularly interesting in itself. Any study of photography should include practice in how to recognize what will make a good picture and how to make the most of the everyday subject.

What are interesting subjects? Usually they are people. Sometimes they are animals. Occasionally, they are landscapes, still lifes, or

The more interesting your subject, the simpler your treatment can be.

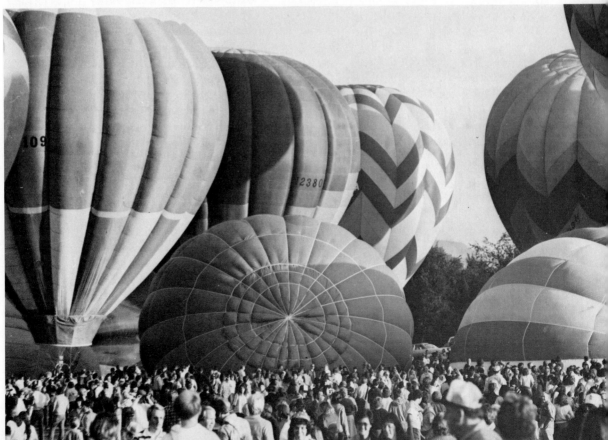

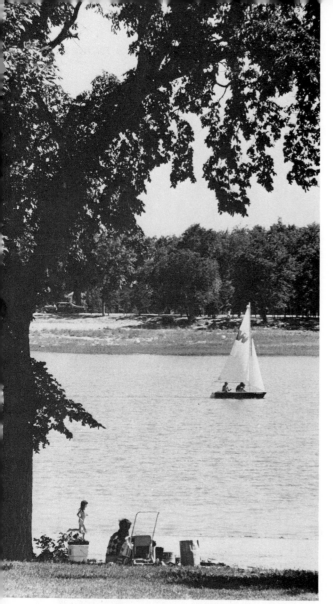

To the human eye, this is a pretty spot. But in a picture, imagine how empty the lake would look without the sailboat.

plants, but not very often. When people look at photographs, they are usually more interested in other people than in rocks and trees. Photographers can get interesting shots of landscapes, plants, and objects. But these give more trouble than any others to beginning photographers. Why? Such subjects depend

heavily on treatment. Plain, everyday shots of mountains, trees, rocks, lakes, and oceans often don't work very well.

If you find special clouds or lighting, a rainbow in an attractive place, a low-hanging bank of fog against a mountain range, or fascinating detail in a leaf, you can get an interesting picture. Or if you have a very good eye for placement, you can make do where many other photographers fail. If you can get a once-in-a-lifetime picture of a rose, or do something special with colored bottles or colored glass. . . . But that's the point. Most rocks, trees, and hills by themselves don't have what it takes to make someone "ooh" and "aah."

This is easy to see if you look at pictures of landscapes you like. Ask if there is something special about the way the subject is placed in the picture, about the lighting, or about other features of the picture. Whenever your own pictures don't quite seem to work, take a close look to see if the special something is lacking.

People and animals also need a bit of skill in treatment, but people and animals move and change. A picture of John Doe today isn't usually the same picture someone else could have taken yesterday. Expressions change. Moods change. Lighting changes. Actions change. Backgrounds change.

Which pictures of people or animals will be the most successful? Briefly, pictures of the following:
• People or animals in action.
• People or animals interacting with others or with their environment.
• Expressions.
• People or animals in front of interesting scenery.

Treatment

All the technical material you ever master will be learned for a single purpose: the skillful treatment of your subject. A skillful treatment begins with framing, composition, and backgrounds. Framing and composition

are related. Framing has to do with what is left in—and out of—pictures. The **frame** is the edges of the picture. It is the square or rectangle within which the picture exists. The placing of the material within the frame is called **composition**. A **background** is what is behind the subject or, in some cases, it is the subject's surroundings. Framing, composition, and background will make a difference even in pictures taken with a simple camera.

FRAMING

The words *framing* and *composition* are sometimes used interchangeably. There is nothing wrong with this. Composition is often determined, at least in part, by how the frame is placed around the subject. However,

it is also useful to consider both framing and composition in their most limited sense.

The frame is one way to include—and exclude—material from a picture. When you move closer to your subject, the frame closes in on all sides of the subject. As you move away from a subject, the frame includes more and more of the subject's surroundings.

Why do you need to frame your subject? For one thing, there is a distinct difference between the way your camera "sees" a subject and the way your eye sees it. The human eye takes in over 180 degrees, more than half its surroundings. A "normal" camera lens, the lens most often sold with a camera body, takes in about 45 degrees. Thus, it takes in only a small portion of what the eye sees.

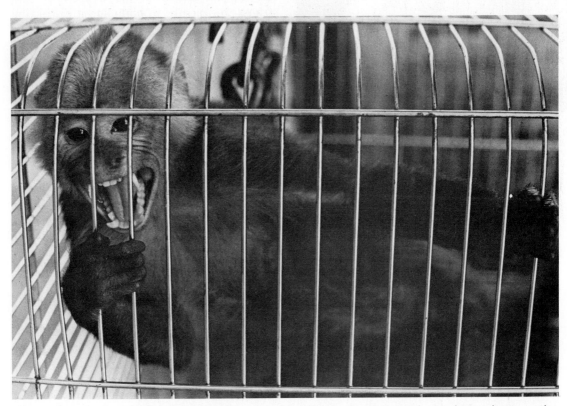

Taken with a 35 mm camera and a normal lens, this shot relies on the photographer's subject selection and a little patience. With the energetic monkey, this pose was available in a matter of moments.

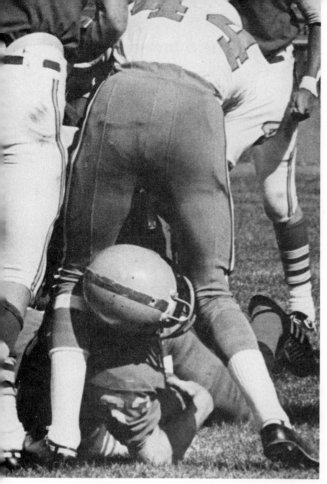

The human mind organizes what the eye sees. When you see a friend across the room, your mind tends to concentrate on the friend. Your mind eliminates most of the distracting objects or activity around your friend. The camera simply won't do this, at least with a normal lens. Within the 45 degrees, everything the camera sees will be recorded on film.

You must therefore use the frame to organize what the camera sees. You must check the frame and see that all the distractions are eliminated. You must take control. The unusual position of the players in the photograph above would have been lost if the picture had included too much of the playing field.

Tight framing allows you to exclude distracting backgrounds.

If you study snapshots, you will soon notice how seldom snapshooters pay attention to framing. You see not only the little girl on the tricycle, you see half the neighborhood behind her. Yes, the girl on the tricycle is a good subject, but the photographer's purpose was to picture the girl, not the neighborhood.

The key word is *purpose*. Each picture you take has a purpose. You may want the little girl's excited expression, but you probably also want to show something of the reason for her expression. In other words, you want to show what makes her excited. Show the child on the tricycle, show her expression, and frame the picture to eliminate a distracting background.

One of the most useful habits you can develop is to *always* check your frame before you shoot. Have you included the subject, the whole subject, and nothing but the subject? Until you're very comfortable with a camera, consciously notice all four sides of the frame. Have you included in the frame all you wanted to include? More importantly, have you eliminated all that doesn't belong?

Beginning photographers are sometimes advised to first frame their subjects as tightly as possible and then move three steps closer to the subject and frame again. Usually the beginner finds that moving three steps closer does not eliminate anything essential to a good picture. In fact, the new framing usually improves the picture.

COMPOSITION

Some photographers claim there are no rules for composition or arranging material in the frame. In the final analysis, they may be right. No rule applies all the time. Still, the vast majority of professional pictures do in fact follow a few simple rules.

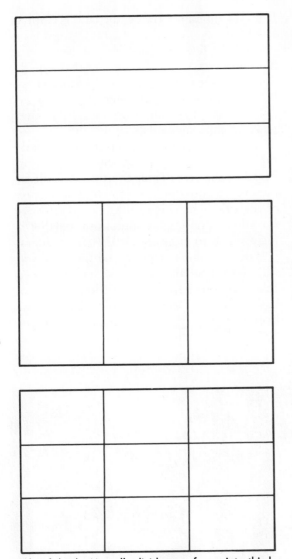

Rule of thirds: Mentally divide your frame into thirds, both horizontally (top) and vertically (middle). Important elements of your composition should fall near these lines (bottom).

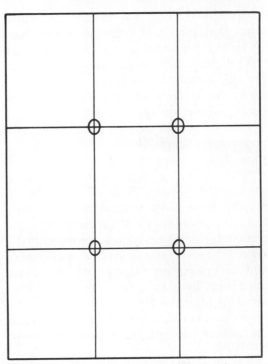

When your frame is vertical, the one-third lines are still your guide. Important smaller elements usually should fall close to where the lines cross—at the "O's."

The first of these rules is the **rule of thirds**. Imagine two horizontal and two vertical lines within the picture's frame, as shown in the illustration above. These lines divide the frame into thirds—both across and up and down. In many published pictures, the most important features within the picture fall along these lines.

What are important features? Anything that stands out is an important feature. In some pictures, it will be nothing more than bands of light or darkness. In other pictures, it will be more concrete features. Consider the human face. Usually the eyes are the most important feature and, usually, they fall along the line one-third down from the top. Or, consider a landscape with a human figure. The human figure draws attention and should be along one of the vertical one-third lines. Outdoors, when the horizon line (where the earth meets the sky) is visible, it becomes an important feature. The horizon

17

line should usually fall roughly one-third down from the top of the frame or one-third up from the bottom.

The intersections of the rule-of-thirds lines are also important. In many published pictures, small but eye-catching elements fall at points where the lines cross. Within the human figure, the head is usually the most important feature. Often it falls at one of these points of intersection.

Note that none of the lines crosses the center of the frame. Generally, you should avoid centering important elements in a picture. For example, when the horizon line is centered, it fails to organize a picture for the viewer. Neither sky nor land is emphasized, and the viewer does not know which is more important. By placing the horizon line one-third up from the bottom of the frame, the sky is emphasized because it takes up more of the picture. By placing it one-third down

from the top of the frame, the land is emphasized.

All four lines are not always used. As a matter of fact, you will often find that a single line, or a single point where the lines cross, has guided the photographer.

Not all photographers are aware that they make compositions based on the rule of thirds. That's why some professional photographers can honestly say they have never heard of the rule. Their compositions please the eye because they have made intuitive use of the rule. The rule of thirds is an effective way to emphasize an important part of a picture and to organize pictures for viewers.

When you look at published pictures, you will often find that the rule has not been followed precisely. The pictures are not based *exactly* on one-third lines. If you look closely, though, you will see the rule in action.

Try this experiment. Take a sheet of note-

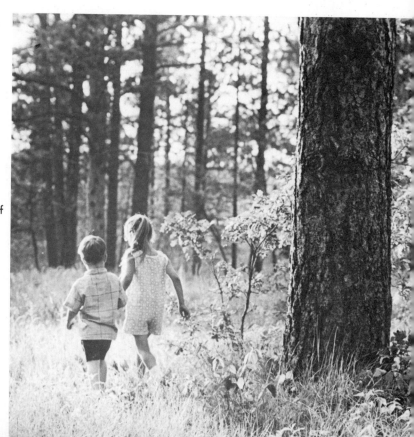

An example of use of the rule of thirds.

book paper and place it over the photograph on page 18. Trace the outer edge of the picture onto the paper. Place the paper on your desk. Divide this "frame" you've traced into thirds—both horizontally and vertically. Now again place the paper over the photograph. Notice how the picture follows the rule of thirds. The tree is about one-third in from the right. The horizon line is about one-third down from the top. Where do the children fall? Notice in other pictures how subtly the rule is sometimes followed. A tree branch may lie across the upper horizontal line. A fence may lie along the lower line.

There are other rules of composition. When the rule of thirds doesn't seem to apply, in its place may be a triangle. If you connect three important points in the picture, the connecting lines will form a triangle. The top of the triangle is generally near the upper frame line. The base may fall along the lower one-third line. Sometimes, the triangle is inverted, or it may be somewhat skewed. It,

too, can help a photographer avoid centering important features within the frame.

For now, though, simply imagine those one-third lines etched in your viewfinder. Put the important features of your picture along these lines or at the points where these lines intersect. The rule of thirds will serve you well, long after you have shot your first few rolls of film.

BACKGROUNDS

Bad backgrounds ruin more snapshots than perhaps any other problem. Trees grow out of a subject's head. Telephone wires crisscross the Rocky Mountains. All sorts of pointless items show up in what would otherwise be good pictures of fascinating subjects.

There are three ways to deal with the background. The first way is to include it as part of the picture. If you use a background, consider it when you compose the picture. How does the background in the photograph below show the viewer something about the

One way to handle backgrounds is to make them show something about your subject.

Backgrounds can be blurred. Throw them out of focus.

The last method is often the easiest. By moving in close, you can leave out of the frame anything that has nothing to do with your subject. Move left. Move right. Circle the subject until you find an appropriate background. Move closer to the subject, or move the subject. Never let a background detract.

As you begin taking pictures, and before you snap each shot, ask yourself two questions:

"How interesting is my subject?"

"What will my treatment be?"

If you remember that treatment begins with framing, compositon, and backgrounds —and you *actively* ask yourself those

Another option with backgrounds is to throw them into darkness, or move in close enough so they won't show.

subject? Does this picture follow the rule of thirds?

The second way to deal with a background is to simplify it. It can be blurred by throwing it out of focus. It can be kept clean and uncluttered. Two natural and very clean backgrounds are grass and sky. Blank walls may also be used.

A third way is to get rid of the background. Sometimes it can be dark. The picture can be set up so that light falls on the subject, but does not fall on the background. A background can also be removed by moving so close to the subject that the background doesn't show.

20

questions—your pictures will show immediate improvement. Later on, you will automatically look for interesting subjects. You will automatically check framing, composition, and background. Now is the time to develop the best habits you can.

SUMMARY

Pictures themselves have two key elements: the subject and the treatment of the subject. The more interesting the subject, the simpler the treatment can be. The most interesting subjects tend to be people. Pictures without people tend to rely more heavily on treatment.

A skillful treatment begins with framing, composition, and background. The frame includes material wanted in the picture. Composition is the arrangement of material within the frame. One useful guide to composition is the rule of thirds. Important features are placed one-third in from the frame edge.

There are three ways to deal with backgrounds. The first is to include them in the pictures and make them show something about the subject. The second is to simplify them. The third is to get rid of them by placing them in darkness or by moving in close to the subject.

Discussion Questions

1. All pictures have two key elements. What are they?
2. Define composition.
3. Name two things that make interesting subjects.
4. What does a frame do?
5. According to the rule of thirds, what should fall along the one-third lines?

6. What should fall where the lines intersect?
7. Name three ways to deal with backgrounds.
8. Before you snap each picture, what two questions should you ask?

Assignments

Bring to class a copy of *National Geographic* or another picture magazine. Find the following:
1. Three examples of the rule of thirds.
2. An example of an "included" background.
3. An example of a simplified background.
4. An example in which the background has been eliminated.

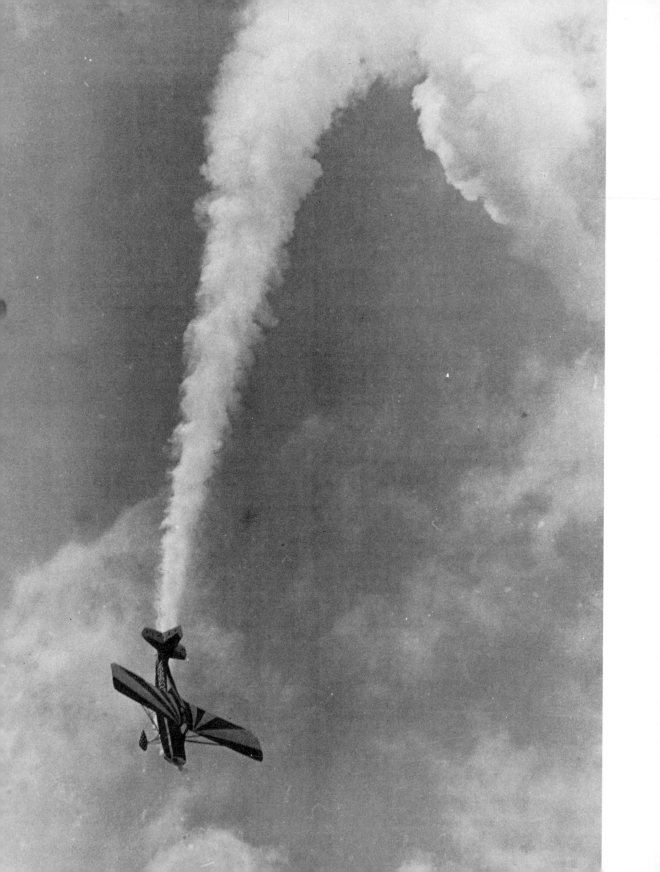

CHAPTER 2

Getting To Know Your Camera

The basic tool of photography is the camera. Obviously, then, it is to your advantage as a photographer to understand in detail how your camera works. This chapter will teach you just that. You will learn:

- The parts of the camera.
- How to care for the camera.
- How to open the camera and load and unload film.
- How to advance the film.
- How to focus.
- What f/stops and shutter speeds are and what they do.
- How to use the light meter.

Don't be afraid of the camera or its controls. No matter how long you use your camera, for most shots you'll make only one or two control adjustments.

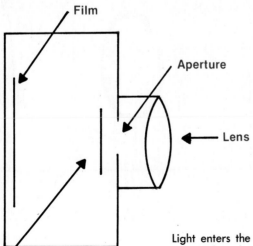

Light enters the camera through the lens and aperture. When the shutter opens, the lens focuses the light on the film.

CAMERA BASICS

A camera is a light-tight box. It has a place for film or other light-sensitive material. It has a hole, called an **aperture**, through which light enters the camera to expose the film. Between the hole and the film is a **shutter**. The shutter—just as a shutter does on a kitchen window—opens to let in light and closes to shut out light. The camera usually has a button that triggers the shutter—making it open and close. On cameras that take several pictures on a single strip of film,

Terms to Learn

aperture
depth of field
film advance lever
film chamber
film rewind knob and
 crank
film take-up spool

focusing ring
frame counter
f/stop
f/stop ring
lens
light meter
overexposure

shutter
shutter release button
shutter speed dial
transparencies
underexposure
viewfinder

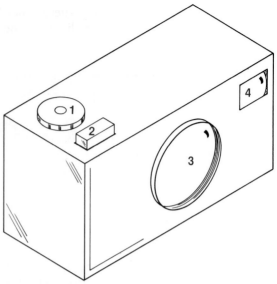

On most cameras, you will see (1) a film advance knob or lever, (2) a shutter button, (3) a lens, and (4) a viewfinder.

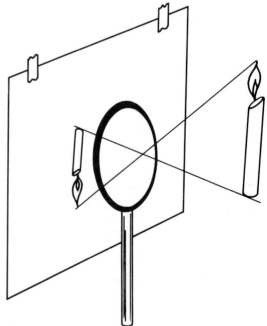

With a magnifying glass, which is itself a simple lens, you can actually see a lens at work.

there is a **film advance lever** or knob. The lever or knob moves the film after each exposure. Most cameras have a viewfinder. You look through the **viewfinder** to frame the picture.

In front of the aperture, the camera usually has a **lens**. The lens focuses light on the film. To see a lens in action, use a magnifying glass. (A magnifying glass is really just a simple lens.) Take a magnifying glass into a darkened room with an outside window, and go to the wall opposite the window. If the wall is light colored and not too rough in texture, you can use the wall itself as a piece of "film." Otherwise, hold or tape a plain sheet of paper on the wall. Hold the magnifying glass about a foot from the wall. Move the glass in and out until you get a sharp "picture" of the scene outside the window. You will see that the image is in full color, and if people or cars are moving around outside, the image will show the same movement. The camera lens works much the same way as the magnifying glass. And just as the image on the wall is upside down, the image on the film in your camera is upside down.

Though other cameras will be mentioned, the remainder of the book will concentrate primarily on the manual 35 mm single lens reflex (SLR) camera. The manual SLR will be discussed in detail for several reasons. The film is fairly inexpensive and yet large enough that professional-quality work can be done with it. Manual models—or the manual overrides on automatics—allow you full control, so you can practice with all controls you need to understand. The cameras are versatile and allow you to experiment with a large number of films and a variety of accessories. Finally, they are fairly easy to handle and understand.

Much of what will be said about the 35 mm SLR could, with a little modification, apply equally well to other cameras. However, there are so many different kinds that it is impractical to cover each in depth. If you have a good manual camera of another type or an automatic SLR, you needn't make a change to a manual SLR.

New cameras usually come with an instruction book. Most features—though common to many cameras—vary greatly from model to model in the way they look and handle. There is no substitute for a good instruction book to tell you exactly how each feature of a particular camera works. If you need a book for your camera, and the model you have is a fairly recent one, write to the manufacturer for a copy. There are other resources as well. Libraries usually have books with general explanations of common models. Photographer friends can be of help. The staff in camera stores and repair shops also may explain details that you can't find explanations for elsewhere.

The best way to learn about a camera is to become acquainted with it through handling. First, though, take note of the precautions on page 26.

THE MANUAL 35 MM SINGLE LENS REFLEX

What is a manual 35 mm single lens reflex? Let's break it down word by word. The *35 mm* refers to the film size. A single 35 mm negative measures about 36 × 24 mm. The *manual* means that you have to make adjustments by hand for different kinds of light. On automatic cameras, these adjustments are made by the camera itself.

Single lens means that both the viewing and picture taking are done with the same single lens. Some cameras have two lenses. One is for viewing and one is for picture taking. These are called twin lens reflex cameras. Other cameras have a single lens, but the viewing is done through a viewfinder which is entirely separate from the lens. Only in the SLR do you see exactly what the picture-taking lens "sees."

Reflex means that the image you see in the viewfinder is made up of reflected light.

Outside the Camera

THE LENS AND VIEWFINDER

When you look through the viewfinder of a

HANDLING THE CAMERA

- Don't force anything. The camera is a precision instrument and can be easily damaged.
- Don't touch the glass on the lens.
- Have lens tissue handy. If the glass is touched, breathe a mist on the lens and gently wipe dry. If you use liquid lens cleaner, put the cleaner on the tissue rather than directly on the lens.
- Don't use eyeglass tissues for lens cleaning. They can damage the coating on the lens.
- Avoid cleaning the lens more than necessary.
- Don't let camera straps hang over the edges of furniture. Always put the strap around your neck when you pick up the camera.

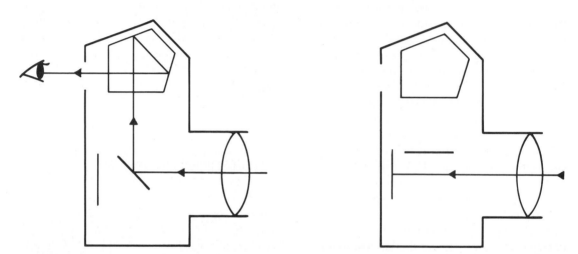

In the 35 mm SLR (left), a mirror, which is indicated by the angled line behind the lens, throws the image up into a prism. The prism turns the image upright (remember that the lens has turned it upside down) and presents the upright image to the eye. When the shutter button is pressed (right), the mirror flips up, causing the viewfinder to go black for an instant. The lens then focuses the image on the film (indicated by the vertical line at the back of the camera).

SAFETY REMINDERS

- Since this may be your first time framing a picture through a viewfinder, it won't hurt to say it again: Watch your step.
- Make sure—always—that you have room to work.
- When you change film in your camera, try to do it away from any action you happen to be photographing. Your attention is directed to the task at hand (changing film) and you are likely to be less aware of what is going on around you. If you remain in the center of action, you risk—at the very least—being jostled and damaging your equipment. In some situations, you risk injury to yourself and others.

35 mm SLR, you're seeing exactly what the film would "see" if a picture were taken. The image is reflected from the lens to the viewfinder by means of a prism and mirror. When you snap the picture, the mirror flips up out of the way and the viewfinder goes black for an instant. Once the film is exposed, the mirror flips back down and you can see through the lens again. Viewfinders vary from camera to camera. See your instruction book for detailed information on how the screen in your viewfinder works.

The lens is made of glass or other clear material and focuses the image on the film. If you were tiny enough to sit inside a camera as an exposure was being made, you would actually see the image as it flashed onto the film.

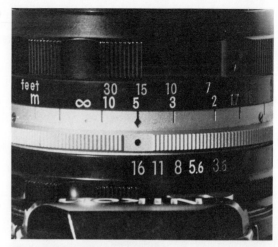

The knurled ring at the top of the picture is the focusing ring. Notice that distance, in both feet and meters, is marked on the lens. This lens is focused at 5 meters or about 15 feet.

Focusing Ring

Encircling the front of the lens is the **focusing ring**. This ring controls sharpness of the image. Hold the camera with your right hand. Look into the viewfinder. With your left hand, turn the focusing ring until you have a sharp image. The focusing ring is one of the three most important controls on the camera. In most situations, you will change the focus setting for each shot you take.

At the front of the camera near the focusing ring you will notice a series of numbers and dials. These control f/stops and sometimes shutter speeds. They will be discussed later in this chapter.

Film Controls

Next, find the **film rewind knob and crank**. These allow you to return the exposed film to its cassette. They are usually on the top left of the camera. To be sure the camera isn't loaded, gently turn the crank several times in the direction of the arrow. If you feel no resistance after six or eight turns, you can be pretty sure no film will be ruined when you open the camera back. On some models this knob also opens the camera back.

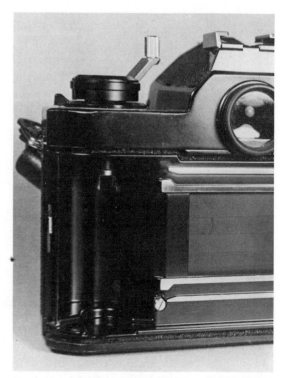

On the top left of the camera is the rewind crank and knob.

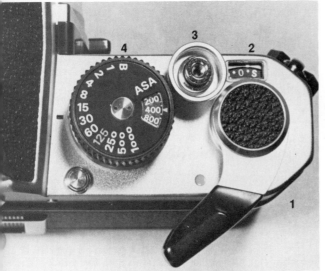

This view is the top right side of the camera. You should note (1) the film advance lever, (2) the frame counter, (3) the shutter button, and (4) the shutter speed dial. On the shutter speed dial, the figures *B* to *1000* indicate shutter speeds. On this camera, 1/1000 second is the fastest shutter speed. The slowest timed speed is 1/1, or one second.

Once you're sure the camera is empty, get the feel of the **film advance lever**, usually located on the top right of the camera. This lever not only advances the film from shot to shot, it also cocks the shutter and operates the frame counter.

The **frame counter** tells you how many pictures have been taken on a roll of film. The counter is usually near the film advance lever. On most models, it begins counting two frames before zero. Because the first few inches of a new roll of film are exposed when you load the camera, you have two shots to get to the good film. On most models, the frame counter automatically resets itself when you open the camera back to reload film.

SHUTTER RELEASE BUTTON

Near the film advance lever is the shutter release button. The **shutter release button** triggers the shutter.

With your right thumb, stroke the film advance lever as far to the right as it will go. If you meet resistance, the shutter may have

been partly cocked already. Once you meet resistance, release the lever and push the shutter release button. Use your right index finger and squeeze gently. At the click, the shutter will open and let you take the picture. On some models, the shutter button can be locked. (The lock is primarily a switch for a motor attachment.) Check your instruction book to be sure you know how to keep your shutter button unlocked.

As you can imagine, you will be using the advance lever and shutter button all the time. Become comfortable with them. With your eye to the viewfinder, practice arranging a picture and focusing. Without removing your eye from the viewfinder, stroke the lever and gently squeeze the shutter button several times.

LIGHT METER

Light meters measure the brightness—or intensity—of light. Each time you load film into the camera, the light meter must be set to coincide with the film rating. Once you adjust the meter for the type of film, a built-in meter can tell you when you have the right amount of light and the right settings for a picture.

The light meter itself is enclosed in the camera and readings are usually taken

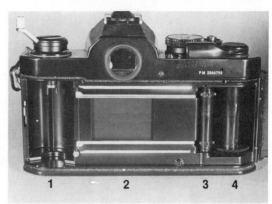

From left to right inside the back of the camera, you can see (1) the film chamber, (2) the shutter (the recessed rectangle in the center), and (3) the sprocket roller. A film cassette is loaded nipple down into the film chamber. The sprockets on the sprocket roller engage the sprocket holes on the film and hold the film steady as it is rolled onto (4) the take-up spool on the far right.

through the viewfinder. Check your instruction booklet for how to read the meter.

Most built-in meters are battery operated. Your instruction book will tell you where the battery goes, how to change it, and what kind you need. (It's a good idea to keep a spare battery on hand.) Don't leave batteries in the camera for long periods of time. They can leak and corrode the battery compartment.

On some cameras when the film advance lever cocks the shutter, it also operates the camera's light metering system. Make sure your meter is off when it is not in use, especially when you put the camera away. It takes only about 24 hours to completely drain a battery. Don't store the camera, even overnight, with the shutter cocked. The best practice is to cock the shutter just before you take a picture.

Inside the Camera

Now open the back of your camera. Again, you may have to see your instruction book. Even within the same brand, different models may open different ways. Be very careful with the camera while the back is open. Don't put in film until you've finished studying this chapter.

FILM CHAMBER AND TAKE-UP SPOOL

Inside the camera on the left is the film chamber. In the middle is the shutter. On the right is the film take-up spool. As the name implies, the **film chamber** holds the film cassette. Film is drawn from the cassette, across the shutter, and onto the take-up spool. The **film take-up spool** holds the exposed film. The spool turns when the film advance lever is operated. Notice that the take-up spool is not shielded from light. Consequently, once all the pictures have been taken, the film has to be rewound into the cassette *before the camera back is opened*. If you open the back before rewinding the film, the film on the take-up spool will be exposed to light and ruined. Once the film is rewound into the cassette, it is protected from light, and the back may be opened safely for a film change.

Stroke the film advance lever. See how the take-up spool advances the film. Turn the rewind crank. Notice how it works in the cassette to rewind film.

SHUTTER

The shutter is located just in front of the film between it and the lens. When you press the shutter button, the shutter opens to expose the film to light. Some shutters travel vertically and some horizontally. Watch the shutter while you press the shutter button. Notice how quickly the shutter opens and closes.

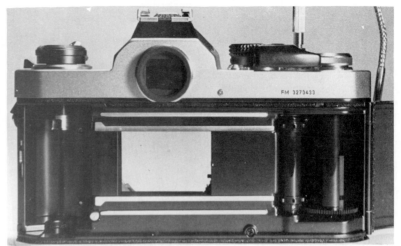

When you push the shutter button, the shutter opens to expose film to light.

The Exposure Controls

F/STOP RING

You have already read that one of the three most important controls on the camera is the focusing ring. The second is the f/stop ring.

An **f/stop** is a hole through which light enters the camera on its way to the film. Remember this hole is usually called an "aperture." The f/stop is one of your controls over light and therefore one of your controls over the exposure of your film. The f/stop helps control the film exposure because the size of the f/stop hole can be adjusted to control the amount of light reaching the film. A big hole lets in more light. A small hole lets in less light. The size of the hole is controlled by the **f/stop ring**. The f/stop ring, like the focusing ring, encircles the lens. You turn the ring one direction to enlarge the hole. You turn it the opposite direction to make the hole smaller.

The different numbers on the f/stop ring designate different size holes, or apertures. It is here that beginners may get confused because the larger the number the smaller the aperture, and vice versa. It is just the opposite of what you may expect. On the normal lens, f/16 is usually the smallest aperture. The largest aperture is most often something between f/2 and f/1.2.

The f/stop ring will probably be labeled this way:
- f/16—the smallest hole
- f/11
- f/8
- f/5.6
- f/4
- f/2.8
- f/2—the largest hole

Each f/stop either doubles or halves the light admitted by the f/stops next to it. For example, other controls remaining the same, f/16 lets in half as much light as f/11. Likewise, f/11 lets in half as much light as f/8. The f/8 setting lets in half as much light as f/5.6, and so on. If you open up one stop, you double the light reaching the film. If you close down one stop, you cut the light in half.

You have the best advantage when you can focus with the aperture wide open. Therefore on most cameras when you adjust the f/stop ring, the aperture remains open. It does not actually close down to the correct f/stop until you push the shutter button. To see how the ring works, set the f/stop to f/16.

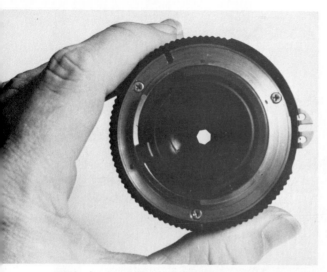

With the lens off the camera, you can easily see changes in the size of the aperture. Here, the lens is set at f/16. Notice that the highest number goes with the smallest hole.

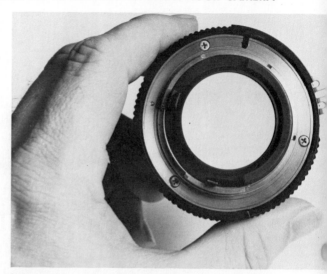

On this lens, the widest opening is f/1.4. All else being equal, the wider the opening, the more light hits the film.

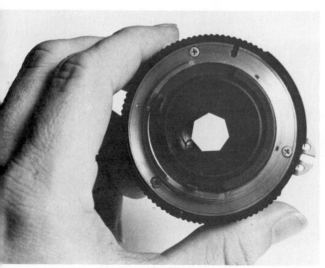

Here the setting is f/5.6 and the hole is larger.

Stroke the advance lever. Turn the camera so you can look into the lens from the front. Push the shutter button and watch carefully. See if you can notice the aperture close down.

At f/16 the aperture closes down to a very small hole. If you don't see it close down the first time, try several times until you do.

Now set the ring to f/5.6. Again stroke the lever and press the shutter button. Notice that the aperture again closes down, but this time not as much. This is because f/5.6 is larger than f/16.

Set the ring to the widest opening. Again cock the shutter and fire. This time you will see no change.

Besides being an exposure control, the f/stop affects how much of your picture, near and far, is in focus. This is called **depth of field**. The greater the depth of field, the more objects both close and distant are in focus.

Check your instruction book to see if your camera has a depth-of-field preview button. If it does, try this experiment. Place an object about 3 feet in front of the camera. Set another object about 10 feet in front of the camera. Set the f/stop ring at f/16. Focus on the object 3 feet away.

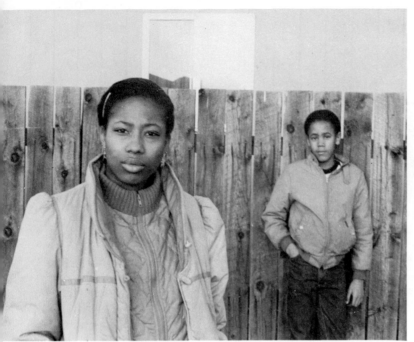

For maximum depth of field—or "depth of focus"—use small apertures.

To throw part of your picture out of focus, either the foreground or background, use wide apertures.

R. Neil Worley

32A

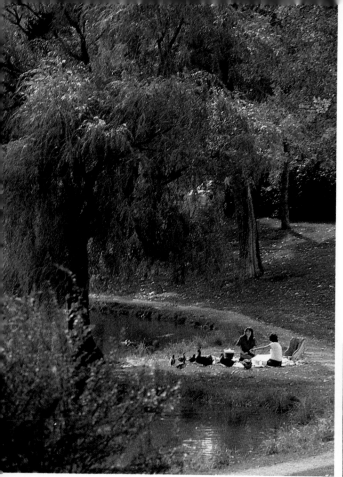

With color film, you can put a spot of red in
a field of green.

Color can sometimes carry a scene that in
black and white would be lifeless.

With slower color films, you can use different combinations of f/stop and shutter speeds. Notice how the water in the waterfall is sharp. The motion is frozen because the picture was taken with a fast shutter speed. The out-of-focus foliage in the foreground gives you a clue that a wider f/stop was used.

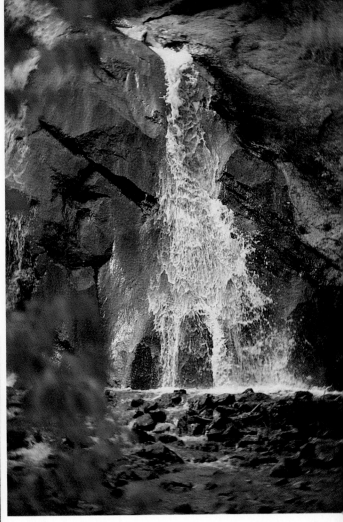

Here, the sharp foreground and the motion blur in the water indicate a small aperture and a slow shutter speed.

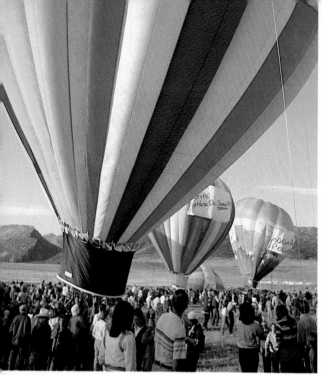

R. Neil Worley

One of the uses you will find for color pictures is in the color layout. Note the variety of camera-to-subject distances and the use of color on these two pages. Showing the crowd and several balloons, this picture is an "establishing" shot and a good way to open the story. Note the use of people within this frame and the other shots.

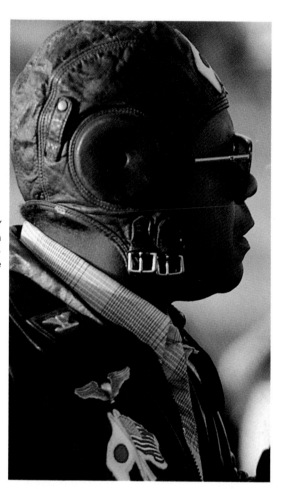

R. Neil Worley

Comedian Flip Wilson is also a balloon pilot. Though the lighting is unconventional, the profile is recognizable and the old pilot's helmet receives appropriate emphasis.

R. Neil Worley

The colors are bright and bold. They convey an impression of "freedom"—just what you want with balloons. The patterns and shadow are attractive irrespective of their context, but their reality gives them another dimension.

32D

R. Neil Worley

Again, design elements converge with reality. The figure in the basket puts another person in the layout. Notice how these shots are all verticals. Include verticals among any pictures you submit for publication.

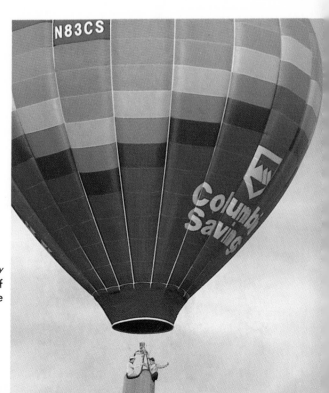

R. Neil Worley

The most abstract of the pictures, this shot is tied to reality primarily by its placement with the others in the layout.

R. Neil Worley

As the camera-to-subject distance grows, the size of the balloon diminishes and creates a fitting end to the picture story.

Light bulbs create warm tones on daylight color film. With color negative film, acceptable corrections can often be made during printing. For slides, solutions include using tungsten-balanced film, filters, and alternative lighting.

Fluorescent tubes often create a green cast on daylight color film. Solutions include the use of filters and alternative lighting such as a flash.

Outdoors, daylight film usually renders acceptable colors. Overcast skies and shadow areas may, however, come out unacceptably blue. To correct that, warming filters and fill-in flash could be used.

32F

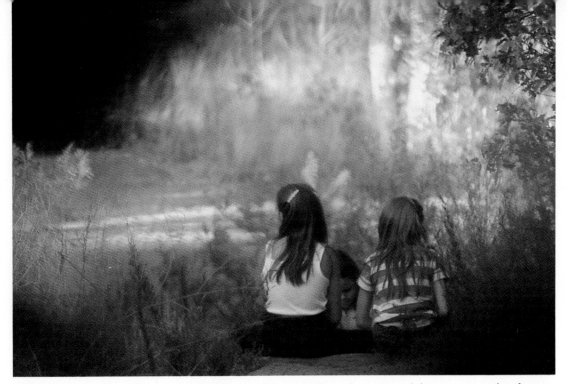

Another use for color pictures is a slide show. The photographs on this page and the next were taken from an actual slide show made for a hospital social-work department. Note the horizontal format to make maximum use of the horizontal projection screen.

32G

This shot demonstrates the effect of a multiple parallel attachment. The purpose of this photograph in the slide show was to convey disturbing emotions. As you will see in the chapter on filters, many special effects may also be created with homemade equipment.

Here the script for the show comments on some of the department's objectives: health and family togetherness. This is a very simple picture. As you can see, it depends almost completely on the appeal of the subjects to carry it. Also in its favor is the gentle lighting which brings out the colors.

32H

The slide show script discusses "a complete kind of care, care that is more effective because it brings into the picture social and psychological support systems available to the patient."

With your eye still to the viewfinder, push the depth-of-field preview button. Don't move the focusing ring. Notice how, when you push the button, two things happen:

1. The viewfinder darkens. That's because as you push the button the aperture closes down, just as it would if you pressed the shutter button.

2. The focus greatly improves on the object 10 feet away. That's because depth of field—or "depth of focus"—*improves at smaller apertures.*

When you want objects in focus from near to far, use small apertures. If you want to throw a background or foreground out of focus, use larger apertures. When you are shooting, a depth-of-field preview button is a handy tool to see the effects of different f/stops on image sharpness.

SHUTTER SPEED DIAL

The third important control is the shutter speed dial. (Remember that the other two controls are the focusing ring and the f/stop ring.) Along with the f/stop ring, the shutter speed dial controls the light and thus the film exposure. The **shutter speed dial** adjusts the length of time the shutter is open.

On most 35 mm SLRs, the shutter speed dial is near the film advance lever. On a few models, shutter speeds are on a ring encircling the lens. In these cases, the shutter speed ring is usually behind the f/stop ring.

On the dial or ring, you will see a series of numbers and usually a *B* and/or a *T*. The *B* and *T* settings allow you to make exposures longer than one second. The numbers begin at 1 and go to 500, 1000, or, in some cases, to 4000. The numbers refer to fractions of a second. Each of the numbers on the dial should be read as the denominator—the bottom number—of a fraction. The numerator —the top number—of these fractions will always be 1. Thus, the "1" on the dial indicates 1 second (or 1/1). The "2" on the dial is 1/2 second. The "4" is 1/4 second, and so on. Notice that each number is roughly—and sometimes exactly—twice or one-half the number next to it.

The shutter speed dial is usually labeled this way:

Number	Length of Exposure
1	for 1 second
2	for 1/2 second
4	for 1/4 second
8	for 1/8 second
15	for 1/15 second
30	for 1/30 second
60	for 1/60 second
125	for 1/125 second
250	for 1/250 second
500	for 1/500 second
1000	for 1/1000 second

Each setting either doubles or halves the light admitted by the shutter speeds next to it. (This assumes that no setting but the shutter speed is being changed.) A 1-second setting exposes the film twice as long as a 1/2-second exposure, and so on.

Sometimes shutter speeds are referred to, in a general sense, as fast or slow. The fastest speed is often 1/1000. The slowest speed on the dial is usually 1 second.

As you may have guessed, the f/stop and shutter speed work hand in hand. A slow shutter speed and small aperture can let in the same amount of light as a fast shutter speed and large aperture. The shutter speed and the f/stop *combine* to allow the right amount of light to your film.

Set your shutter speed for 1 second. Set the f/stop ring to the widest opening. With the camera back open, aim the camera toward something light. Push the shutter button, and you will see the shutter open for 1 second. Because 1 second is such a long time for an exposure, you can imagine how any movement of the camera or your subject will be recorded as a blur on the film. If a photogra-

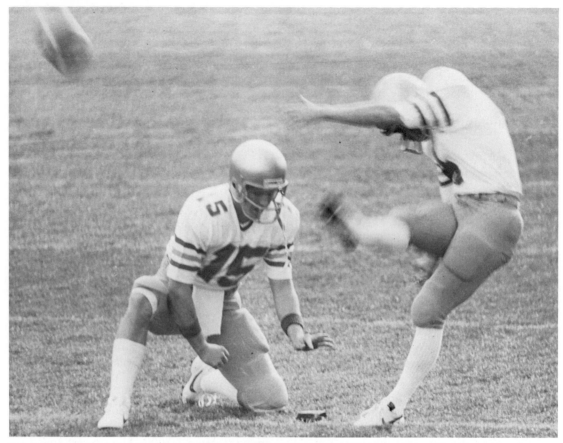

To create a motion blur, shoot fast action with a slow shutter speed. Slower action can be blurred by shooting with a slower shutter speed.

pher wants to deliberately blur movement, a slow shutter speed is used.

Set the shutter speed for 1/60 second. Stroke the lever and press the shutter button again. Notice how quickly the shutter moves now. It is fast enough to compensate for a slight movement of your hands as you take the picture. Unless you *want* a blur, don't handhold the camera at speeds slower than 1/60 second, at least not with a normal lens. With other lenses, different minimums apply.

To avoid accidental blurring, it is good practice, when you can, to use 1/125 second or faster.

Set the shutter speed for 1/1000 second. Again trigger the shutter. At 1/1000 second, all but the fastest movement of your subject will be frozen. For instance, when helicopters are shot at 1/1000 second, they sometimes appear to hang in the air with their rotors stopped.

Close the back of the camera.

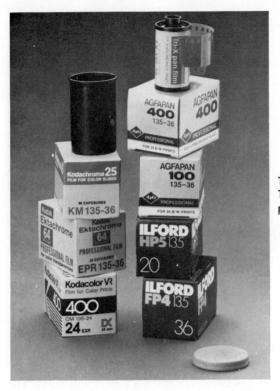

These are only a few of the 35 mm films available. The film comes in cassettes (top right) which are packaged in canisters (top left). The canisters are enclosed in the small cardboard boxes.

ABOUT FILM

At this point, there are just a few things you need to know about film. There are films for black and white prints, for color prints, and for color slides. Slides are sometimes called **transparencies**.

Films come in a variety of film speeds. A film speed indicates how quickly a film reacts to light. Higher numbers mean faster films. At first, film speeds will be important to you at two different times: when you buy the film and when you set your light meter. (Film speed will be covered in detail in Chapter 5.)

Buying Film

When you buy a roll of film, you must specify four things:

1. The film format. The format indicates negative size. If you have a 35 mm camera, the format is 35 mm.
2. Whether the film is for black and white prints, for color prints, or for color slides.
3. The film speed. (See Chapter 5.)
4. The number of exposures—or pictures— per roll. The 35 mm rolls usually come in 12, 20, 24, and 36 exposures.

The choice of film is yours. At first, a fast black and white film (ISO 400) probably will be the easiest for you to control. Other choices, of course, are available, and you may want to discuss alternatives with your instructor.

Putting Film in the Camera

The exact procedure for loading your camera is detailed in your instruction book. At the end of the chapter, when you are ready to

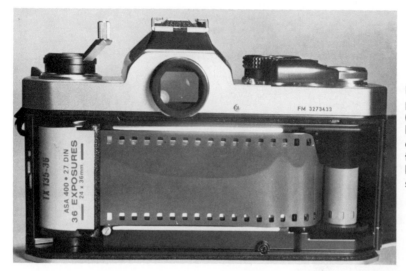

Film cassettes are loaded, nipple down, into the film chamber (left). Make sure the sprocket holes fit over the sprocket teeth and that everything is snug before you close the camera back. Be sure to take up any slack in the cassette with the rewind knob (top left).

load, see your instruction book. Load the film in subdued light. If you have to load in sunlight, use your body to create a shadow.

As soon as you close the camera back after loading the film, gently turn the film rewind crank in the direction of the arrow. This tightens the film in the cassette. Stop when you meet resistance. Once the film is secured and tight, the rewind knob will turn each time you stroke the film advance lever. This tells you that the camera is loaded and, generally, that the film is moving smoothly from cassette to take-up spool. Loose film is more likely to jam in the camera.

Each time you load film the first part of the roll is exposed as you load it. Before shooting, advance the film two frames to get to unexposed film. To advance the film, stroke the film advance lever and squeeze the shutter release button.

Adjusting the Camera

Note the film speed rating on the film box. It will be shown in numerical form preceded by "ISO" or "ASA." Set the light meter to the same rating. The technique for setting the meter varies from model to model, so again see your instruction book.

Once set, the meter can tell you which combinations of shutter speed and f/stop will give you a correct exposure. A correct exposure admits just the right amount of light to your film—not too much and not too little. Notice that you are dealing with *combinations* of f/stops and shutter speeds.

For any combination of f/stop and shutter speed, the meter will tell you one of three things: that you have an overexposure, a correct exposure, or an underexposure. If you have a correct exposure, if the aperture is small enough to give you the depth of field you want, and if the shutter speed is fast enough so you can handhold the camera, nothing more is needed. You can take the shot. If you have an **overexposure**—too much light reaching the film—you can cut the light by speeding up the shutter, closing down the aperture, or both. If you have an **underexposure**—too little light reaching the film—you can increase the light by slowing down the shutter, opening up the aperture, or both.

This picture was taken indoors with nothing but a 35 mm camera and normal lens. The light is daylight coming in an open door.

With your first roll of film, don't worry too much about mastering all the controls. Use 1/125 second as a basic shutter speed, and use the f/stop ring to control exposure.

The easiest light to shoot in is even light throughout the frame. The light meter is most likely to give you accurate readings in even light. It is tricky to get an accurate light-meter reading when your light source is shining toward your camera. The background will be light and the subject dark. Also, direct sunlight casts harsh shadows and generally should be avoided. A hazy day with soft light will give better results. If you choose an ISO 400 film, you may try to shoot indoors without flash. If you are using black and white film, fluorescent lights work nicely.

With your first roll of film, concentrate on the following:
- Pick interesting subjects.
- Watch your framing, the rule of thirds, and your backgrounds.
- Focus carefully.
- Expose carefully.
- Choose subdued, even light instead of harsh light.

Unloading the Film

When you have used all your film, rewind and then unload the camera in subdued light.

See your instruction booklet for exact details. On most cameras there is a release button you must push before you can use the rewind crank. Push it and then rewind the film into the cassette. When the film is rewound, open the camera back and remove the cassette.

SUMMARY

The camera must be handled and cleaned carefully. On an SLR, the viewfinder shows exactly what the lens "sees." The lens focuses light on the film. The focusing ring, f/stop ring, and shutter speed dial all help you achieve a sharp image. The f/stop and shutter speed control exposure. The film advance lever, rewind knob, and frame counter work with the film during its movement through the camera. The shutter release triggers the shutter which lets light reach the film. Light meters measure light intensity. Inside the camera, the film chamber and take-up spool store the film during use.

Large f/stop numbers mean small apertures and vice versa. F/stops affect depth of field or depth of focus. The shutter speed dial adjusts how long the shutter is open in fractions of a second.

Film is available for black and white prints, color prints, and color slides. Some films react more quickly to light than others. Film should be loaded and unloaded in subdued light. Beginners may want to start with ISO 400 black and white film at a shutter speed of 1/125.

 Discussion Questions

1. The hole through which light enters the camera is also called an _____.
2. The _____ opens to let light into the camera.
3. You look through the _____ to frame the picture.
4. With f/stops, the larger the number, the _____ the hole.
5. What does the 125 mean on the shutter speed dial?
6. What are the three most important camera controls?
7. What is depth of field?
8. To adjust depth of field, adjust the _____.
9. How should lenses be cleaned?
10. Define overexposure.
11. Define underexposure.

1. Go over your camera several times saying the names of each of the parts until you can remember them without looking in the text or your instruction manual.

2. Without putting film in the camera, practice snapping pictures. Stroke the film advance lever. Frame your subject in the viewfinder. Focus. Press the shutter release. Practice these movements until you can do them smoothly.

3. Put film in the camera and adjust the settings.

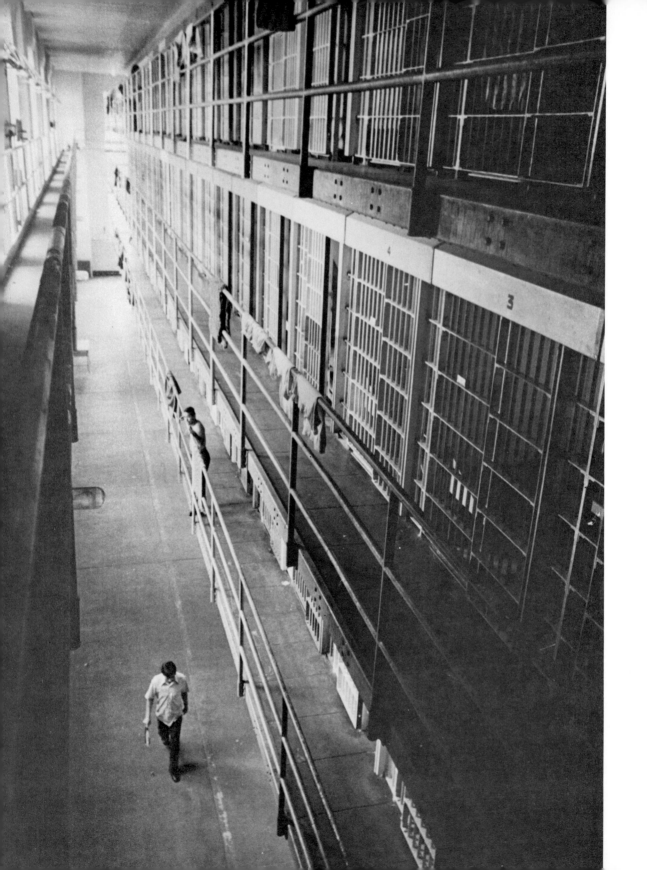

CHAPTER 3

Making Simple Pictures

Successful photographers "make" pictures—as opposed to just "taking" them. How?

It's very easy—especially if a beginner is attracted to a particular advertising or magazine picture—to fail to think of the photograph in terms of its original purpose. Perhaps the picture is of an exotic subject—one the novice may not have easy access to, or a simple subject may be presented in an unusual way. The beginner tries to mimic the original picture and fails. Something is missing in the duplicate photo that was not missing in the original. The beginner's picture does not show the same purpose. A sense of purpose is critical to good photographs. This chapter will show you how to bring a sense of purpose to your work.

There is nothing wrong with trying to copy a technique you see. That's one excellent way to learn. The important thing is that you understand all that is happening in the pictures you like. You may like the lighting in a picture of a Japanese temple, and the lighting itself may be worth borrowing. But you have to remember that part of the power of the original has to do with the unusual subject matter, and your own photograph may suffer by comparison.

ESTABLISHING YOUR PURPOSE

For some photographers, the most difficult and pressing problem is to come up with good subjects. The subject is the first key element of a good photograph and usually indicates the picture's purpose. For example, if you're taking pictures for the family album, your most likely subjects are family members —their involvement in activities, their interaction, their expressions.

The second key element of a picture is the treatment of the subject. Given the subject, do you need a close-up? Should a background be included? How will you frame the subject? The photographer's job is to adequately present, or treat, a subject.

Two groups of photographers have no trouble coming up with good subjects. Oddly enough, the first group is the snapshooters— the people who carry simple cameras and who could hardly care less about f/stops, shutter speeds, and focusing rings. Almost by instinct, snapshooters know a good subject when they see one. They take pictures of holidays and vacations, during weddings and birthday parties, and any time a new baby comes into the home. Their picture taking has a purpose. That purpose is creating memories. However, snapshooters often fail

Terms to Learn

pose
scenics

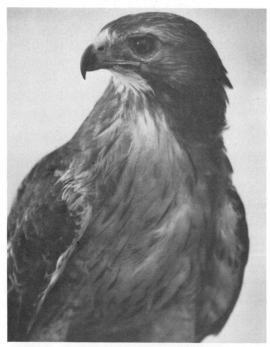

The first key element of a good photograph is an interesting subject.

in the treatment of their subjects. People's heads are cut off or the picture is out of focus. The light is bad, the backgrounds are usually distracting, and the framing leaves much to be desired.

The professionals, likewise, have no trouble coming up with subjects because the subjects are often assigned. The professional is told to shoot a wedding, to portray a personality, or to shoot a particular product for advertising purposes. Professionals, of course, *must* provide adequate treatment of their subjects.

In between the snapshooters and the professionals are the photohobbyists. Photohobbyists have a tendency to forget the importance of subjects. That may be because they concentrate more on equipment and technique—forgetting the real reason they're taking pictures.

As a beginner you may spend a greater amount of time concentrating on equipment at first because you are learning about it. However, you must not forget your main purpose: To treat a subject in such a way that the things you want to say about it are clear.

Self-Assignments

There is a way to avoid problems with subjects: Make assignments for yourself. The more specific they are, the better. You may, of course, take on a broad subject like "my home town" and do a series of pictures to cover it, but then you must break down the assignment into specific shots that will eventually make up the series. An aerial shot—from an overlook or a plane—might cover the assignment in a single frame. An aerial, though, is unlikely to show the character of the town. The character of the town is part of what makes the subject appealing in the first place.

By thinking of your pictures in terms of assignments, you give yourself three advantages:

1. An assignment clarifies your purpose. Whenever you pick up a camera without

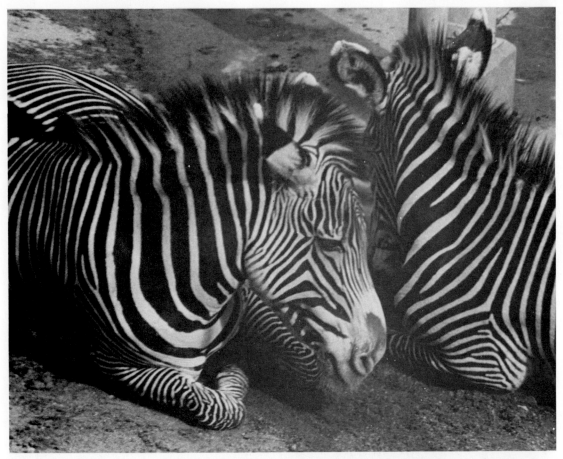

This is the kind of picture a professional might look for when assigned, for whatever reason, to shoot at a zoo. The vague assignment is "the zoo." Then, consciously or not, the photographer makes a more specific self-assignment of "zebras." With adequate treatment—framing, background selection, etc.—the picture works. If the zebras had been too difficult to shoot well, the photographer would simply have self-assigned other animals.

knowing what you intend to shoot, you're in trouble. Before you shoot, ask yourself: What do I really want a picture of? A vague assignment is better than no assignment at all. You simply have to make it more specific before you shoot. Then, once you've decided on a subject, concentrate on the treatment.

2. An assignment helps you set priorities. Let's say you begin with the thought that you 'want to show a subject's movement. Since "subject" must come before "treatment," you

must first select a subject that moves. Then you can decide how to treat it.

3. You can evaluate your results. If you have a problem, first see if it is with your subject. If the problem isn't with the subject, then see if it's with the treatment. As often as you can, try to make an evaluation *before* you push the shutter button.

Having a purpose gives direction to your work, and, from the very beginning, avoids a waste of your time, film, and money. Giving

43

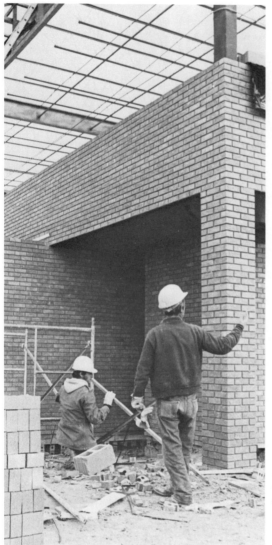

yourself an assignment, and keeping the two key elements in mind, will help you advance your skills faster and more effectively than any other method.

As you work on assignments, notice how they help guide your thinking about pictures. Notice how they encourage you to think in terms of subject and treatment. Consider the kinds of pictures you might be taking if you had no assignments at all.

Ideally, assignments should fit your own personality. You may want to explore the traditional territory of the snapshooter—holidays, vacations, birthdays, and new babies. Then, once you've selected your subjects, make them interesting to a wide audience. Present them so they capture the eye of more than just family and friends. You may want to explore a particular sport, such as gymnastics, football, or cycling. You may prefer to make a series of pictures of any activity that intrigues you. If you choose **scenics**, pictures of landscapes, remember that you will have to work especially hard on their treatment.

The assignment that led to this shot was "construction work on a building." In evaluating this shot, you would note that the picture is usable because the workers add some life within the frame. The composition is acceptable. You might also note that such a setting could offer other interesting subjects—close-ups of the individual workers, for instance.

SAFETY REMINDERS

● Avoid shooting in streets and on highways. Don't attempt to frame pictures in the way of traffic. Most shots can be as easily obtained from the side of a road as they can in the road itself. Sometimes you can shoot from buildings across the road from your subject. If you must, give up the picture.

● Stay aware of any hazards associated with special activities you photograph. Even professional photographers have been injured on the sidelines at football games. As a beginner, your best rule of thumb is to shoot from the stands at sporting events. Even after you become used to your equipment, it is a good practice to change film and lenses away from the sideline.

The informal portrait takes a human subject and suggests an interpretation of that subject.

As you work on any series of pictures, vary the camera-to-subject distance from shot to shot. In other words, try extreme close-ups and long shots as well as the everyday medium shots.

THREE ASSIGNMENTS

Following are three general assignments. Try them all. A person could make a career of specializing in any one of them. Jill Krementz, for instance, has specialized in informal portraits of writers. Her work can be found on the dust jackets of many a best seller.

The Informal Portrait

The informal portrait, of course, assumes you have—or can find—a human subject. The assignment itself suggests an interpretation of the subject. An informal portrait differs from a formal portrait in that it does not depend on a studio with lights, light stands, tripods, and painted backgrounds.

You will instead use available light, indoors or out, and you will have to control the background with your frame.

Almost any issue of the major news magazines will carry good examples of the informal portrait. Look through some issues and notice the variety of techniques.

In this assignment, you have a choice of subject, choice of location or setting, choice of camera angle, and some choice of light. At this point, you many want to limit the choice of light to a soft, even lighting until we look at the details of lighting techniques in a later chapter. Work out the subject's **pose**—how the body is positioned—either by directing the subject to pose in a certain way or by allowing the subject to assume a natural position of his or her own.

Choose the camera-to-subject distance. The camera-to-subject distance affects the framing. Do you want to include the subject's full figure, only the head and shoulders, only

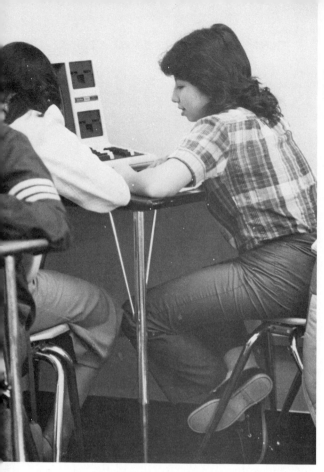

In the informal portrait, you may either direct the person to pose in a certain way or allow the subject to assume a natural position of his or her own.

Conventional choices don't have to be dull. Good informal portraits often depend on the subject's relation to his or her setting or the subject's expression. Even people you know fairly well can have interesting possessions and hobbies that you may not have realized. Poses, clothing, or props can tell viewers something about the subject. The more the picture tells about the subject, the better. And a simple expression, tightly framed, or a simple prop or two might do the job quite well.

Tips for an informal portrait:
● If you can, find a willing subject. Close relatives and best friends are sometimes reluctant to pose, and their reluctance may show.
● Consider using a vertical frame. Verticals are often preferred for subjects, such as humans, who are taller than they are wide. Verticals are usually easier to take with your right hand beneath the camera.
● Pay attention to framing, composition, and background. A setting appropriate to the subject can give you an edge. A storekeeper can be shown in a store. A student can be shown in a class, with books, at a library, or with a typewriter. With your framing and composition, emphasize the subject. Remember the rule of thirds.
● Unless you are aiming at a special effect, focus on the subject's eyes.
● Good expressions on a subject can give you an even greater edge—if you can catch them and make the most of them. If not, settle for a smile or a straight face, and try to make up for the lack of expression in some other way. Pros often have to do the same thing. The idea is to get a competent picture.

the head, or perhaps only a particular feature? Some portraits don't concentrate on the face. A well-known picture of Winston Churchill, prime minister of England during World War II, portrays the heavy, old man from the back. Feet, legs, arms, and necks have sometimes been made to say what the photographer wanted to say about a subject. Alfred Hitchcock, the film director, has been pictured as a mere shadow—the shadow cast by his famous profile.

There is an infinite range of choices to make. However, in the beginning, you are more likely to be successful with more conventional choices because they are easier to control. If you must experiment, at least take a few conventional shots to be on the safe side.

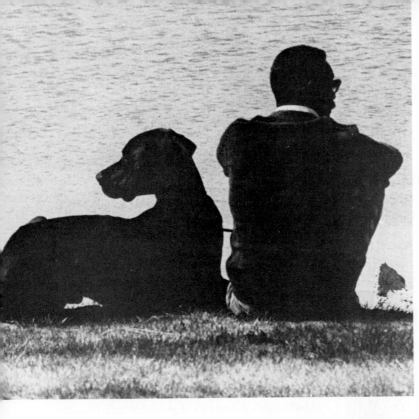

The silhouette treatment of the subjects emphasizes their postures and their individuality. Notice the framing, composition, and background.

• Put your model at ease. Don't be afraid to say "good," "nice," or "that's it" when things are going well. Don't be afraid to suggest changes when things are not going right.

• Before your model is posed, set your f/stop and shutter speed and advance the film. Avoid making the model wait any longer than is necessary.

A Person Involved in an Activity

Consider the millions of possibilities a person involved in an activity offers. Any person is fair game—as long as the person is doing something. This kind of picture is found in magazines, books, newspapers, and bro-

The assignment of "a person involved in an activity" offers millions of picture possibilities.

chures and other advertising media. In some ways, this assignment is similar to the informal portrait. The informal portrait, however, doesn't require an activity, and this assignment doesn't emphasize the model. The emphasis instead is shifted to the activity. Try to show the involvement and the concentration or enthusiasm of the model. The location and background are important as well.

You probably will want to select an interesting activity. Until you get completely comfortable with the camera, you might also want to select a slow-moving activity. Your choice might be an aircraft mechanic inspecting the engine of a light plane, a chess player concentrating on a move, a police officer issuing a ticket, a nun instructing a small child, a rescue worker during a disaster, or a head of state during a political convention.

Generally, the camera-to-subject distance will be greater for this picture than for the informal portrait, but there are exceptions. For example, you might do a close-up of a jeweler inspecting a ring. The ring might be in sharp focus in the foreground, and the jeweler slightly out of focus in the background. You probably would use a medium to wide aperture for reduced depth of field.

Tips for a picture of a person involved in an activity:

● Find a model and activity that will not press you for time. As you become more comfortable with the camera, you will be able to shoot more quickly, but give yourself plenty of time at first.

● Don't feel you have to shoot a long shot. Experiment, if you can, with closer camera-to-subject distances. See how much of the surroundings you can eliminate and still suggest all that you want about the subject.

● Notice that the involvement doesn't *always* have to show in the model's face. With non-professional models, the involvement usually has to be sincere to be effective in the picture. Sometimes the involvement can be much more effectively conveyed with body language. If, in the activity you select, the model's posture is more expressive than the face, take advantage of the posture. For example, a football player, sitting on the bench with his elbows on his knees and his face resting in his

It's clear these people are voting, yet all you see of them are ankles and feet.

The interior of the U.S. Air Force Academy cadet chapel is very distinctive. The building is recognizable to anyone who has seen it.

hands may say more about fatigue than a tired facial expression.

A Building with People

This assignment will give you experience in conveying a sense of place. It also may show you ways to dress up a somewhat drab location.

If you use the exterior of the building, you don't have to shoot the whole building. You don't even have to confine yourself to the exterior of the building. Inside or out, though, do try to make the building recognizable. If you choose a school, for instance, pick one of the more distinctive areas—perhaps an entrance everyone knows, the library, the cafeteria, or the gymnasium. You also can show the function of the place. For example, at a school you can portray the teaching and learning aspects. This may be done in a classroom or lab.

Ask yourself: Which characteristics of this building tell me something about the building? What features tell me what kind of building it is? How is the building being used? What is outstanding about this building? Where is it located? Decide what there is about the building you would like to convey. What will look good in a picture? In the classroom, for instance, the pattern made by rows and rows of students at their desks can be interesting.

Tips for a picture of a building with people:

● The standard way to make a building look interesting is to put at least one person in the frame—usually walking toward or away from the building. Especially if you are working inside a building, see if you can use people in a more creative way. For instance, they may be used to tell something about the function of the building.

● Light will be one of your tools whenever you take pictures. Although light will be covered in detail later, you might want to consider some simple experiments with light here. In the daytime, textured surfaces—like

An old church spire reflected in the glass windows of a modern bank building creates an interesting study. You may want to see if you can make use of repeating patterns and unusual reflections.

those on stone or stucco buildings—show up best when the light is coming from the side. Night pictures can be taken with a handheld camera using ISO 400 film. Since part of the drama of night pictures comes from the placement of light areas in the midst of dark, you should take you meter reading from the light areas (but not from the lights themselves) and then move back to take the picture. Don't meter the dark areas. They're supposed to go dark anyway.

● See if you can make use of the character of the building. Glass-front buildings offer interesting repeating patterns and sometimes offer fascinating reflections as well. A picture of an old gas station may be enhanced by the presence of its equally ancient owner. The

same gas station might also provide contrast to a well-dressed young man or woman in a sports car.

● When you're using a 35 mm camera, buildings can present special problems. When the camera is level, there is no trouble. If, for instance, you can shoot a skyscraper from the middle of another skyscraper, it will look all right. If you tilt the camera slightly up, the edges of the building appear to converge toward the top. In the picture, the building will appear to be falling backwards. However, oddly enough, as you get closer to the building, the effect is increased but the picture is improved. When shooting buildings, check your viewfinder to make sure this tilted effect is not objectionable.

MAKING THE MOST OF WHAT YOU HAVE

Learn to think creatively so that you will learn to make the most of your opportunities.

This means thinking creatively about your subject as well as your tools.

For example, all three of the assignments just discussed could possibly be fulfilled by a single picture. Imagine the press box at a large football stadium. Inside are long rooms with long tables next to the windows which overlook the playing field. At the tables, all in a row, are press people—announcers, sports writers, and statisticians. If you were in a corner next to the window and could see all these people lined up in your viewfinder, you would have an informal portrait of the nearest person—perhaps an announcer at a microphone. You would also have shown the person's location and something about what the person does. Next, you would have a picture of a person involved in an activity—announcing the game. Finally, you would have a picture of a building with people. The function of the building would be clear to anyone who has seen a press box on television.

As a professional, you could encounter any one or all of the three assignments. They are designed not only to give you a feel for the camera, but to let you practice many of the skills you are likely to need later. Once you've selected the specific subjects you want to work with, concentrate on framing, composition, and backgrounds.

If you like, feel free to experiment with the creative controls—the focusing ring, f/stop ring, and shutter speed dial, but don't feel you have to do so. The most important thing at this point is to select and frame the subjects well.

These assignments can be done—and done well—with the equipment already covered. Other equipment and other techniques

Many people prefer to avoid dentists. When the dental office is in the state penitentiary, well. . . . Note the clues to the location: the sign, the bars, the bare walls, the ugly bench, and the plain tile floor.

These students in a biology lab inspired a simple picture taken with a normal lens and without a flash.

might enhance your ability to do each of the assignments. For example, the portrait might be easier to do with an 80 mm, 100 mm, 135 mm, or even a 200 mm lens. The building might be easier to shoot with a 4 × 5 view camera. And you might feel the need to know a great deal more about light than you do now. Remember, however, that you already have a powerful set of tools and techniques at your command. For the time being, don't worry about their limitations. Make use of their power. Get to know the basics—both the tools and techniques. Make them do all they can do. The strongest photographers are those who can squeeze good results from the most severe limitations.

See your subjects in terms of what the camera *can* do with them. Train your eye to imagine subjects with frames around them. Look out for cluttered backgrounds. Look

for special effects with light. As much as you can, see as if you were looking through the camera. Photography is more than just seeing a subject. It's seeing the subject as part of a *picture*.

SUMMARY

A sense of purpose is critical to good pictures. Making assignments for yourself can help you avoid purposeless pictures.

Informal portraits usually depend upon the subject's expression or pose. When shooting a person involved in an activity, the emphasis is less on the person than what she or he is doing. Pictures of a building should convey its function and will be more interesting if people are included.

Strong photographers learn to make the most of the subjects and equipment they have. Beginners must learn to do the same.

Discussion Questions

1. Successful photographers _____ pictures as opposed to just taking them.
2. What are the three advantages to self-assignments?
3. For an informal portrait, consider using a _____ frame.

4. What should you do before your model is posed?
5. Name several ways a person's involvement with an activity can be shown.
6. What happens if you tilt the camera up when taking shots of a building?

Make the following pictures:
1. An informal portrait.
2. A person involved in an activity.
3. A building with people.
Try to make the most interesting and professional-looking pictures you can.

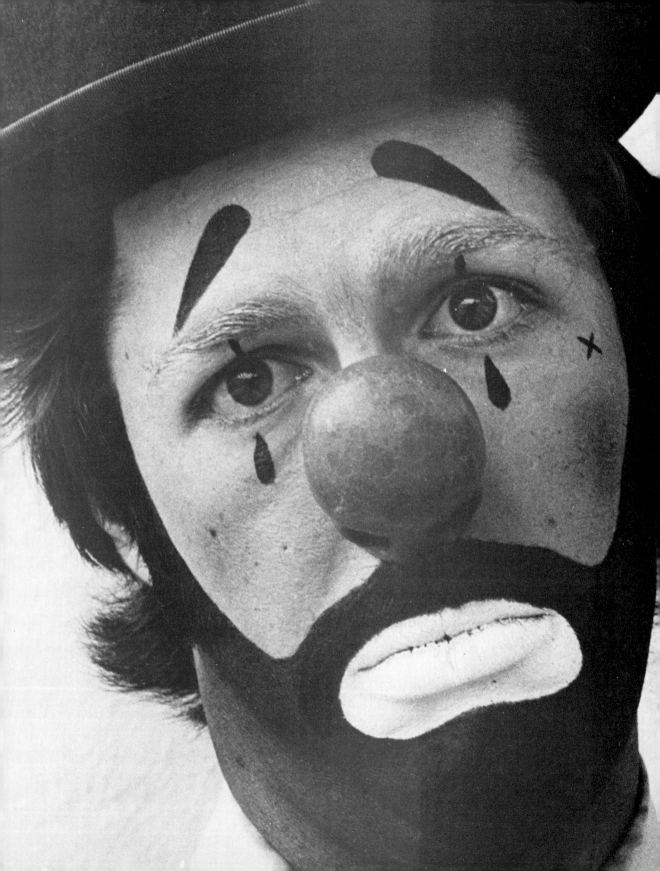

CHAPTER 4

Light

The magic of pictures lies in light. Light can do much more than make an image on film. It can bring a life of its own to your pictures. It can emphasize, subdue, or alter moods. It can help you say many different things about your subjects.

In this chapter, you'll learn how to make light really work for you. You will see how you can capture the drama of light—how to make your subjects look harsh or soft, how to make silhouettes, how to separate your subjects from a background, and how to make backgrounds recede into darkness. You will see how to bring out textures or how to make wrinkles disappear. You will learn that darkness itself plays a role in lighting, and that shadows are sometimes as important as highlights.

Only in the studio is your control over light unlimited. Elsewhere, especially in sunlight, you must often accept light "as is." That's not all bad. We have grown up under the changing lights of our environment. We have seen the pleasing effects under streetlights, near windows, and down hallways. Certain light appeals to us. In fact, in the studio, photographers often recreate light they have seen and liked elsewhere. Photographers take great pains to duplicate in the studio the best light from the world around us.

Outside the studio, light is "controlled" by controlling other things. You can move subjects and the camera to places where you know the light will be to your liking. Ahead of time, you might choose to shoot at a certain time of day when you know the light will come from a certain direction. You can also use reflectors or add flash or some other form of artificial light.

How do you make use of the best of the light you have seen? First of all, learn to see it and recognize it. Then analyze it so you know what makes it work. Finally, learn how to control it and get it on film.

Light can be reduced to five features of particular interest to photographers. The first four are the light's intensity, quality, direction, and color. A fifth feature, contrast, is related to intensity, quality, and direction.

INTENSITY

As a photographer, you must deal directly with the **intensity**—or brightness—of light. The light meters in cameras measure light's intensity. The intensity affects f/stops and shutter speeds. However, the intensity can change and all the other features of light can remain the same. So, once you have enough light intensity to make a proper exposure, you can turn your attention elsewhere.

Terms to Learn

averaging meter
backlighting
bracketing
center-weighted meter
color temperature
contrast
data sheets
direct light

direction of light
filters
frontlighting
gray card
hard light
intensity
latitude
lens shades

overhead lighting
quality of light
reflected light
rim light
sidelighting
soft light
spot meter

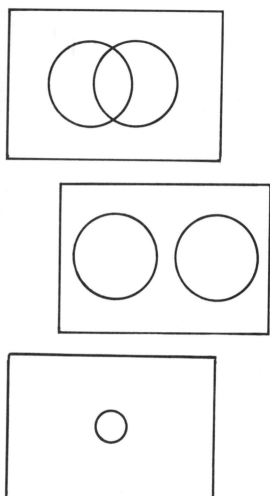

There are three general types of through-the-lens meters. They are (from top to bottom) the center-weighted, averaging, and spot. The circles in these simplified drawings show where the light is measured within the frame. Note how the center-weighted meter gives double emphasis to light in the middle of the frame.

Intensity can refer either to direct light or indirect, reflected light. **Direct light** is light from a light source, such as the sun, light bulbs, or fluorescent tubes. **Reflected light**, as the name implies, is light that bounces off people and things.

Light Meters

In this section we will look only at through-the-lens (TTL) meters. They are designed to measure reflected light.

There are three general types of TTL meters. These are the averaging meter, the center-weighted meter, and the spot meter.

This is an example of a typical metering system. To the right of the frame in the camera, you would see three dots. When the exposure is correct, the center dot lights up. An overexposure is indicated by a light in the upper dot, and an underexposure is indicated by a light in the lower one.

Most 35 mm cameras today use a center-weighted system.

The **averaging meter** measures the light in different areas of the frame and averages the results. The **center-weighted meter** gives priority to light values in the center of the frame. Both the averaging and center-weighted systems evaluate most of the frame. This is not the case with the spot meter. The **spot meter** reads a very small section, or "spot," in the frame. The reading is more precise, but much trickier to use. If you happen to have a spot meter, read the section in Chapter 9 on handheld meters before using it.

The first step in using your meter is to know how it works. If you have any doubts, review your instruction book. Most TTL meters need a battery to operate. The meters have an "on-off" switch. Usually, in the viewfinder, there is either a needle or a series of lights that will tell you when an exposure is accurate. Most TTL meters simply indicate underexposure, overexposure, and correct exposure.

When you set the film speed, you tell the meter how sensitive your film is to light. The meter then recommends settings that are appropriate for the particular film you have

in the camera. A correct setting for one film is not necessarily correct for another.

Measuring Intensity

Can you trust the light meter in your camera? It depends. A through-the-lens meter is a simple machine—just like all meters. Assuming that it's working properly, it tells you what it sees.

In average lighting and with average subjects, the TTL meter does a fairly good job of recommending exposure settings. It will tell you what to do even if you don't know how it works. Automatic cameras are designed with the idea that most subjects are lit from in front and that most pictures contain an average range of light and dark areas, or tones, within the frame. Most of the time, this is true. Sometimes, though, it's not. Then the meter will tell you a lie.

You will get the best use from your meter once you recognize when to trust it. Your light meter reads light as if it were reflected from an object of *average* brightness. The meter reacts to a white wall as if the wall were an average gray. It reacts to a black wall the same way. It recommends an exposure on either wall as if the wall were gray. If you use

A meter reading of this egg would suggest an exposure that is too low. The recommended exposure would turn the white into an average gray tone. To get white whites, you have to realize that the meter tries to see every scene as if it were an average gray, and you have to adjust your exposure accordingly.

the meter's recommendations, when the pictures are developed both walls will look gray.

Adjusting the Camera

Before we look in more detail at using f/stop and shutter speeds as light controls, you should know that the term "stop" is often used to refer to more than just f/stop settings. It is also used when speaking of shutter settings, film speeds, lens speeds, and the intensity of light. For example, a shutter may be speeded up by one, two, or more stops. One film may be several stops slower or faster than another. The maximum aperture of one lens may vary one or more stops from the maximum aperture of another lens. By moving a light source closer to a subject, you can boost the intensity of light on the subject by several stops. In general, the word "stop" simply refers to the settings that double or halve light or light sensitivity.

Let's assume for the moment that your light meter has recommended an accurate exposure for a specific film speed. Let's also assume that your f/stop and shutter speed are not yet at the recommended settings. This means the film will be either overexposed or underexposed.

If the settings would give you an overexposure—too much light hitting the film—you have three choices. You may reduce the light by:
1. Speeding up the shutter,
2. Closing down the lens, or
3. Both speeding up the shutter and closing down the lens.

If the settings would give you an underexposure—too little light hitting the film—you also have three choices. You may *increase* the light that will hit the film by:
1. Slowing down the shutter,
2. Opening up the lens, or
3. Both slowing down the shutter and opening up the lens.

Now let's say you've changed the setting or settings. The meter says you have an accurate exposure. What if at f/16 your shutter speed is now 1/15 second and you don't have a tripod? It's not good practice to handhold a camera at less than 1/60 second. What can you do?

Remember that correct exposures come in pairs. Your f/stop and shutter speed work together. *A change of one f/stop equals a change of one shutter speed, and vice versa.* Once you have an accurate setting, you can speed up

58

If the meter reading says f/5.6 at 1/30 of a second and you're handholding the camera, change the aperture to f/4 and the shutter speed to 1/60.

the shutter one stop and open the lens one stop and still have an accurate setting. In other words, if you halve the light admitted by the shutter and double the light admitted by the aperture, the exposure remains the same. You may also do just the opposite—slow the shutter and close down the lens—and the exposure remains the same. That means that *if* a shutter speed of 1/15 at f/16 is

accurate, so are the following: 1/30 at f/11, 1/60 at f/8, 1/125 at f/5.6, 1/250 at f/4, 1/500 at f/2.8, and 1/1000 at f/2. All you need do is choose.

It is best to make the setting you need for a special effect first. For example, if you prefer a small aperture for maximum depth of field, adjust the f/stop first, then the shutter speed. If you need a fast shutter speed to freeze

59

Sometimes you can set your meter at 1/125 or faster and make all your exposure adjustments with the f/stop ring.

The light at night can be strange. In some areas of this picture, the effects are almost those of daylight. The light-toned walls, for instance, wouldn't look much different in the daytime. A gray card reading from these walls produced the picture you see here. Telltale signs of the night are the silhouetted utility poles and the hot spot near the light in the upper left corner.

motion, set the shutter speed and then adjust the f/stop. If you're having any difficulty, reread the section in Chapter 2 on f/stops and shutter speeds.

With average brightness and average tones, settings don't have to be complicated. Whether you're outdoors in hazy sunlight or in a well lit office building, you can generally trust the meter. Sometimes you can just set your shutter speed at 1/125, make any necesssary adjustments with the f/stop ring, and concentrate primarily on focusing and framing.

When you're photographing people, it often makes sense to do exactly that. Only in unusual light or with unusually bright or dark subjects do you have to worry about the meter at all.

Basically, your task is to *think* about the intensity of the light you see in the frame. Ask yourself if you have an average subject and average light. If you don't have them, think about the areas within your frame that you want to come out "normal" in the finished picture. If, for instance, you're shooting a night scene, you have to make some choices. You will want more than just any light bulbs to be visible. You will probably prefer that the darker areas of the frame remain as black as they look to your eye. You might pick a spot on a wall that you would like to look much as it does to the eye. Take your most accurate reading from the light falling on that spot on the wall. Make your settings accordingly.

SAFETY REMINDERS

- When shooting at night, remember that you are less visible than you are in the daytime. Wear white or light-colored clothing.
- Household light bulbs get hot enough to burn skin and singe hair. They can burn you even after they're turned off.
- Don't ever work around electrical appliances or fixtures when your hands are wet or when the floor you're standing on is wet.
- Be careful with electrical cords. Don't use them if they are worn and watch that they are not placed where they may be tripped over either by you or by others. Also, don't defeat their safety features. Never cut off the grounding prong on a three-pronged plug.

Don't be afraid to meter several areas within a frame. When faced with strong lights and darks, consider making silhouettes. A dark figure set against an evening sky can be very effective. Meter for the sky, and let the figure go black.

You can certainly depend on the basic meter reading in most situations, but get in the habit of thinking about the different intensities of light and reflectance within the frame. Such a habit will greatly improve your percentage of acceptable exposures.

Film Data Sheets

The intensity of reflected light, of course, is not even throughout the frame. Some areas of the frame may be in deep shadow. Some objects will be dark. Others will be light. The important thing to remember is that your light meter takes in the lights, the darks, and the middle tones. It then recommends an exposure as if all the tones were a single shade of gray.

Also, if your scene has brilliant highlights and deep shadows, they may cause trouble.

Whenever the intensity of the light varies over 10 exposure settings within the frame, either the highlights will go white, the shadows will go black, or both. The meter can also be fooled by lighting from the back or side of the subject. For instance, when the sun is behind your subject, the meter will average out the brightness of the sky and the relative darkness of the subject's face. If, within your frame, the sky is large and the face is small, the face is likely to be two stops underexposed. In the printed picture it will be dark.

There are methods for dealing with those and other similar problems. One of the simpler methods is to use the information that comes with the film—either printed inside the film box or on a sheet of paper enclosed with the film. These **data sheets** recommend exposures for several kinds of situations. The data sheet information reflects a system for making fairly accurate guesses at outdoor exposures. The system is based on easy rules.

1. Let your film speed determine a basic shutter speed. If, for instance, you had an ISO 400 film, your basic shutter speed would

Data sheets, either enclosed with the film or printed on the inside of the film box, give a great deal of information on the film. The data sheets recommend exposures for several kinds of situations.

This picture was taken with Tri-X, an ISO 400 film. Since it was shot in direct sunlight, and the subject is of average brightness, the exposure was f/16 at 1/500 second.

be 1/400. If your film were ISO 25, the shutter speed would be 1/25. Since most SLRs don't have exactly a 1/400 or 1/25 shutter speed, you would use the shutter speed nearest the exact number. Thus, for ISO 400 film, you would set your shutter speed at 1/500 second. Instead of 1/25, you would use 1/30. (For more on film speed, see Chapter 5.)

2. Set your f/stop. The basic f/stop in the system is f/16 for average subjects in direct sunlight. In other words, whenever you have a subject lit in front by the sun, set the lens opening at f/16.

Assuming that you have set your shutter speed the same as the film speed, the following f/stops would then be fairly accurate:
- In bright sun, or slightly hazy sun with distinct shadows.f/16
- In hazy sun with soft shadowsf/11
- Cloudy bright—no shadows.f/8
- Heavy overcastf/5.6

For pictures on snow or light sand, use f/16 and speed up the shutter. For outdoor close-ups of subjects lit from behind, use the recommended rating for the shutter speed and set the lens opening at f/8.

With slower films (especially with ISO 25)

you would, of course, avoid handholding the camera at 1/30 second. In bright sun, when your basic exposure was 1/30 at f/16, you would simply go to another pair of settings, such as 1/125 at f/8.

What about lighting from the back? A meter reading that is correct for the surroundings may be two stops less than the exposure you need for your subject's face. An exposure that is correct for the face will overexpose the surroundings.

Of course, you might turn the subject around and shoot from his or her sunny side. Direct sunlight, however, is not usually very flattering. You may move closer to the subject and just expose for the face. However, the data sheet system tells you how to make adjustments when you know your meter will be wrong. If you know the meter will lie to you, you can rely on the settings offered on the data sheet.

Film Latitude

Film can tolerate an exposure that isn't quite ideal. Film **latitude** is the measure of a film's ability to acceptably record images at less than or greater than an ideal exposure. Latitude is a safety margin, but it varies from film to film. Print films have more latitude than slide films. Black and white films are more flexible than color. Faster films have more latitude than slower ones. A fast black and white negative film may tolerate a two stop overexposure and still give acceptable results. A slow color slide film may tolerate only a half stop error.

Best results, of course, come with as accurate an exposure as possible. If you need to rely on the safety margin, however, it helps to know in which direction to err. With negative print films, choose overexposure. With slide films, choose underexposure. It's easier to get an acceptable print from an overexposed print negative than from an underexposed one. An overexposed negative retains the image. Slides, on the other hand, are washed out when they are overexposed. A slight underexposure can enrich the colors in slides.

A meter reading that is correct for a backlit subject is often two stops less than a correct reading for a sunlit background. Note the low contrast, a characteristic of backlight.

Bracketing, making exposures over and under the one you expect to be accurate, is useful especially with night shots. This scene would have been particularly difficult to meter accurately, so bracketing gives you a selection of exposures to choose from.

Bracketing

Bracketing is simply taking several different exposures of the same subject. For example, you might underexpose the first shot by one stop, expose the second shot normally, then overexpose the last shot by one stop. One of the three shots should be fairly accurate.

Bracketing is usually done in half or full stop increments. Three or five shots may be taken with the "normal" exposure in the middle. When the shot is important and you have questions about the exposure, the extra film is a cheap form of insurance. The professional will virtually always bracket under certain conditions. Night scenes, for instance, are particularly difficult to meter properly and are usually bracketed. However, in fast-

The tones in this picture range from black to white. Underneath the compass sits a gray card. The exposure was measured with the gray card, and as a result, the blacks are black, the gray card is gray, and the brightest whites came out white.

A hard light is direct and casts distinct shadows.

breaking situations, bracketing is not always possible. It would be futile, for instance, to try to bracket every shot at a car race.

Gray Cards

When the background and subject are both white, any TTL meter reading will give you an underexposure. To prevent this, use a gray card. **Gray cards** are usually about 8 × 10 inches in size and are an "average" gray. They are sold in photo stores or can be obtained from photo suppliers.

A gray card reflects 18 percent of the light that hits it. When you put the card in the same light as your subject, you can take your light meter reading from the card instead of the subject. The gray card guarantees that your meter won't lie, because the card truly is an "average" subject.

If carrying a gray card is inconvenient, you may take a meter reading from the palm of your hand. If you're Caucasian, however, you'll have to open up about one stop for a correct exposure. White skin is about one stop brighter than a gray card, but at least it is a subject of known reflectance.

QUALITY

The quality of light is so important that the famous photographer Hiro has said, "When the light is right, don't change it to have a more convenient f/stop. Change your way of working."

The **quality of light** can be either hard or soft, harsh or diffuse. A **hard light** throws distinct shadows. It comes from a point source, such as an electronic flash or the sun on a clear day. It is harsh. **Soft light**, on the other hand, casts a soft, indistinct shadow. Soft light comes reflected from a broad surface, out of haze, or through a diffusing material, such as a lampshade. Soft light is often indirect light. We see it all the time on the shady side of buildings. Except in the studio, the hardness or softness of light is usually controlled indirectly. You can move the subject, change the camera position, or both.

Practical photography makes use of both hard and soft light. Hard light, especially when it comes from an angle, can give a dramatic effect—strong, bold, or angry. A soft light is used for more subtle effects—the

gentle or the glamorous. Quality is a feature of light to which you should devote a lot of your attention.

Look at how light quality was used in the pictures you like. Observe the different styles of lighting—in advertising, television, movies, newspapers, and magazines known for their effective pictures. On television, for instance, you will see different styles. The lighting used for soap operas looks different from the lighting used for a dramatic series, for a situation comedy, or for a feature movie.

The budgets for particular programs or films may be guessed at from the lighting styles. Budgets are higher for movies and advertising than for a television series. Higher budgets allow for more control of lighting and for more time-consuming effects. The better movies often make elegant use of natural light, which is as available to you as it is to movie producers. The lighting for a television series is more functional. Television series depend on fast shooting and haven't the big budgets for the kind of lighting you see in movies.

Look at the world around you. Notice how light falls on the different objects and people you see. See how, when people move, the effects of light change. Not all the effects are pleasant, but many are. Look at how room light differs from the light coming in windows. Notice the pools of light around street lamps at night. Observe the differences between hard and soft light. You don't need a camera to see the effects, but when the time comes, you *can* capture the effects on film.

DIRECTION

The **direction of light** indicates where it comes from: the front, side, back, or top of the subject. The direction of light determines where shadows will be. By looking at the shadows in a picture, you can determine where the light came from.

More than any of the other features, the

A soft light on, for instance, a hazy day casts softer, less distinct shadows.

quality and direction of light affect the "look" of pictures. The two major problems with flash units mounted on the camera, for instance, are the quality and direction of the

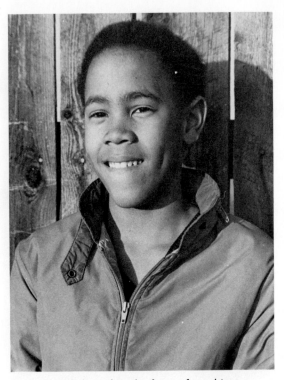

Frontlighting hits the front of a subject.

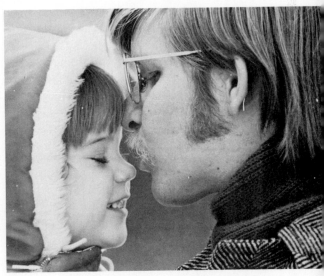

This picture was taken outdoors in a very soft light. Notice the soft shadow areas. Also notice the thin rim light on the little girl's profile.

light. Direct flash offers the intensity needed for a picture. But because the light comes from an unnatural place—from the camera —its quality is unnatural, too. It is too harsh; it casts an ugly shadow.

Light can hit your subject from an infinite variety of directions. Imagine a person standing under a large dome. A light can be pointed at the subject from *any* point on the dome. This variety, though, can be greatly simplified. It can, in fact, be reduced to four basic directions: we can speak of **frontlighting**, **sidelighting**, **backlighting**, and **overhead lighting**. These directions, by the way, are given from the *subject's* point of view. Frontlighting, for example, means that light is hitting the subject from in front. The light source is in front of the subject. Backlighting is hitting the subject's back. The light source is behind the subject.

There are certainly no hard and fast rules about which of these directions you must use. The main reason for learning them is to give you control over them. If you like the effect of sidelighting, it is useful to know that sidelighting is what caused the effect. You can then copy the effect on your own. However, in most pictures, the light source is at least slightly above the subject and usually a bit to one side. Except when a dramatic effect is desired, the light source is usually soft rather than hard.

Frontlighting is used to show details. In the next good outdoor pictures you see, however, notice that few use direct frontlighting. This is especially true in bright sunlight when the pictures include people. Many of the pictures —possibly more than you would expect— make use of backlighting. Backlighting offers a particularly soft light. As a matter of fact, what happens in backlighting is that the subject is lit with the light reflected from the atmosphere and from other surroundings.

Backlighting may be from either a hard or

soft light source. When frontlighting is hard and ugly, photographers will often move to the other side of a subject just to be able to use backlighting. The backlighting softens the quality of the light. Take the meter reading close to the subject. Avoid including too much light background in the frame. Sometimes the backlit subject has a **rim light**. The light source brilliantly illuminates the edge, or rim, of the subject. The remainder of the subject—and most of what the camera sees of the subject—is lit by a much dimmer and softer reflected light. The rim light is very pleasing. It also does a fine job of separating the subject from the background.

Sidelighting—especially when the light comes from near the horizon—is used to bring out textures. A strongly sidelit subject often has dark shadows and bright highlights. A hard, directional light is used more often with sidelighting than with frontlighting. To meter sidelighting, readings should be taken from both bright and dark areas. An exposure somewhere in between can be chosen, but lean toward the reading from the bright areas.

Direct overhead lighting is seldom used alone, especially when the light is hard. On buildings with textured surfaces, a strong light overhead and slightly in front of the building will bring out textures and will have an effect similar to strong sidelighting.

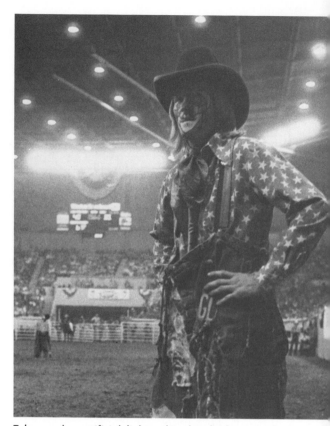

Taken under artificial lights, this shot looks natural enough in black and white. Most artificial lighting, however, yields a distinct cast on color film, especially on color slide film.

COLOR

With black and white film, you can forget about the color of light, at least for the most part. With black and white film, you can shoot a scene under fluorescent tubes, step outdoors for a daylight shot, and then step back indoors for a picture in a cozy little room lit by household light bulbs, or even by candlelight, all on the same roll of film.

Color film, especially slide film, simply won't permit such luxury. You've certainly seen the warm, orange glow cast by candlelight. You also may have noticed the greenish tint from fluorescent tubes. Perhaps in art class, a teacher has told you the shadows in snow are blue. Light from household light bulbs is full of reds, oranges, and yellows. Color film sees all these changes in the color of light and faithfully records them. This is why color films are balanced for either daylight or tungsten (artificial) light.

In some cases, a color shift using the "wrong" film may be tolerable. Under candlelight, you may prefer the warm tones. However, in most cases you will want to prevent the color shift.

Color Temperature

Daylight generally is at the blue end of the color spectrum. An electronic flash produces a light of a similar color. Proceeding toward the red end of the spectrum are clear flashbulbs, photoflood lamps, household light bulbs, and candlelight. Each has a different color temperature.

Color temperature is expressed in degrees kelvin (K) and is based on the color at which an inert substance would glow if it were heated to a certain temperature. Electronic flash is rated at about 6000 K. Noon sunlight is about 5400 K. Photoflood lamps are about 3400 K. Regular light bulbs are about 2900 K. Fluorescent and mercury vapor tubes vary from brand to brand and type to type. The lower the temperature, the more red there is in the light.

Filters come in a variety of styles. The most common filters are made of glass that is mounted in a metal ring. These filters are designed to screw into the front of the lens housing.

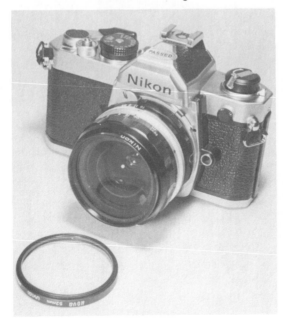

Color Correction

Steps may be taken to correct the colors produced by different lights. More complex corrections involve such things as color-temperature light meters that are used only when the color in the finished picture is critical.

Corrections for color print film can usually be made with the negative in the darkroom during printing. With color slides, however, you get back from the lab the same film you sent in for processing. There is no intermediate step during which corrections can be made. Because color temperature is more critical with slides, several types of slide film are made. The first is for daylight. The second two, A and B, are for tungsten lighting. Type A film is balanced for studio lights in the 3400 K range. Type B is balanced for 3200 K and can be used indoors with household light bulbs.

Whenever you combine daylight and tungsten lighting—in other words, where window light contributes to the overall light indoors—daylight film is preferable to tungsten film.

FILTERS

Filters, glass pieces that are attached to the front of the lens, are available for color correction. The filters screen out different types of light so the resulting pictures are more balanced and realistic.

For general color work, three filters can be useful. These are 85B, the 80A, and the FLD filters.

The 85B is used with tungsten film both in daylight and with electronic flash. This filter is yellowish orange in color and causes a light loss of two-thirds a stop. Because your TTL meter measures light from behind the filter, the meter makes an adjustment for the loss. When using a handheld meter, you will have to make the adjustment yourself.

The 80A filter is used with daylight film under incandescent—or household—bulbs. The 80A filter is blue. It causes a light loss of

two stops. Again, your TTL meter will adjust for the light loss.

The FLD filter is used with daylight film under the most commonly found fluorescent lighting. The filter is a salmon color (a mixture of magenta and yellow) and it causes a one stop loss of light.

If you use only daylight film outdoors and with electronic flash and use only tungsten film under incandescent lights, you won't need the 85B and 80A filters. If, however, you need to mix daylight and indoor shots on the same roll of film, the best practice is to use tungsten film and add the 85B filter for the outdoor shots. This practice maintains the effective speed of the film where you need it, under the dim light indoors. The 80A filter is used with daylight film under incandescent light, but it causes a light loss indoors where you can least afford it.

Before adding an FLD filter to your equipment, you might want to make a test shot under any fluorescent lights where you expect to shoot regularly. In some gyms, for instance, the lights are fairly well balanced for daylight film. Of course, if the test shot comes back with a strong green tint, the FLD will be necessary for your work with color slides in these locations.

Another situation where color correction may be necessary is when an interior is lit from a north window. The color temperature of the clear, blue sky can soar above 10,000 K. This strong, blue light can be corrected by adding light from household bulbs or with any number of the warming filters.

CONTRAST

Contrast has to do with the brightness range within your frame. How bright are the highlights? How dark are the shadows? Is there a great deal of difference between the two? Do you have adequate middle tones between the highlights and the shadow areas?

Contrast problems, when you have them, come in two forms: too much contrast and too little. High contrast pictures have black shadows and white highlights and few or no middle tones. This is a problem when the different levels of light and dark fall over too vast a range for the film to record them all. Low contrast pictures may be made up only

Light that is perfectly satisfactory for black and white film may be wrong for color film. To correct this, a wide variety of filters are available for color adjustment. Some of these, however, are very strong. They cut the light where you need it most, indoors.

High contrast pictures have bright highlights and dark shadows with few or no middle tones.

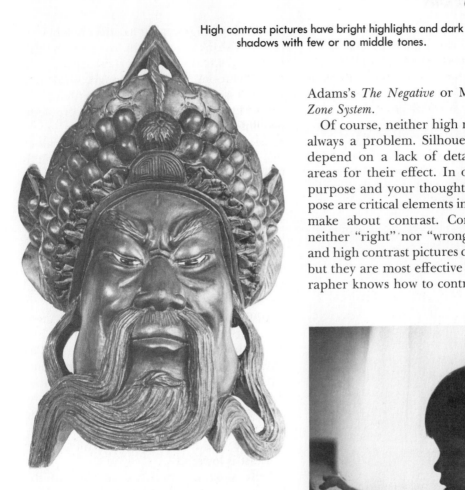

Adams's *The Negative* or Minor White's *The Zone System*.

Of course, neither high nor low contrast is always a problem. Silhouettes, for instance, depend on a lack of detail in the shadow areas for their effect. In other words, your purpose and your thoughts about your purpose are critical elements in the decisions you make about contrast. Contrast in itself is neither "right" nor "wrong." Low, medium, and high contrast pictures can all be effective, but they are most effective when the photographer knows how to control the contrast.

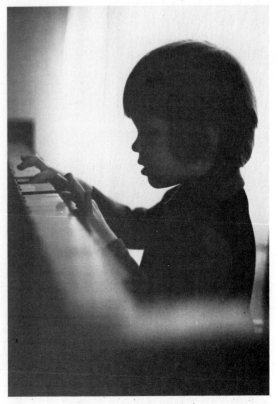

Silhouettes depend on a lack of detail in the shadow areas.

of dark or middle tones and there is not enough variation between lights and darks.

If you stay out of harsh, direct sunlight, the most common available-light situations usually won't be a problem as far as contrast goes. Most often you can find a light you can work with. In direct sunlight, look for backlight possibilities and look for shade.

Black and white films offer a variety of techniques for dealing with contrast in the darkroom, both in processing the film and in making prints. Color films are not so versatile. When contrast problems exist, your exposure becomes more critical. For detailed information on dealing with contrast, especially with black and white films, see Ansel

Low Contrast

In natural light, you should quickly learn when contrast may be a problem and when it may not. Low contrast is less often a problem than high contrast. The chief causes of low contrast problems are haze, fog, smog, and backlighting. Hazy conditions can create beautiful effects, but if you don't happen to be looking for the effect, you don't have many choices. For one thing, you can wait until conditions clear. You might try a polarizing filter. The skylight (or haze) filter cuts

haze ever so slightly, but its effect is subtle. It certainly won't cut through fog. Some adjustments, as mentioned earlier, can be made in the darkroom. Usually, though, your best solution is to wait for better conditions.

Backlighting creates low contrast problems two different ways. In the first place, a backlit subject is essentially lit by reflected, rather than direct, light. The light source itself is behind the subject. The source lights up both the atmosphere and reflective objects in front of the subject. The atmosphere and the objects then bounce light back onto the subject with the result that the lighting on the subject is quite diffuse and soft. Usually such light is attractive. Sometimes, though, it is too soft, and there is not enough detail in the final picture.

More often, stray light from the light source itself bounces around in the lens. The lens is aimed too close to the light source. The effect is a within-the-lens fog—not a real one, but an apparent one. You've probably noticed the same effect on a car windshield when the car is driven toward the early morning or late afternoon sun. When the windshield is toward the sun, it's hard to see through. The contrast is lowered.

Lens shades, which are attached to the lens, reduce the effect by blocking some of the light from behind the subject. If you don't happen to have a lens shade with you,

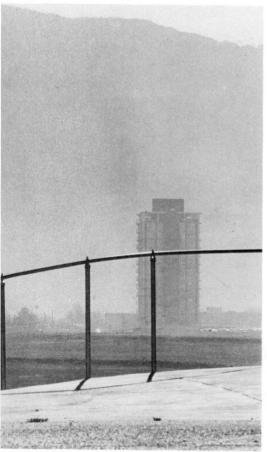

The foreground elements in this shot show high contrast: Note the whites and blacks on the hand railing. Off in the distance, as the lens looks into more and more haze, the contrast diminishes. There is very little detail in the apartment building. In the mountains in the background, there is no detail at all. Incidentally, except to show high and low contrast in the same frame, this picture has no reason to exist; notice how much it needs a human figure or two in the frame.

shield the lens with the palm of your hand, just the way you would shield your eyes under similar conditions. You may also want to move the camera so the lens is not pointed directly toward the light source. Sometimes, you can move the subject so the backlighting is not as direct.

High Contrast

What about excessively high contrast? First, be sure you don't want to make high contrast work for you. A few pools of light, arranged in a dark background, can be very attractive. Expose for the pools of light, and let the background go dark.

On the other hand, faces lit by the mid-morning sun give you shadows, especially in eye sockets, that you don't need. When the contrast is too high, move the camera, the subject, or both. Manipulate the film and the print in the darkroom. Introduce new light into the dark areas. New light may be added to a high-contrast scene with reflectors or fill-in flash.

SUMMARY

The five features of light of special interest to photographers are intensity, quality, direction, color, and contrast.

Light should have enough intensity—or brightness—that it affects the film at the f/stops and shutter speeds desired. The intensity of light is measured with a light meter.

The light meter suggests a set of f/stops and shutter speeds for a given light level. With frontlighting and with subjects of average brightness, the meter reading generally can be trusted. Otherwise, steps must be taken to ensure a proper exposure, such as using data sheets, film latitude, bracketing, or gray cards.

Not everything in a picture has to be lit. You may have one or more areas adequately exposed and let the rest of the print go dark. In this shot, you can see the bars and the tabletop where the man is working. For the rest, the darkness tells a viewer something about the atmosphere. The picture was taken on a tripod at a slow shutter speed, a point you can detect by noticing the slight motion blur in the man and his right hand.

The quality of light may be harsh or soft and should be appropriate to your subject. Notice the quality of light in pictures you like and in your environment.

Light may hit your subject from the front, side, back, and overhead. If the light isn't too harsh, frontlighting can be quite effective, especially for rendering details. Sidelighting and overhead lighting enhance textures. Backlighting puts the subject in a soft, reflected light. Exposure is more critical with backlighting, but the effects make the additional effort worthwhile.

Light adds color to pictures, depending upon its temperature. Color temperature is measured in degrees kelvin; the lower the temperature, the warmer the color. Slide films are more seriously affected by color temperature than are color negative films. Color slide films come in several types for daylight or tungsten light. Films may be obtained for most of the lighting you are likely to encounter; however, filters may be used to correct color problems.

Contrast refers to the brightness range within the frame. Low contrast can be a problem under hazy conditions or when backlighting is used. High contrast is a problem whenever the brightness range within the frame is too great for the film to record.

Sidelighting offers some unusual effects. With bright light coming through the door on the left and with little light reaching the background, this picture is also high in contrast. The wall on the right acts as a reflector, filling in on the dark side of the girl.

Discussion Questions

1. What are the five features of light?
2. When we speak of intensity, we are referring to the _____ of light.
3. What is the quality of light?
4. From what four directions does light fall on a subject?
5. With what temperature system is light color measured?
6. Define contrast.
7. What color does fluorescent light often produce?
8. What is a gray card?
9. If your light meter registers an overexposure, what three things may you do to remedy this?
10. If your light meter registers an underexposure, what three things may you do to remedy this?

11. What are the three general types of TTL light meters?
12. What film is likely to have the least latitude?
13. What are data sheets?
14. _____ light comes from a point source.
15. What basic lighting directions will bring out textures?
16. On color film, what kind of light is likely to give a red cast to pictures?
17. What is a rim light?
18. Why are filters used?
19. A shutter speed of 1/60 at f/8 is accurate for a particular shot. Name two other combination settings that would also be accurate.

Assignments

Remember that the two key elements of a picture are the subject and its treatment. The use of the light falls under treatment. For this assignment, select your own interesting subject or subjects and use the following treatments:

1. A silhouette.
2. A subject that is sidelit to bring out texture.
3. A frontlit subject, showing details.
4. A backlit subject.
5. A subject lit by a hard, directional light.
6. A subject under soft light.
7. A night shot. If you don't have a tripod and you need a shutter speed slower than 1/60, put the camera on a pillow or cushion and use the self-timer to release the shutter. See your instruction book for use of self-timer.
8. A backlit subject with rim light.

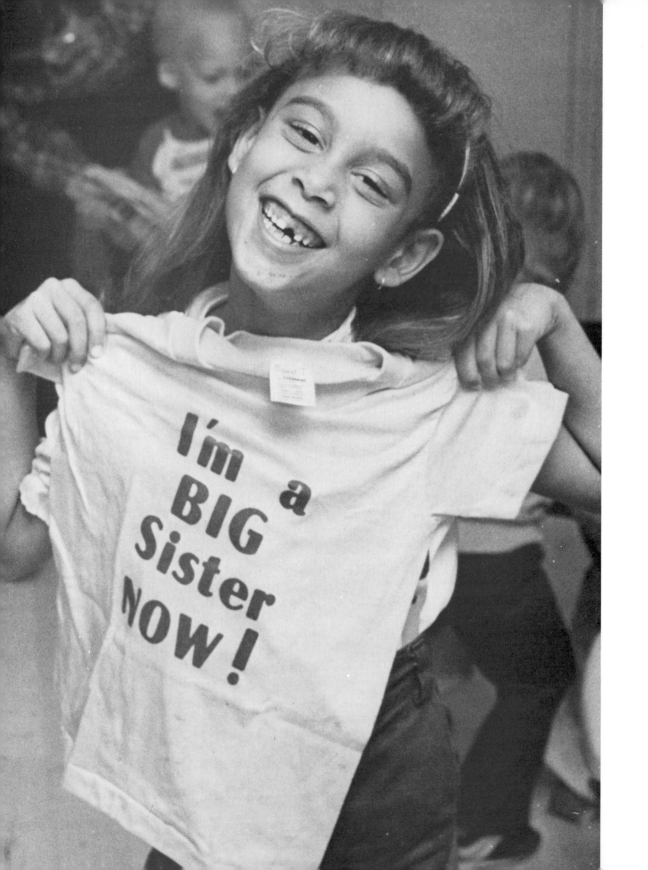

CHAPTER 5

Film

As in many other areas of photography, the purpose of your pictures provides guidelines for choosing film. A film desirable for one kind of work may be totally wrong for another. For instance, newspaper photographers need a fast (very light-sensitive) film so they can get pictures even when light is dim. The problem with fast films, though, is that they produce grainy photos. The news photographer trades the fine-grain appearance of slow films for the additional speed. The trade-off is acceptable for the news photographer because picture reproduction in newspapers, even at its best, is not particularly good.

On the other hand, salon prints (made for display and contests) are expected to be of the highest quality. Large-format cameras and slow, fine-grain films are used for these.

Even the photographer's choice between color and black and white is guided by how the picture will finally be used. For magazines, newspapers, yearbooks, brochures, and other print media, black and white pictures are less expensive to reproduce. Even today more black and white than color is seen in print. For weddings, school pictures, and certain kinds of advertising, color is more common. A wide variety of processes are available to convert color to black and white—and there are even ways to convert black and white into color—but it is generally best to shoot the film appropriate to the job.

HOW FILM WORKS

A strip of black and white film is made of several layers. The **emulsion layer** is where the image is formed. This layer is generally a gelatin-like substance containing crystals of silver bromide. The crystals are sensitive to light. When light strikes the crystals, a chemical change takes place. During the film's de-

Film is made in several layers, the most important of which are shown here. The top layer (1) is the emulsion; it contains light-sensitive silver bromide. The middle layer (2) is an acetate or plastic base. The bottom layer (3) is an antihalation coating which prevents "halos" around the brightest parts of your pictures. In other words, once the light hits the emulsion, the coating keeps the light from bouncing back up through the film and creating a fog.

Terms to Learn

antihalation coating
ASA
base
bulk film
bulk loader
chromogenic
color shift

emulsion layer
expiration date
fast films
film speed
grain
infrared film
ISO

negative
orthochromatic
panchromatic
positive
reciprocity failure
reversal film
slow films

tion coating. This coating prevents light from reflecting back through the base of the film and causing unwanted exposure.

Color film has three light-sensitive emulsion layers. The layers react to three colors in the light spectrum—blue, red, and green. During film processing, the silver in the layers combines with color dyes to reproduce the colors of the original scene.

Film is processed or developed to produce a negative. A **negative** is the opposite of the original scene in terms of light and dark areas or color. For example, on a black and white negative, a white swan would appear black. With a color negative, a red apple looks green. When the negative is printed, the colors produced are true to the original. Color film can also be a reversal film. A **reversal film** is processed in a special way to make a transparency. Although the transparency can be seen through like a negative, its colors are already true to the original scene, and it is called a **positive**. Slide films are reversal films.

Reciprocity Failure

Films usually work as expected within a normal range of shutter speeds. Film's reaction to light, however, does alter under abnormally long or short exposures. This is called **reciprocity failure**. For a 10-second exposure, for example, the lens may need to be opened one stop wider than the light meter recommends. For a 100-second exposure, the increase over the meter reading may be two stops. With color films, especially slide films, you may also encounter a **color shift**. The colors shift because the film layers react at different rates to light. Usually, color shift may be corrected with filters and additional exposure.

If information on reciprocity failure is not included with the film you buy and you need the information, get in touch with the manufacturer for specifications. When in doubt about exposures, bracket.

velopment, the crystals change to silver, and clumps of the silver form the negative image. The emulsion layer adheres to a layer of flexible backing, or **base**, usually made of acetate. The base is covered with an **antihala-**

With normal shutter speeds, you can depend on the ISO rating to indicate a film's sensitivity. With time exposures, film usually reacts with diminished sensitivity. For a 10-second exposure, for instance, you may have to open up a stop wider than the meter recommends.

Color Sensitivity

Different films are also sensitive to different colors in the light spectrum. General-purpose films, both color and black and white, are **panchromatic**. This means, like the human eye, they are sensitive to most visible waves in the light spectrum. **Orthochromatic** black and white films, on the other hand, record mainly blue and green light waves.

Infrared films in both color and black and white record infrared light waves that are invisible to the human eye.

As you learned in Chapter 4, color slide film is categorized according to light sources —tungsten and daylight. If daylight slide film is used indoors, it will produce a golden tone because its color balancing is incompatible with the color range of artifical light. A bluish

79

Fast films are good for shooting indoors without a flash.

tone results from using tungsten film, color balanced for artifical light, in the natural light outdoors. Always select the right type of film for the light conditions, or correct the color imbalance with filters.

FILM SPEED

Film comes in a variety of film speeds. **Film speed** indicates a film's sensitivity to light. Some films are more sensitive to light than others and they react more quickly. These sensitive films are called **fast films**. The less sensitive films are called **slow films**.

The film speed itself is measured in several ways. For now, we will look at only two: the old ASA ratings and the new ISO ratings. **ASA** stands for American Standards Association. Many current cameras still use ASA ratings on their light meters. **ISO** stands for the International Standards Organization, and new film boxes are likely to display an ISO number more prominently than an ASA number. An ISO 400 film is the same as an ASA 400 film, and the two ratings do correspond throughout, so all you have to be aware of is that you may see either set of letters indicating film speed.

The ratings, like shutter speeds, are fairly straightforward. Fast films are rated with high numbers. Slow films are rated with low numbers. An ISO 400 film is twice as fast as an ISO 200 film. An ISO 200 film is twice as fast as an ISO 100 film. Among easily available films, film speeds tend to range between ISO 25 and ISO 400.

A large print made from any film will show **grain**, or texture. When you look closely at a large print, you can see a texture that looks like grains of sugar. The texture is usually much more apparent, or grainy, in prints made from fast films. This larger grain is usually caused by larger silver bromide crystals used for fast films. The size of the crystals is what determines the film's speed. Development methods, though, can also affect the size of the grain in the final negative. The chromogenic films, and, more recently, the "T-grain" films, represent technological advances, new ways to reduce the effects of large grain in faster films.

Fast Versus Slow Films

What types of pictures will you be taking? Portraits? Fast-moving sporting events? What

Generally, the faster the film, the grainier the film. This photo is an enlargement of a portion of an ISO 400 negative. Chromogenic films are the exception to the rule.

techniques do you wish to develop? Shooting techniques can vary widely depending on the film a person chooses. While it is good practice to stick with a single brand and type of film for most of your work, you should also be aware of what else is available. For instance, those who work mainly with slow films should remember the advantages of faster films and not be afraid to use them when the occasion demands. Likewise, the available-light photographer who depends heavily on fast films should know something about how the slow-film user works. In the first place, the available-light photographer may well be called on from time to time to shoot a slower film. In the second place, some techniques of the slow-film user can greatly extend the range of fast films.

What are the advantages of fast film? They parallel the advantages of 35 mm photography in general. Obviously, these films are excellent wherever light levels are low—and that includes many places where people gather to be themselves. Most available light is not designed for photography. Fast films, small cameras, and fast lenses work hand in hand to catch people at their most natural. Fast films and equipment take photography out of its primary home, the studio, and into the world where people can be themselves.

Fast films yield other advantages. It's possible to stop down lenses for greater depth of field. Shutter speeds can be faster to stop motion and freeze an interesting subject. The delicate, and very real, beauties of natural light can be captured. The photographer can leave behind all the cumbersome lighting equipment, disappear into the crowd, and work without attracting attention.

What do slow films offer by comparision?

Window light—out of the frame on the right—and overhead light combine in this picture to give a natural look. Fast film was needed for a smaller f/stop and increased depth of field.

The quality of the image is one answer. The smaller grain in slow films offers the chance to make better prints and enlargements. Photographers have a history of going to great lengths to get the kinds of pictures they want. Slow film may require more work, but the efforts are sometimes necessary and give the photographer an extra edge. Take the added weight of a tripod. For general shooting, especially with fast films, the tripod is not usually necessary. In a fast-breaking situation, it may even be undesirable. However, the available-light photographer can still make good use of it.

We have already seen that a shutter speed of 1/60 second is the slowest that should be used for general, handheld work. At slower speeds, normal body movement can blur pictures. However, this does not mean that subjects cannot be photographed at slower speeds. A speaker, for instance, posed on a platform, can be shot at speeds at least as slow as 1/2 second. The camera is mounted on the tripod. The photographer waits for a moment when the speaker is still and trips the shutter. At rest or at a distance, people can be shot effectively even at slower speeds. The slower shutter speed offers several desirable choices: A smaller lens opening for increased depth of field, the possibility of a shot when the maximum lens opening has already been reached, the avoidance of artificial lighting,

With the camera mounted on a tripod, this picture was taken at a shutter speed of 1/15 second. The mother is still, so no motion blur occurred. The slow shutter speed was selected to allow a smaller f/stop and more depth of field. The film had a relatively fast speed of ISO 400, but it was not fast enough to allow both depth of field and handheld speeds in room light.

or the use of slower film for better quality enlargements.

Using slower films can also acquaint you with the creative effects of the blur. Freezing motion with faster films does not always give the best effect. Race cars, for instance, shot at 1/1000 second appear to be at a dead stop. For such a scene, it is often better to use a slower shutter speed, move the camera along with the moving car, and shoot for the blur. When you move along with the car, the car appears reasonably sharp in the final picture, but the background is streaked. That effect gives the car the appearance of movement.

Slower films allow you to experiment with slower shutter speed and make use of blurring. Blurring can come from camera movement, subject movement, or minimum depth of field. Each of these kinds of blurring is more common with slow films than fast. Each kind of blur also has its own creative applications. Fast-film shooters should be aware of these applications and be ready to adapt them whenever they are appropriate.

The slow-film user is also more likely to be proficient with artificial light. Sometimes, the most effective solution to a problem is the addition of artificial light, and fast-film users should be ready to use it when needed. Artificial light, of course, can also greatly extend the range of what can be done with fast films.

CHOOSING FILM

There is much to be said for picking a film and sticking with it. Too many newcomers to

The jeep itself appears frozen. There are, however, the motion blurs in the tires and the dust behind to suggest movement.

photography allow themselves to get bogged down by choices, trying dozens of different films and never quite mastering the use of any. Major brands include Kodak, Ilford, Agfa, GAF/Ansco, and Fuji. Each brand includes a range of films for different purposes. Photography magazines occasionally run tests on competing films, and although small differences do exist from brand to brand, the major differences appear between slow and fast films. Worth considering before you take the plunge are availability of a particular brand and film type and the availability of processing and chemicals. Some films, such as Kodak's Kodachromes, are not designed for home processing.

Film choice is finally a personal matter. After some experiments, you will find those that you like best.

Black and White Film

CONVENTIONAL ISO 400 FILMS

For general black and white work, especially if it is to be published in sizes smaller than 8 × 10 inches, you should consider an ISO 400 film. Kodak's Tri-X and Ilford's HP-5 make good choices. The moderately high speed often allows you to shoot indoors without a flash, and the grain is small enough for acceptable prints up to at least the 8 × 10 size. These films are standard for newspaper photographers.

With careful handling, these films can do a wide variety of other work as well. They are ideal for candids. They have good latitude. They can, when necessary, be push processed to increase their effective ISO rating. (Push processing means the film is shot and developed as though it had a higher ISO rating than it actually does.) With the use of a tripod, ISO 400 films are remarkably effective in dim light. Also, they are not too fast for general outdoor photography.

ISO 400 films can easily be processed in a home darkroom or in normal room light with

Indoor light comes in a huge variety. This high-contrast shot, with the strong blacks and the properly exposed face, was taken at an open door with a fast film.

special equipment. When processing times are adjusted, they can be processed over a wide variety of temperatures.

CHROMOGENIC FILMS

An alternative to conventional ISO 400 films is the **chromogenic** black and white film. Chromogenic film is similar in design to color film. During processing, all silver is removed. The film has two emulsion layers, a faster one on top and a slower one near the base. The manufacturers suggest that it can be shot at speeds between ISO 125 and ISO 1600, all on the same roll. Users say the best performance is between ISO 200 and ISO

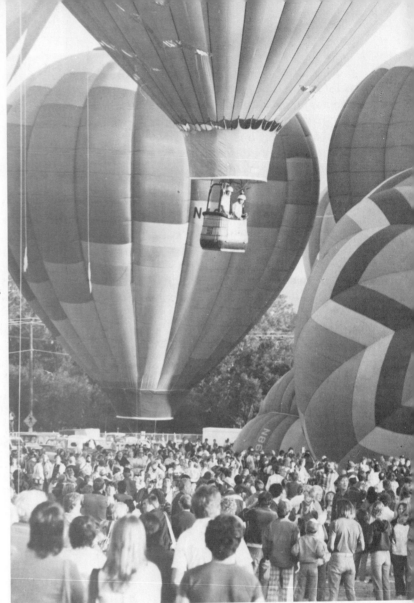

Chromogenic films offer faster speeds with less grain.

400. For enlargements 11 × 14 and larger, the film outperforms conventional black and white ISO 400 films. Some users claim that the grain size compares favorably with conventional slow-speed films.

The film does have a few drawbacks. For one thing, it's generally more expensive than standard ISO 400 films. For another, it is processed *as if it were a color negative film*. Temperature control is critical, and the proc-

essing usually takes more steps than conventional black and white. At this writing, the chromogenic films are less readily available than conventional films.

KODAK RECORDING FILM 2475

Kodak Recording Film 2475 is a very fast black and white film. The basic ISO rating is 1000, but Kodak says it can be rated between 1000 and 3200, depending on exposure and

processing. Some users have rated it as high as ISO 4000. The grain pattern is coarse. The film has increased sensitivity to the red end of the spectrum, is high contrast, and not as sharp as slower films.

For general photography ISO 400 or chromogenic film is preferred. Sometimes, however, the extra speed in extremely low light is worth the larger grain. Occasionally the large grain itself is desirable. Push processing and degree of enlargement also increase the grain size. When you want a large grain pattern, choose a fast film, push process it, and enlarge a small portion of the frame. The larger grain can give an almost abstract quality to a print.

ORTHOCHROMATIC FILM

Orthochromatic, or high-contrast film is handy for several kinds of work. It is slow—an ISO rating of 6 or 12 is not uncommon—and of very fine grain. It can be processed into either a negative or a positive. Though it is designed for copying documents, where strong blacks and whites are needed, the 35 mm user is most likely to take advantage of the film for special effects.

Audiovisual productions may depend on high-contrast film for masking and titles. The artwork is shot on high-contrast film. The film is processed into a negative, giving white letters on a black background.

Color Film

NEGATIVE FILM

If you're shooting for the family album, an ISO 400 color negative film may be your choice. It is almost as versatile as its black and white counterpart. For enlargements, however, an ISO 100 may be better. The grain is smaller in the ISO 100, and, to prevent color temperature shifts, photographers often add flash or other light to their indoor settings. With the additional light, slower films become more appropriate for indoor use.

Three Eastman film types can be treated together. The best known is type 5247, a color negative film with an ISO rating of 100. The other two are similar: 8518, which has a rating of ISO 250, and 5293, which has a rating of ISO 500. These films are designed for motion picture work. Basically, they are color negative films from which color transparencies are made. As such, they are ideal when many copies are needed of a slide.

This is an enlargement of a frame of high-contrast copy film, a very slow, fine-grained, orthochromatic film.

Slides are designed for projection on a screen and are also referred to as transparencies and color reversal film.

Some photographers also use the negatives to make prints, a process not recommended by the manufacturer. Labs that process these films will usually offer a choice of slides, prints, or both. The negatives, of course, are always returned to the photographer.

With these films, the slide you get is *not* the piece of film you ran through the camera. The slides are made in much the same way as prints from conventional negatives. Since there is an additional step between film and slide, changes can be made that simply are not possible with conventional reversal film.

REVERSAL FILMS

Slide, or color reversal film also presents some interesting choices. ISO 400 (and faster) slide films are available. These, too, can be quite useful under candid and low-light situa-

tions. The faster speeds may be used for slide shows and filmstrips.

Slides are the film of choice for magazines and several other kinds of color reproduction. Because editors may choose to use small portions of a slide instead of reproducing it in full, they often prefer the slowest speed and finest grain available. Most color work for reproduction is done on ISO 25 and ISO 64 films. The ISO 25 films make remarkably fine color enlargements for print media. Enlargements for framing and wall display are usually more costly and time consuming with slides than with negative film.

For viewing slides, you need either a hand viewer or projector and screen. A darkened room is not essential, but it helps. These disadvantages, however, produce a positive result. A well-edited slide program, pre-

sented on a screen in a darkened room, perhaps with music and narration, becomes a theatrical experience. You don't need a darkroom to process many slide films. Since the film you shoot is the slide you get, the processing can be done with modest equipment in the daytime on the kitchen table. The processing temperatures are more critical than for black and white, and there are a few more steps, but these differences can be mastered. When the film is dry, the individual frames are cut apart and mounted.

Shooting slides is good discipline. A slide can be cropped when it is duplicated, but good originals depend on accurate framing when the picture is taken. This forces you to watch your frame and to make the most of your composition when the picture is taken, just as you should with all your pictures. Slide films don't have the latitude of negative films and demand accurate exposures. When a slide is good, you know you did your work well.

Slides have a final edge over negative films. Since negative films must be printed before they can be viewed, all prints are "second generation." In any duplication, some loss in sharpness is unavoidable. In addition, print-ing paper does not have the full range of tones of the original film. With slides, you get the complete range of the original, and if a detail is in the original film, it is visible to the viewer.

Infrared Films

Infrared films come in both color and black and white. They are sensitive to the red end of the color spectrum. Infrared light is not visible to the human eye. The films have military, industrial, and medical uses, but their unique properties open them up to special-effects uses as well.

Black and white infrared film yields almost normal images when used without filters. Blues are a bit lighter and reds, greens, and yellows somewhat darker. Of course, they are all reproduced in black, white, and shades of gray. With red-orange filters, the effects are more pronounced. Since the blue end of the spectrum is blocked by the filters, the sky darkens, vegetation glows a ghostly white, haze disappears, and distant objects are clearer.

Conventional color film responds to blue, green, and red. Color infrared film responds to infrared, green, and red. The infrared

The copy film negative you saw earlier in the chapter was copied onto slide film. Then a slide, taken at dawn in Colorado Spring's Garden of the Gods, was copied onto the same frame. This double exposure produced the effect you see here.

Even a good picture loses some detail when it is duplicated from film to paper. With slides, you usually see the image from the film itself and thus a full range of tones.

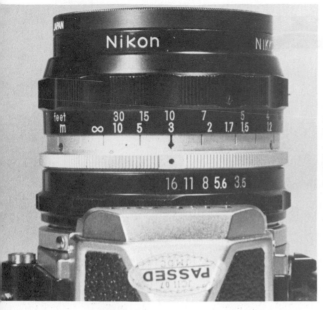

For normal pictures, this lens is set to focus at 3 meters (about 10 feet). If you notice on the silver ring, there is another mark which falls roughly between the 5- and 10-meter indicators. This mark indicates proper focus for infrared film. If the camera were loaded with infrared film, the lens would be correctly focused for objects between 5 and 10 meters away.

film, when used with the recommended yellow-orange filter, turns green foliage red. Green, red, orange, and purple filters all cause typical color shifts.

Use of infrared films takes special care. The black and white versions must be refrigerated and the color versions frozen for storage. All exposed film should be processed immediately or refrigerated. The camera should be loaded and unloaded at least in subdued light; total darkness is preferable.

Since light meters are designed to read visible light, exposure readings are not trustworthy with infrared. You should bracket exposures in half-stop increments at least one stop above and below the reading given by the meter. The exposure of infrared films is more critical than it is with conventional films.

Focus can also become a problem. Infrared wavelengths are longer than those of visible light. They focus on a different plane. Your camera instruction book will tell you if your lenses have an infrared indexing mark. With a normal lens, a setting of 12 feet would be about correct for an object 15 feet from the lens. In any event, the smallest aperture possible should be chosen when shooting

SAFETY REMINDERS

- When showing your slides in a darkened room, be sure electrical cords are not strung in the way of traffic. If cords must cross a traffic area, tape them down with gaffer's tape or duct tape.
- When working in the dark, whether bulk-loading film cassettes, loading your camera with infrared film, or doing darkroom tasks, make sure your own traffic areas are free of obstructions.

Bulk film is generally found in 50- and 100-foot rolls. The cassette, spool, and cap give you an idea of the size of the box.

infrared film to get as much depth of field as possible.

Instant Films

Polaroid and Kodak make instant films. These films are essentially self-processing, and results can be seen within minutes of the actual shooting. When they are not used in the cameras that the film manufacturers themselves make, these films are most commonly used in larger format cameras. To the professional photographer, these films permit the checking of exposures, lighting, and the color of light. In other words, they are used as test films before the exposure itself is made on another kind of film.

Most 35 mm users don't do this kind of testing, but the techniques are invaluable under certain conditions. Corporate-industrial photographers, for instance, may well have to deal with a variety of fluorescent lights. In a large, open plant lit by hundreds of tubes, available light may be the most practical lighting for the picture. Sometimes, test shots on instant film are the only way to

ensure correct color, especially if the photographer is using a slide film for the project. Polaroid now has a 35 mm "instant" color slide film.

BULK FILM

Considering the investment in time, equipment, and sometimes travel that a person has in shooting an assignment, film expense is low by comparision. It is usually better to shoot a little more film than necessary than to shoot too little.

Still, the cost of film is an expense nevertheless. One way to cut the cost of film is to load your own cassettes. Most generally available films can be obtained in 50- and 100-foot rolls. These rolls are also known as **bulk film**. Often enough, the cost of the same amount of prepackaged film roughly equals the cost of the bulk film *plus* the cost of the bulk loader. The **bulk loader** is a device that allows the loading of reusable film cassettes in daylight. With the second roll of bulk film, you begin to save large amounts on film costs.

You can obtain reloadable cassettes with

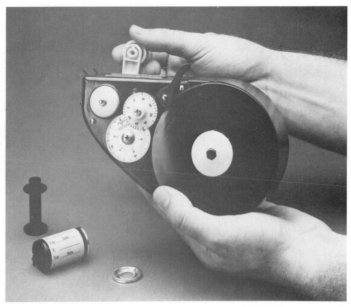

Shown here is a bulk loader with reloadable cassette, empty spool, and cassette cap. This loader will handle 50- or 100-foot rolls of bulk film. Once the bulk film is loaded into the loader, the cassettes may be rolled in the daylight.

Notice the expiration date: "Develop before 01/1985."

snap-on or screw-on caps from photo suppliers and stores. You then load the bulk loader in total darkness with the bulk film. The bulk film is wound into the cassettes in a light-tight chamber within the loader.

You also can bulk load film without the

loader. In total darkness, a length of film is cut from the bulk roll, loaded into the cassette, and the cassette closed. In the light, the leader (blank section at the beginning of the roll) is trimmed. The cassette is then ready for use in the camera. The loader does, however, make the process a great deal easier.

Bulk loading has both advantages and disadvantages. The chief advantage is the cost savings. In addition, you can control the number of exposures on the roll. When you need only five or six shots, for instance, you can load a five- or six-exposure roll, shoot the pictures, and then return to the darkroom and process the roll without having wasted unused film.

There are several disadvantages. Dust can get on the film and the film may be scratched during loading, so the loader and cassettes need to be clean. Well-used cassettes with snap-on tops can occasionally pop open on their own. This isn't a major problem until a roll of irreplaceable film is lost. Special care must be taken with snap-top cassettes. Prepackaged film comes with edge numbers. Each frame of the film is marked from 1 to 20 on a 20-exposure roll or from 1 to 36 on a 36-exposure roll. Bulk film may have no edge numbers. Also the length of film in a prepackaged roll is also more likely to be exact than in a bulk-loaded roll. With some loaders, it is difficult to count exactly the number of exposures loaded.

Bulk-loaded cassettes may be stored in the plastic containers that come with prepackaged rolls. The plastic containers can be saved from prepackaged rolls or obtained at little or no cost from a photo dealer.

CARE OF FILM

All film should be stored in a cool, dry place. Neither camera nor film should ever be stored in the glove compartment of a car or any other place where heat buildup may be a problem. Keep film boxes out of direct sunlight. Color film should be processed soon after exposure—within a week is best.

The **expiration date** of film is marked on most film packages or data sheets. It usually reads: "Use Before: *(date)* ." It is a good idea to check the expiration date on rolls of film you are about to buy. Some stores reduce the price of film just before—and in some cases just after—it expires. However, it is not always a bargain. Old film tends to lose contrast and effective speed.

Expired film *can* be used if it has been stored under certain conditions. It's a good idea to store all film, especially color, in the refrigerator or freezer. Film that has been kept frozen can be used well past the expiration date. Frozen film should be allowed to warm *within the package* at least an hour or so before use. Condensation can form on frozen film that is opened too quickly to warm air. It can even cause moisture problems within the camera if the film is loaded too soon.

In dry or cold climates, film should be wound and rewound carefully. In dry air, static electricity can build up in a roll of film—just as it does in your body when you walk across a rug on a dry day. The electricity in the film can discharge, throwing a spark. The spark exposes, and ruins, the film. Static electricity is often caused by rapid rewinding of the film. In cold weather, moreover, the film becomes slightly more brittle than usual and loses some of its flexibility. Rapid winding and rewinding may cause breakage.

SUMMARY

A beginner should select a primary film and learn to make it do all it can. Special films should be experimented with and used when the occasion demands.

Film is made of emulsion, base, and antihalation coating layers. The light-sensitive part

Film that has been refrigerated or frozen may be used past the expiration date.

of film is made of silver bromide crystals. Negative film produces negatives and prints. Reversal film produces transparencies.

Reciprocity failure takes place under abnormally long or short exposures. Film can be push processed at a higher ISO rating.

Film comes in a variety of film speeds. Fast films are more sensitive to light than slow films and react more quickly. Choice of film speed will affect shooting techniques.

There are a number of black and white, color, infrared, and instant films available. To save money, film may be bought in bulk. Film is best stored under refrigeration.

Discussion Questions

1. _____ films are likely to create problems with grain.

2. What does the antihalation coating on film do?

3. A film's reaction to light alters under abnormally long or short exposures. The changed reaction is called _____.

4. The image is formed in the _____ layer of the film.

5. What is the difference between negative and reversal film?

6. What is a film's emulsion layer made of?

7. What does film speed indicate?

8. How soon should film be processed after exposure?

9. Film that has been stored _____ may be used past the expiration date.

10. What are the differences between conventional ISO 400 and chromogenic films?

11. Name several advantages of both fast and slow film.

12. What is bulk film?

Assignments

1. Name the film you are now most inclined to make your first primary film and tell why you chose it.

2. List the special films reviewed in the chapter. Discuss how you might use each one. Indicate whether you are likely to try each one in the near future.

3. Buy a roll of the film—primary or special —that most intrigues you. Shoot it. Report on your results in class.

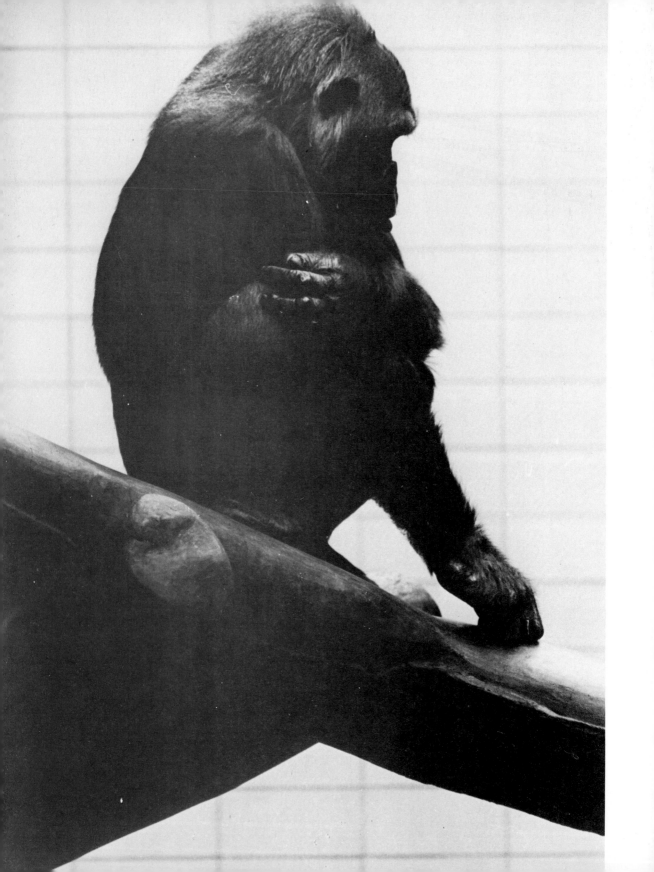

The Creative Controls: F/Stop, Shutter Speed, Focus

On the camera, the creative controls are the f/stop ring, the shutter speed dial, and the focusing ring. You have already learned the hard parts about them. Now it's time to have some fun with them.

One of the secrets of photography lies in learning to see like a camera. In the beginning, most of us see like ordinary people. We don't notice fine lighting. We don't mentally compose objects into arrangements within an imaginary frame. We don't look at dark hallways with an open door at the end and secretly long for some silhouetted figure to walk toward the door.

In the beginning, we see only with the eye and the brain. Working together, the eye and brain can ignore distracting backgrounds. They can spot an attractive person across a crowded room and ignore the other people. Combined, the eye and brain can appreciate a red and gold sunset—no matter that the clouds are crisscrossed with telephone wires.

However, the camera sees the subject *and* the background. It sees the crowds. It sees the telephone wires. Effective photography depends on training ourselves to remember what the camera sees.

The camera teaches us new delight in a rim light we spot around a friend's profile. It teaches us to notice cluttered backgrounds. Our minds learn to review the ways a camera can get rid of messy backgrounds—or to integrate them with the subject into a meaningful image. We learn to think about lighting and framing. Our minds play with different treatments.

Part of photography training includes learning to see subjects specifically in terms of the camera's three creative controls. Most of this chapter will be devoted to how these controls affect sharpness and blurring in specific situations.

To quickly review: Sharpness can be either the sharpness of focus or frozen motion. Blurring can come from soft focus or from movement—movement of the camera, the subject, or the background. The focusing ring and aperture affect focus. The shutter speed dial controls the effects of motion.

Sharp lenses are desirable, and accidental blurring is painful. But photographers who can't or won't make use of a blur in their pictures have failed to make full use of their equipment.

Terms to Learn

infinity
painting with light
pan
tracing with light

FOCUS AND F/STOP

Sophisticated use of the focusing ring is not much different from the simple uses. With the single lens reflex, it's usually easy to tell when a subject is in focus. The subject *looks* sharp in the viewfinder. Of course, there are exceptions. The exceptions we are most concerned with in this section involve a concept we briefly discussed earlier—depth of field.

Depth of Field

Depth of field—or depth of focus—is controlled by the f/stop ring and to some degree by the focusing ring. Let's say you have a subject about 15 feet in front of the camera. Let's also say you're using a small f/stop, such as f/16. When the lens is focused on the subject, a large zone, both in front and back of the subject, will also be in focus. In other words, at a small aperture with the lens focused at 15 feet, you have great depth of field.

At f/16 with a normal lens and the focus at 15 feet, the zone of acceptably sharp focus

extends from about 8 feet in front of the camera to as far as the eye can see—to **infinity**.

At the widest apertures, only the subject will be in focus. At wide apertures, the depth of field is shallow and foreground and background are blurred. At the same focus and a moderate aperture of f/5.6, for instance, the depth of field includes about 3 feet in front of the subject to about 6 feet behind.

You don't need to memorize depth-of-field charts. The important thing is the general principle. Small apertures give you great depth of field. Large apertures give you shallow depth of field.

An additional point: The closer the point of focus is to the camera, the shallower the depth of field. With close-ups, depth of field is quite shallow. You can increase and decrease it with the aperture, but it is still quite shallow.

When you need more specific information on depth of field, you have one of two choices: Go to the depth of field scale, which is marked on the lens, or use the camera's depth-of-field preview button.

Almost all lenses for SLRs have a depth-of-field scale marked on the lens. To see how it works, let's review several of the scales marked on the lens. Most often the focusing ring is at the front of the lens. It rotates. On the focusing ring itself there are usually two distance scales. One is in feet; the other, meters. At the top of the lens near the focusing ring is an indicator mark that may be either a line or a dot. The indicator mark is stationary. When you focus on a subject 15 feet away, the number *15* on the focusing ring matches up with the indicator mark.

Usually, on either side of the indicator mark is a series of other lines. They, too, are stationary. These lines are marked with colors or numbers that correspond to the different f/stops. Notice that there are two lines for the f/stop. These lines make up the depth-of-field scale.

The Observer
At smaller f/stops, depth of field may extend throughout the frame.

99

The closer the camera is to the point of focus, the shallower the depth of field.

U.S. Dept. of Labor

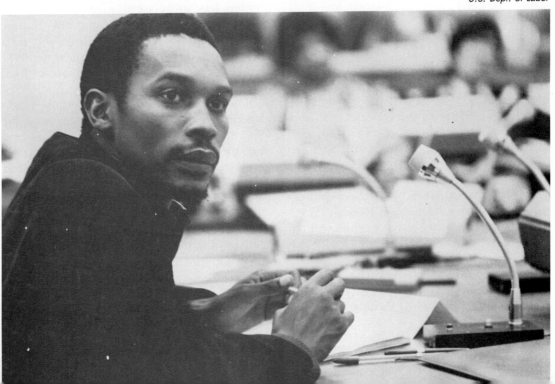

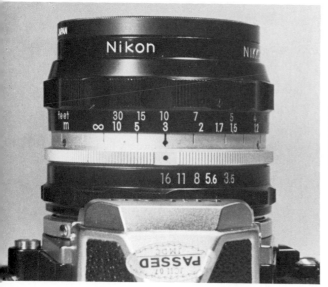

On the silver ring, the short lines to either side of the indicator arrow make up the depth-of-field scale. The short lines are read in pairs. Lines to the right of the indicator arrow show the nearest point of sharp focus for particular f/stops. Lines to the left of the indicator show the farthest point of sharp focus.

The indicator mark shows you your point of focus. It points to a specific distance on the focusing ring. The other lines then show the depth-of-field scale.

To read the scale, you must use *both* lines for the specific f/stop. Both lines point to the distance scale on the focusing ring. Above one line on the focusing ring will be the nearest point of acceptable sharpness. Above the other will be the farthest point of acceptable sharpness.

Let's say the lens is set at f/16 and the focus at 15 feet. On the depth-of-field scale, one line for f/16 will point to infinity. The other will point to an area between the 7- and 10-foot markings on the focusing ring.

One of the problems with the depth-of-field scale is that it doesn't tell you how far *out* of focus certain areas of your frame will be. The depth-of-field preview button helps solve that problem.

Most cameras are fitted with a depth-of-field preview button. As you may remember from Chapter 2, most SLRs focus with the aperture wide open. Only when the shutter button is pushed, does the lens automatically close down to whatever aperture has been set on the f/stop ring. The depth-of-field preview button lets you close down the lens to the preset aperture without using the shutter button. With the lens closed down, you get a look at how the smaller f/stops affect depth of field. You can get an idea of what the final picture will look like.

The preview button is also especially handy when you want to be sure certain areas of the frame are completely out of focus. You can, for instance, be sure you're rid of a distracting background. You can make sure that a soft-focus foreground is truly out of focus.

One caution: When you push the preview button, the viewfinder usually gets darker. The viewfinder is also smaller than most prints. What looks good in the viewfinder may not look as good when the picture is enlarged.

The best practice is to make regular use of both the depth-of-field scale and the depth-

Taken at f/16, these 3-inch-high figurines were separated by about a foot. The focus was set for the minimum lens-to-subject distance. Notice how the background figure, even at f/16, is out of focus. The less your lens-to-subject distance, the less your depth of field.

of-field preview button, certainly not on every picture, or even every roll, but often enough so that you're comfortable with them.

POINTS TO REMEMBER

When focusing, keep in mind the following three points:

1. The closer the camera to the subject, the less the depth of field. When the lens is focused at 2 feet, the depth of field is no more than 6 inches, even at f/16. When the lens is focused at 5 feet, the depth of field increases to about 3 feet. With the focus at 15 feet at f/16, everything from about 8 feet to infinity will be acceptably sharp.

2. To get maximum depth of field at any given f/stop, first focus on infinity. Then set the focusing ring so the infinity mark matches up with the appropriate f/stop mark on the depth-of-field scale. At f/16, the lens will again be focused at 15 feet. At wider apertures, the point of focus will be closer to infinity.

3. If you want two objects in focus, one near and one far, you should generally focus on a point about one-third the distance behind the nearest object and two-thirds the distance in front of the farthest. Don't simply focus at a point in the middle. Be as accurate as you can. Then check the depth-of-field scale to be sure both objects will be acceptably sharp.

Creative Use of Depth of Field

How does depth of field affect your pictures? Let's consider several possible assignments and see.

● Indoors, a person is working on a handicraft project and the background is unattractive. You've found an angle that will give you excellent available light. The unsightly background is the only problem. How can you get rid of it? To reduce the depth of field and throw the background out of focus, you have at least two choices. You can speed up the shutter and shoot at one of the widest aper-

101

tures. You may also move closer to the subject. Frame the subject as tightly as possible and take advantage of the rule: The closer the camera to the subject, the less the depth of field.

• You have to shoot the exterior of a three-story school building on a Saturday. The building sits on a lot with trees and bushes, but no one is around to lend life to the scene. You have to deliver the picture on Monday morning. One option: Find a good angle near a bush. Using the widest possible aperture, move the lens in as close as you can to some of the leaves on the bushes. Focus on the building in the distance. The out-of-focus leaves will leave an interesting haze on the outer edges of the picture. The building itself will be sharp. Similar effects can be obtained with special filters or with a plain filter smeared around the edges with petroleum jelly. If you're shooting at less than maximum aperture, be sure to check the effect with the depth-of-field preview button.

• An informal portrait of a person in an office is the next assignment. The background is interesting and you want it to show up in the picture. You are working with available light, and the light levels are low. If possible, use a tripod and a slower than usual shutter speed. This step allows the smallest aperture. Then back the camera away from the subject. By using the smallest possible aperture, backing away from the subject, and focusing on a point behind the subject, you've made the most of the camera's ability to get both the subject and background in focus. Adding light to the scene could, of course, make the job easier.

• You're outdoors in a fast-breaking situation, and you don't know where the action will happen next. If you can use f/16, the focus can be preset at 15 feet. Anything from about 8 feet to infinity will then be in focus. Usually, of course, you should take time to frame and focus precisely. But when you don't have the time, a preset focus will occa-

sionally give you a picture you might otherwise miss. You should be aware of the technique.

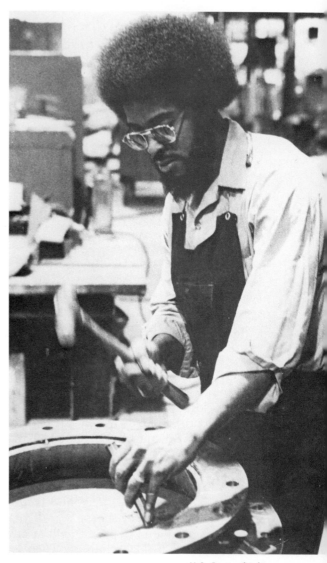

U.S. Dept. of Labor

By moving closer to the subject, the photographer threw the background out of focus. In this case, a slower shutter speed was chosen (notice the movement in the hammer). A faster shutter speed and wider f/stop would have thrown the background more completely out of focus.

SHUTTER SPEED

Use of the focus and f/stop to control blurring is probably more commmon than use of the shutter speed. The two methods depend on different principles. The focus-and-f/stop method depends on properties of the lens at different apertures and points of focus. The shutter-speed method depends on motion—of the subject, the camera, or both. However, the principles of the shutter-speed method are probably easier to understand. If there is movement, and the shutter speed isn't fast enough to freeze it, the movement will be recorded on the film as a blur.

The effects of shutter speeds can often prove quite interesting. The blur of movement speaks well of the photographer's timing. Sweeping, curving blurs, especially when they are combined with points of sharpness in a picture, can add a marvelous abstract quality to what might otherwise be an ordinary photo. Meaningful blurs—indicating speed—provide a sense of action. Streaks of light in a night shot combine with sharp, stationary lights to convey life in a still photo.

Slow Shutter Speeds

Many photographers seem to be afraid of slow shutter speeds. Seldom do amateurs—and even many professional photographers

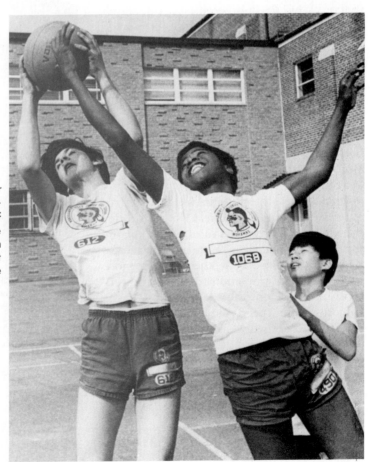

U.S. Dept. of Labor

Presetting your focus at about 15 feet with a normal lens gives you depth of field from about 8 feet to infinity. The technique is particularly useful when you're shooting action and are not sure where the next action will take place.

When the shutter speed is slow and you follow a moving car with the camera, a motion blur results.

—make use of the camera's ability to record motion. Why? Possibly because the effect isn't entirely predictable. First of all, a moving subject must be caught in action. The photographer really does have little control over *exactly* how the effect will appear in the final picture. If the photographer *must* have a particular shot, it is much easier to freeze the motion and be done with it. However, it costs only a few frames of film and a little time to become confident with slow shutter speeds. Don't be afraid to experiment whenever you get the chance.

Particulary with color film, you may want to experiment with handheld slow shutter speeds. The slower the shutter speed, or the faster the movement, the more abstract the picture will look. Usually, the picture is more acceptable to a wide audience when the subject is at least identifiable. Depending on the subject, shutter speeds between 1 second and 1/30 second are worth a try.

What do you need to know to make the most of slower shutter speeds? Let's take it step by step.

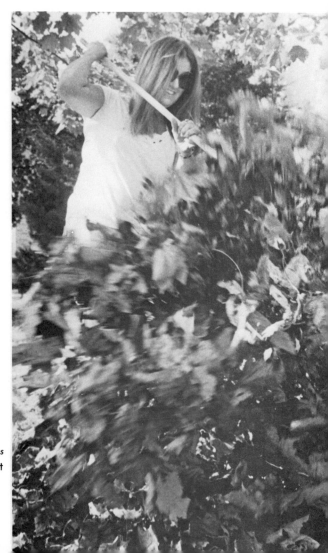

Tazewell Publications
A slow shutter speed was used to catch this subject raking fall leaves.

MOTION BLURS

Motion blurs occur two ways: Either the shutter is open long enough to detect almost every movement, or the movement is fast enough that the selected shutter speed can't freeze it.

Since motion blurs are sometimes related to the speed of your subject, it is important to know how the direction of the movement affects the appearance of speed. A subject moving toward you appears—both to your eye and to the camera—to be moving slower than a subject that passes in front of you. It's easier to freeze an oncoming car than a car speeding past you. It's also easier to obtain a blur on a car speeding past you.

Imagine the subject moving in a straight line. Also imagine a line from the camera to the subject. The camera-to-subject line intersects the line of the subject's movement. The closer the two lines are to forming a right angle, the easier it is to obtain a blur.

Let's look at a race track example. To get a blur with a race car, you have two choices. You could mount the camera on a tripod, set a slow shutter speed, and try to trip the shutter as the car passed. The effect would be a stationary background with a blurred car. This effect is common with night shots. The photographer mounts the camera on a tripod, exposes for identifiable stationary objects in the frame, and allows car lights to form streaks through a portion of the image. Especially with color film, you must allow for reciprocity failure. These shots are usually made with small apertures so that the shutter

With a tripod and a time exposure (the *T* or *B* setting on your shutter speed dial), streaked car lights are easy to get. Mount the camera on a tripod, focus on identifiable stationary objects in the frame, release the shutter with a cable release, and let the car lights form streaks as they move past. This was about a 10-second exposure.

may remain open long enough to get complete streaks, rather than short, incomplete ones.

You can also **pan** with the moving car—moving the camera to follow the car in the viewfinder—and trip the shutter at some

SAFETY REMINDERS

- When using a tripod, take care that it is not left unattended in traffic areas. You also need to remain aware of the tripod's location to avoid tripping yourself.
- When shooting at dragstrips or raceways, do not, as an amateur, cross barriers set up for the general public. If, as a professional, you choose to break this rule, you may wish to remember that pictures exist showing race photographers as they were killed in the line of duty.

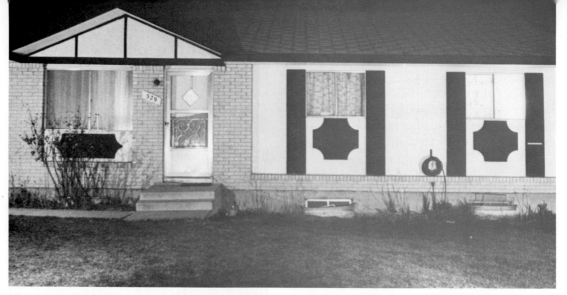

"Painting with light," opening the shutter and firing a flash several times from several different places, gives the illusion of a scene lit by more than one light.

point during the pan. The effect will be a fairly sharp image of the car against a streaked background. This effect is usually more successful and easier to get.

USING FLASH

Flash introduces other opportunities with long shutter speeds. An interesting shot can be done in complete darkness with the camera on a tripod and the shutter open. The subject holds a flashlight or penlight and swings it in, for example, a circular motion. The film picks up the light source, but not the subject's movement. When the subject has completed **tracing with light**, the flash is fired. The effect is of a stationary subject frozen by the flash, plus a "drawing" made by a moving light source.

The same principle comes into play in a technique called **painting with light**. The technique is usually applied to building interiors at night. The camera is tripod mounted and the shutter opened. A small aperture is used most often. The room is relatively dark. The photographer sets off a flash at several different places in the room. An assistant may be needed to cover the lens between flashes to

avoid overexposure of room lights. The effect is of a room that appears to be lit from a variety of sources at the same time. The photographer doesn't appear in the picture because the photographer is never "exposed" by the flash. This same technique may also be used outdoors at night when the light level is low.

A strobe may be used for multiple images of a subject in action. The camera is tripod mounted and the shutter opened. The strobe fires several short bursts of light. Each burst exposes a different view of the subject's action.

SUMMARY

The smaller the aperture, the greater the depth of field. The closer the point of focus to the front of the lens, the less the depth of field. The depth of field scale makes two readings for focus, both near and far.

The faster the shutter speed, the more likely that motion will be frozen. The slower the shutter speed, the more likely that motion will cause a blur. Using flash and strobe lights can help create special effects at night, such as painting with light.

Discussion Questions

1. The closer the point of focus to the camera, the _____ the depth of field.
2. At f/16 and with the focus at 15 feet, the depth-of-field scale marks will point to _____ and an area between the _____ and _____ foot markings on the focusing ring.
3. If, at a slower shutter speed, you pan with a moving subject, the background will be _____ and the subject _____.

4. What is painting with light?
5. What is tracing with light?
6. Why are two readings necessary for depth of field?
7. What method would you use to get both a near and far object in focus?

Assignments

Pick appropriate subjects and complete assignments 1-4. Assignments 5-8 are optional.
1. A close-up. Shoot for *maximum* depth of field.
2. A picture that is sharp from 7 feet to infinity.
3. A picture that makes creative use of *minimum* depth of field.
4. A picture with a motion blur.
5. A night shot with streaks of light.
6. With flash added, a tracing-with-light picture.
7. A painting-with-light picture.
8. A picture in which a series of motions are frozen by a strobe light.

CHAPTER 7

Lenses

Shortly after the Daguerreotype process was introduced in America in the first half of the 19th century, an American dental supply manufacturer named Alexander Wolcott attacked the problem of the fairly insensitive photographic plate. Portraits were difficult because subjects tended to move during the long exposures needed. Wolcott introduced a mirror lens. The mirror lens brought much more light to the plates than did conventional lenses. The mirror lens had some drawbacks. Only the center portion of the image was sharp. Still, the mirror lens solved a picture problem.

Today, lens-design problems usually are handled by computers. Most photographers leave lens testing to the manufacturer. The photographer buys a good lens, made by a respected manufacturer, and concentrates on pictures.

You will likely be more concerned about how a lens helps you make a picture than with how the lens is made. You don't need a degree in optical physics to be a competent photographer. At the same time you should know how a lens works and have a knowledge of the different types of lenses available.

Some photographers do most of their work with a single lens. This is truer of medium- and large-format users than of those who shoot 35 mm. Still, an infinite variety of pictures can be taken with nothing more than the normal lens. The camera-plus-normal-lens *is* the basic combination.

Other photographers, though—and this is particularly true of 35 mm users—avoid the normal lens. They tend to use a moderate wide angle lens as their "normal" lens, and some photographers work with a huge variety of lenses.

There is no right and wrong way to choose lenses. The suggestions offered in this chapter are based on the assumption that additional lenses, such as telephotos and wide angles, offer a worthy variety of effects. In the 35 mm format, these effects are usually more affordable than they are in other formats. Extra lenses give the photographer a versatility that isn't available without them. When a variety of effects is desired, as it certainly is in layouts and slide shows, a few additional lenses are an effective way to achieve it.

Yearbooks and school papers, for instance, can make good use of the alternative views that different lenses offer. So can brochures. Slide shows often benefit from a wide angle or telephoto shot. With one or two extra lenses, even your personal shots will take on an exciting new look.

Magazines, movies, and television shows have trained the public eye to expect these effects. Besides, candid photography, for which 35 mm is probably the best format, occasionally demands the far-reaching grasp of a telephoto or the wide-ranging view of the wide angle.

Terms to Learn

angle of view
catadioptric lens
extenders
fisheye lens
focal length
macro lenses

micro lenses
ringlights
telephoto lens
wide angle lens
zoom lens

This picture was taken at the U.S. Air Force Academy with a normal lens, a 50 mm. The normal lens roughly duplicates perspective as the human eye perceives it. Five other pictures in this chapter were taken from the same place, each with a different lens. In this picture, notice the tree on the left, the rectangular building in the midforeground, and the Academy Chapel (the building with the many spires) in the background.

FOCAL LENGTH

Lenses are identified by their focal length and can be spoken of as having long, short, or normal focal lengths. In technical terms, the **focal length** is the effective distance between the lens and film when the lens is focused on infinity. This distance is expressed in millimeters. We say "effective" distance because with modern optics actual distances may be somewhat altered.

The normal lens on a 35 mm camera is about 50 mm in focal length. Focal lengths determine how big each object in the scene appears in the image. A lens with a long focal length—a telephoto lens—makes objects far away look large. A lens with a short focal length—a wide angle lens—makes a foreground object look enlarged in proportion to background elements.

Most lenses have a fixed focal length. Zoom lenses, however, have adjustable focal lengths within a certain range.

110

Make a *T* by stretching your arms out to your sides. Some lenses can see everything in front of your palms.

Angle of View

The focal length of a lens determines its angle of view. The **angle of view** is how much of the scene in front of the camera the lens includes.

To get a better idea of the angle of view, make a *T* of yourself. Stretch your arms straight out from your shoulders with your palms facing forward. Can you see both hands at the same time? Some lenses can take in your palms and everything in front of them. These are the extreme **wide angle lenses.** They have short focal lengths. When photographers haven't framed carefully with such a lens, their shoes are likely to show up in the picture.

Now, with your arms still at shoulder level, bring your hands forward until the tips of

your fingers are within a few inches of touching. Lenses with extremely long focal lengths take in only the view between your fingertips. Such lenses are called **telephoto lenses**.

Angle of view is technically expressed in degrees. The degrees indicate the portion of a circle the lens can see when the film is at the center of the circle. A lens with an angle of view of 180 degrees, or half a circle, for example, obviously takes in much more of the scene in front of the camera than does a lens with an angle of view of 1 or 2 degrees.

The angle of view of a normal lens is about 45 degrees. The angle of view of an extremely wide angle lens, called a **fisheye lens**, is usually somewhere between 180 and 220 degrees. The focal length of a fisheye may range between 6 mm and 16 mm. Extreme

111

telephotos include an angle of view between 1 and 5 degrees. They may be between 500 mm and 2000 mm in focal length.

How Focal Length Affects Perspective

The experiment you made with your arms and hands was important in two ways. First of all, it showed you that lenses of different focal lengths include varying angles of view. Secondly, it may have shown you that perspective can appear to change with smaller and smaller angles of view.

The change in perspective is not always apparent. Let's say you've decided to copy a large photograph or other large, flat piece of artwork. If the camera is level and the film plane is parallel to the artwork, it makes little difference in the final picture whether the copying took place with a wide angle or telephoto lens. The artwork is flat. There is no perspective for the lens to deal with. If, when you brought your fingertips to within an inch of each other, something flat was between them, you probably saw nothing unusual.

On the other hand, if you had been conducting the experiment from a hill overlooking houses in the distance, you might have noticed a startling thing. In the view between your fingertips, the houses would have appeared jammed together. The same applies if you were looking at tall buildings in a cityscape or looking down a long country road. In the distance, perspective would appear to be foreshortened. Crowds would appear denser. Buildings that were many miles from a mountain in the background would appear to be pasted on the front of the foothills.

All of this can be seen with the naked eye. It's not easily noticeable, however, because in effect the eye is a wide angle lens. The area within which the foreshortening occurs is off in the distance. The eye takes in the large picture and the brain tends not to notice the effects in the distance. But they are there, and

This 100 mm telephoto shot, taken from the same place as the earlier 50 mm shot, shows only a branch of the tree, a corner of the rectangular building, and part of the Air Force Academy Chapel. Notice how the rectangular building appears to be very close to the chapel.

you can see them if you look for them. These effects *are* obvious with a telephoto lens.

A similar effect can be noticed with a wide angle lens. It can make objects in the foreground appear much larger in relation to those in the background. Your eye would do the same. An object you were close to would look larger, but your brain knows this is a distortion and ignores it.

All of which brings us to a single point: Lenses themselves don't alter perspective.

When the lens is a 200 mm, foreground and background begin to merge. Again, the Academy Chapel is in the background. Compare this picture to the next one.

With a 28 mm wide angle lens, you see almost all the tree in the foreground. Note, however, that at the bottom center of the picture, the rectangular building still appears to be pasted against the chapel. This telephoto effect, though much more obvious when a telephoto lens pulls it closer to us, still lurks in the wide angle picture.

They simply take in larger or smaller angles of view and make normal "distortion" more noticeable. The point is stressed because even some professional photographers fail to fully understand how angles of view are related to perspective. When you're working with different lenses, it's good to know that in the center of every wide angle shot lurks a telephoto effect.

When you look at different pictures, you should usually be able to tell which were taken with telephoto and which with wide angle lenses. With both types of lenses, the effects on perspective are greatest when some objects in the scene are nearer to the camera than others.

USING DIFFERENT LENSES

Wide Angle Lenses

If you don't count fisheyes, wide angle lenses range from approximately 13 mm to

35 mm in focal length. (Remember, fisheyes can be 6 mm.) If you have a 50 mm normal lens, the 28 mm lens is worth considering as your first wide angle. The 35 mm is a bit too close in effect to the 50 mm to make it a good first choice of a wide angle. If you have already chosen the 35 mm as your standard lens, the 24 mm is then a better selection as a wide angle. Either a 24 mm or a 28 mm will add a distinct wide angle to your pictures without being too wide for general work.

Because the wide angle covers more of the scene in front of the camera, camera shake is not as noticeable in wide angle pictures. Earlier you learned that the rule-of-thumb minimum shutter speed for a handheld normal lens should be 1/60 second. The rule of thumb changes as you change lenses. With a wide angle lens, you can usually get away with slowing down the shutter speed an additional stop, or more if you're using an extreme wide angle.

The new rule of thumb becomes this: Use 1/X, X being the focal length of the lens, as a minimum shutter speed for handheld pictures. Thus, with a 28 mm lens, use 1/28—or, rounded off, 1/30—as your minimum handheld shutter speed. With longer lenses, you have to use faster speeds. With a 200 mm telephoto, for instance, 1/200, or 1/250, should be a minimum. These minimums apply to general practice, when you want to be pretty sure you have a picture. You may certainly experiment with slower speeds. Sometimes, too, you'll need a picture that cannot be obtained at the minimums. Sometimes you must brace yourself and the camera as well as you can and take a chance. Usually, however, the new rule of thumb will help keep you out of trouble.

Besides slower shutter speeds, what are the other advantages of the wide angle lens? Obviously, they are helpful in close quarters —anywhere you don't have room to move around or can't back up far enough to get all you want in a picture. That means they can

be an asset not only indoors but outdoors as well. Some scenic shots that would look quite ordinary with a normal lens can be spectacular with intelligent framing and the right wide angle.

Wide angle lenses offer depth of field that longer lenses do not. All else being equal, *the shorter the focal length, the greater the depth of field.* The wide angle will help you make sharp pictures of two objects when one is near the camera and one quite far away. Both the flower beds in the foreground and the mountains in the background will stay in focus, especially at smaller apertures.

It may be useful to think of the wide angle as a "background lens"—the one you use when the background or other surroundings tell a great deal about your subject. Careful framing remains important, perhaps more

A wide angle keeps both foreground and background in focus.

so, with the wide angles. With increased angle of view and with increased depth of field, it is no longer so easy to remove distracting backgrounds from the picture. *Use* the backgrounds. *Look* at the full frame before pressing the shutter button.

Shooting with the wide angle will differ from shooting with a normal lens, even for general work.

Imagine that you're in an office. A subject is at a desk. With the normal lens, the tendency is to take a head-and-torso portrait. The subject might be photographed working on some project at the desk. Only a portion of the desk would show, perhaps just a small part of the top.

The wide angle lens opens up other possibilities. From the same distance, the subject would appear smaller in the frame. The surroundings take on increased importance. Perhaps the whole top of the desk would be included in the frame—"in" and "out" baskets, the subject's telephone, a flower and flower pot. In addition, the wall behind the subject becomes important. With a wide angle lens, you're more likely to include any wall hangings in the frame. In a picture taken with a wide angle, the subject's surroundings can add meaning to who the subject is and what the subject is doing.

Chapter 3 mentioned distortion with the normal lens. A wide angle lens is much more prone to distortion. This isn't all bad. Sometimes when lines seem to converge at or diverge from a certain point, it gives you just the effect you want. Close foreground objects grow unexpectedly large while background objects recede into the far distance. You can emphasize and de-emphasize with relative ease. As with the normal lens, tilting the camera at a building creates distortion, but the effect is more noticeable with the wide angle.

Generally, to reduce distortion, keep the camera level and square with your subject, avoid placing objects too close to the lens, and

watch the corners of your frames. To exaggerate distortion, tilt the camera and frame at an angle, move in close to objects that you want to distort, and manipulate with the corners of the frame. Remember that exaggerated distortion is sometimes more acceptable than moderate distortion.

When you first get a wide angle lens, put it on the camera and experiment with it. Experiment with tilts. Experiment with moving in close to objects. Try to minimize distortion and then try to emphasize it.

When you're shooting, remember the choices you have. If, for instance, you need a picture of a whole building, find a vantage point, near the center of the building's height, where you can shoot the building with a level camera. With multistory buildings, this

Compare this picture to the previous one. Notice the leaning light pole, which is the result of tilting the camera skyward. In this shot, the tilt is objectionable.

Everyone knows that the old Volkswagens never looked this sleek. But with a 24 mm lens, you can stretch them.

may involve going into a parking garage or a nearby building of similar height. On the other hand, you may choose to move in close to the building to exaggerate the perspective. If neither approach pleases you, find an entryway or some other detail in the facade of the building and forget about including the whole building in the frame.

Continue to practice with the lens. Notice how corners, placed near the lens, appear to be stretched toward the viewer. Notice how the nose on a closely framed face grows large. Items near the edge of the frame are more likely to appear distorted than items near the center. Tilt up. Tilt down. Move in close. Move away.

Remember, you do have to take more care with framing. With increased depth of field, the lenses almost demand that you make good use of backgrounds. Backlighting is perhaps more difficult because the light source is more likely to appear in the frame. The more extreme the wide angle, the more quickly distant objects diminish in size as they are moved away from the lens. You might have a subject well-framed with a normal lens. With a wide angle, the subject becomes smaller in the frame—perhaps too small.

On the whole, at least one wide angle lens may deserve a place in your kit. In close quarters or under a big sky, it will literally open new vistas.

Telephoto Lenses

Just as telescopes do, telephoto lenses enlarge distant images. As a matter of fact, some of the longer and more expensive telephoto lenses can, with an adapter, double as telescopes. Telephoto lenses range in focal length from about 85 mm to 2000 mm and encompass angles of view of between 1 and 28 degrees.

Several characteristics are typical of telephotos. Most obviously, they allow you access to subjects that would otherwise be difficult to reach. Sports and wildlife photographers rely on them to fill the frame with players and wild game that cannot easily be reached any other way. The telephoto can isolate a single football player during a play. It can pick out a deer or bighorn sheep in the distance. For general use, it can isolate a child playing without the photographer having to break the child's concentration. Adults, too, may be captured intent on an activity without the photographer intruding.

A 500 mm lens shows only the cornerpost of the rectangular building, which you've seen in previous shots. The human figures passing the chapel would have been indiscernible with the wide angle or normal lens.

Moderate telephotos, in the 85 mm range, are considered a better portrait lens than the normal lens. The frame may be filled with the subject's features without the distortion apparent in a close-up taken with a normal or wide angle lens.

Even the shorter telephotos capture the compression of perspective that is characteristic of narrow angles of view. As the length of the lens increases, generally so does the compression effect. Houses and high rises appear jammed together. A loosely knit group of people begin to look as if they hardly have room to breathe.

As the length of the lens increases, the depth of field decreases. Thus, with a telephoto, it becomes rather easy to throw cluttered backgrounds out of focus. This is especially possible when the lens is focused at short distances. At wider apertures, you may isolate one subject among many by using just the focusing ring.

With some of the telephoto lenses, you will find minimum apertures smaller than those on the normal lenses: f/22 and f/32, which are one and two stops smaller than f/16. When you have sufficient light, these smaller stops help compensate somewhat for the decreased depth of field. In general, though, focusing has to be more accurate with the telephotos than with the normal and wide angle lenses. Mistakes are more likely to show up and less likely to be covered by the lens's depth of field.

With the longer lenses, the minimum shut-

Through a 1000 mm lens, individual panes of glass can be seen in the windows of the Academy Chapel. Compare this picture with the 28 mm shot taken from the same camera position.

Even with fast film, the room light was insufficient for handholding the 200 mm lens used for this picture. A tripod was necessary, and the shot still took a wide aperture, wide enough to leave the heads in the foreground out of focus. Note the motion blur in the instructor's hand as he writes on the board.

ter speed increases for handheld pictures. The longer the telephoto, the faster the shutter speed needed. Telephotos not only magnify images, they also magnify the natural shake of the body. And this can be more of a problem because telephoto lenses are heavy and difficult to steady. **Catadioptric**, or mirror lenses, are a type of telephoto lens that uses mirrors to reduce length and bulk. They are still heavy, but are lighter than they would be if made without mirrors.

With the longer telephotos, tripods in many cases become a must. Without a tripod, the photographer may often need to make use of bracing techniques: Steadying the lens against a rigid support or holding the arms close to the body, bracing the elbows against the stomach or something solid. Some photographers make use of a bean bag pillow instead of a tripod.

The shorter telephotos—135 mm and under—are usually relatively fast lenses. They have maximum apertures in the f/2 and f/2.8 range. At 200 mm and above, the widest apertures are often f/4 and less. The smaller maximum apertures complicate problems with low-level light.

As a rule of thumb, you can count on increasing light problems with any increase in the length of the lens. Faster shutter speeds

become necessary to handhold the camera. The maximum apertures decrease. The longer the lens, the less the depth of field. Faster films and increased grain almost become necessary. Any use of slower films demands even more attention to light problems.

With their smaller angles of view, however, telephotos offer a dramatic change in perspective. With careful framing and subject selection, the "look" of the telephoto will add impact to any portfolio. Since you can work at greater distances, you will find you can capture action and expressions that simply are

not available to you with the normal lens. You can work at greater distances from your subjects. From intimate close-ups to the larger than life elements in landscapes and cityscapes, the effects of telephotos are tools that many photographers prefer not to be without.

Zoom Lenses

Zoom lenses have the advantage of changeable focal lengths. In a 35-70 mm zoom lens, for instance, any focal length between 35 mm and 70 mm may be selected, usually by adjusting a ring on the lens. Zoom lenses are most often heavier and more expensive than their single-focal-length counterparts. They usually are not as fast because they have smaller maximum apertures.

It used to be that no zoom lenses matched fixed focal length lenses for sharpness. Now computer designs have greatly reduced sharpness problems, and many professionals include zoom lenses in their collection of equipment.

Zoom lenses offer new choices to the photographer. Some effects are impossible without a zoom lens. With slow shutter speeds, a zoom (changing the focal length and thus the size of the image) can take place during exposure and the lens will stay in focus during the change. If, for instance, the lens is focused on the front of a stationary car that is facing the camera and the lens is zoomed during exposure, the effect is as if the car is rushing toward the camera. More often, of course, the zoom lens simply allows the photographer a wide range of focal lengths in a single lens, and single zooms may take the place of several other lenses. When the photographer buys one zoom instead of several fixed lenses, there is probably a savings.

The added weight on the camera can be a problem, but one zoom almost always weighs less than several fixed lenses. When a zoom replaces fixed lenses, your camera case will weigh less. With a zoom on your camera, the camera will weigh more.

The main choices you have to make about zoom center around lens speed, cost, weight, and versatility.

A mild telephoto, this one was a 100 mm, permits tighter framing on informal portraits.

A 2X extender doubles the effective focal length of your prime lens and lets you get closer to your subject.

2X and 3X Extenders

The 2X and 3X **extenders**—also known as tele-extenders and tele-converters or two-by and three-by extenders—are devices that fit between the prime lens and the camera. They double and triple the effective focal length of a lens. With a 2X extender, a 50 mm lens becomes a 100 mm lens. A 200 mm telephoto becomes a 400 mm. With a 3X extender, the 50 mm becomes a 150 mm lens, and so on. Virtually all extenders cause at least a slight loss of image quality. All extenders reduce the light admitted into the camera. The 2X extender causes a two-stop light loss. The 3X extender causes a three-stop loss.

The main advantage of the extenders is that they are an inexpensive way to add new focal lengths to your lens collection. The best ones are usually made by the camera manufacturer, and these often permit you to use the lens-and-extender combination just as you would a new lens. A good quality extender lets you meter with the lens wide open and

Extenders may be used with most lenses and can make a telephoto a longer telephoto.

120

If you want to experiment with close-up effects before buying the equipment, hold a magnifying glass close to the camera lens. This picture was taken through a magnifying glass and a normal lens. As you can see, the quality is not all you would want, but for experimentation the technique is worth a try.

automatically shuts down the aperture as the picture is taken. Some accessories manufacturers also make similar extenders. The cheapest extenders may make additional work for you. Usually, as the price goes down, so does the quality. You should try any extender before you buy it.

The 2X extender is a generally more effective performer than the 3X. The light loss is not a serious consideration because there is a comparable light loss with the longer standard focal length lenses. That's because the longer lenses have smaller maximum apertures than the shorter lenses. For example a 50 mm f/1.4 lens with an extender becomes a 100 mm f/2.8. But a prime lens of 100 mm will have roughly the same maximum aperture.

The extenders have some hidden advantages. The lens-plus-extender has the same minimum focusing distance as does the prime lens itself. A 200 mm prime lens, which focuses to approximately 7 feet, becomes with 2X extender a 400 mm lens that also focuses to approximately 7 feet. The 50 mm lens that focuses at 2 feet becomes a 100 mm that focuses at 2 feet. In many cases, the lens-plus-extender focuses more closely than an equivalent prime lens.

Extenders are also useful in close-up work. When you have added a screw-on close-up adapter to the front of a lens, the 2X extender will double the image size on the film.

Micro Lenses

Some manufacturers call them **micro lenses** and others call them **macro lenses**. Whichever, these lenses are designed for close-up work. Some photographers use them as prime lenses. Most of the micro lenses do focus to infinity. These special-purpose lenses usually range in length from about 50 mm to 200 mm. They are at their best at closer than normal lens-to-subject distances.

Used alone, they can picture objects at half life-size on the film. With an extender, they offer life-size reproduction. The image on film, in other words, is the same size as its corresponding real-life object. Since 35 mm film is almost always enlarged, the final picture can show the object as much larger than life-size. When the human eye, for instance, is life-size on a slide, the eye will fill the screen anytime the slide is projected.

Micro lenses provide edge-to-edge sharpness, and many of them can easily be adapted to specialized lighting equipment for close-up work. Several micro lenses have built-in flash

121

In the long run, better cameras and better lenses are the better buy, but a low-cost system is better than no system at all. When necessary, a low-cost system can be made to pay for better equipment later on.

rings that encircle the front of the lens. **Ringlights**—flashes that can be attached to the front of the lens—can also be obtained.

Micro lenses are usually bulkier and more expensive than, and often not as fast as, their conventional counterparts. Some micros are also zooms. If you plan on doing a good deal of close-up work, the micro lenses are well worth exploring.

There are lens adapters also designed for close-up work. These adapters will be covered in Chapter 10.

BUYING LENSES

Care and patience in buying lenses usually pays off in the long run. Lenses range from the extremely cheap to the extremely expen-

sive. In some respects, your choice of lenses may be even more important than your choice of camera. Choosing the best lenses you can afford makes sense because, more than anything else, the lens on the camera determines the quality of image on the film. Lenses made by the camera's manufacturer usually offer a better quality image and longer life. Well-made cameras and well-made lenses are the better buy in the long run.

It is also good to be able to experiment with some of the less expensive add-ons. When your prime lens is not the best, any quality loss caused by the add-ons becomes much more apparent. If, for instance, you choose to add a middle-range extender to a top prime lens, the quality loss is not as great as if

you had used the same extender with a cheap lens.

If you must go to the less expensive lenses, avoid zooms. The zoom lens is quite complex in its design. Optical quality is more likely to suffer in a low-cost zoom lens than it is in a low-cost prime lens.

Most importantly, don't rule out entering photography just because of costs. Even the least expensive cameras and lenses, when made by the major manufacturers, meet standards for producing good quality pictures. Occasionally, you can find bargains in used equipment. In addition, the camera and photography magazines will point out worthy, and sometimes surprising, bargains. A low-cost system is better than no system at all. You can upgrade later. When necessary, a low-cost system can be made to pay for better equipment, and, as long as it lasts, low-cost equipment can provide a back-up for a better system later.

A Purchase Plan

There are many approaches to equipment acquisition. One possible approach follows.

1. Start with a camera and the normal lens.

Unless you expect to be doing a great deal of work in dim light, avoid the f/1.2 lenses. Usually, you don't need that much speed. While an f/1.4 lens is nice, it may not be necessary. However, it holds its trade-in value a bit better than the slower lenses. When money is an issue, don't be afraid of the f/1.8 or f/2 normal lens.

2. Add a moderate telephoto, perhaps a 200 mm. The 85 mm and 100 mm to 105 mm can be good for portraits if you plan to take many of those. The 135 mm gives a moderate telephoto effect. However, despite the wider maximum aperture, usually in the f/2.8 to f/3.5 range, the 135 mm can often seem a bit short when a telephoto is needed. For many uses, and for a telephoto to give you unmistakable telephoto effects, the 200 mm might be a better choice. The 200 mm has definite advantages for sports and wildlife photography. Scenics are often more impressive with the 200 mm. This lens can also be used at close range for intimate, candid portraits. A zoom, of course, may be substituted for the 200 mm. Extreme telephotos usually should not be included in your first purchases.

3. Add a 2X extender. Your 50 mm be-

SAFETY REMINDERS

- As you change lenses, just as you would when changing film, try to step away from the action. If you are unable to find a quieter spot to change lenses and film, stay alert. Keep one eye on the action around you.
- A telephoto lens allows you access to the action at sporting events without having to be in the middle of the action itself. A 2X or 3X extender offers similar benefits. At the same time, the narrower angle of view of the longer lenses can leave you unaware of trouble approaching.
- Remember that the monopods or tripods used with longer telephotos render you less mobile. In a few rare instances—and race photography is only one of these—you may have to be prepared to abandon your equipment and run for your own safety. Remain attuned to potentially dangerous situations and make necessary decisions beforehand.
- Never look at the sun through your viewfinder. You could be blinded. The effects are more rapid with telephoto lenses. Avoid pointing your camera toward the sun; longer telephotos have been known to explode when radiant heat energy from the sun builds up in the glass. Special techniques (beyond the scope of this text) are required for photographing solar eclipses. Carefully research the techniques before attempting to photograph solar eclipses.

These pumpkins were shot with a 200 mm lens. Notice the compression effect and the soft focus in the background. The pumpkins would not have looked so "crowded" with a normal lens.

comes a 100 mm, and the 200 mm becomes a 400 mm.

4. A macro lens is not necessary unless you plan a lot of close-up work. Instead consider close-up adapters. (See Chapter 10.)

5. Add a wide angle—either a 28 mm or a 24 mm. Wider lenses are often too wide for general work. The 35 mm is probably too close to the 50 mm to make it a good first choice of wide angle for most people. Fisheye lenses are too specialized for a first purchase.

With the above collection, you should be able to work on almost any assignment. You may never need another lens. By the time you've mastered these, you should need no further suggestions. You will be able to fulfill your own needs with confidence.

No lens, of course, will do all your work for you. Some people change lenses just to keep from moving a step or so. The most effective use of different lenses demands intelligent selection. In other words, good pictures—

124

These are the same pumpkins as before now seen with a wide angle lens, a 28 mm. Here you can see the background and tell the pumpkins are spread over a wide area.

especially candids, scenics, and industrial shots—depend on the photographer's willingness to move around. The photographer stalks good framing, lighting, and subjects much like the hunter stalks game. Different lenses simply offer more choices at each vantage point.

SUMMARY

Lenses differ in their focal length and angle of view. Long lenses have narrow angles of view; short lenses have wide angles of view. Focal length affects the appearance of perspective, making objects appear more densely packed or larger in relation to their backgrounds.

Lenses and attachments available include the wide angle, telephoto, zoom, micro lenses, and extenders.

Discussion Questions

1. Where is focal length measured?
2. What is angle of view?
3. Which has greater depth of field, a wide angle or telephoto lens? Why?
4. What is a zoom lens?
5. The differences in perspective are due to different _____.

6. What is a catadioptric lens?
7. Zoom lenses have _____ focal lengths.
8. In effect, a 2X extender _____ the focal length of the prime lens.
9. Micro lenses are designed for _____ work.

Assignments

1. If you have access to a lens other than a normal one, shoot a series of pictures with it. Be prepared to discuss the advantages of the lens and note the instances when the lens did not do what you expected it to do.
2. If you have only a normal lens, shoot a series of pictures, such as a sporting event, that might more easily have been taken with another lens. Do everything you can to overcome the disadvantage of the single lens. Try to obtain close-ups, for instance, or take advantage of the additional speed the normal lens offers. Be prepared to discuss the techniques you used to overcome limitations.

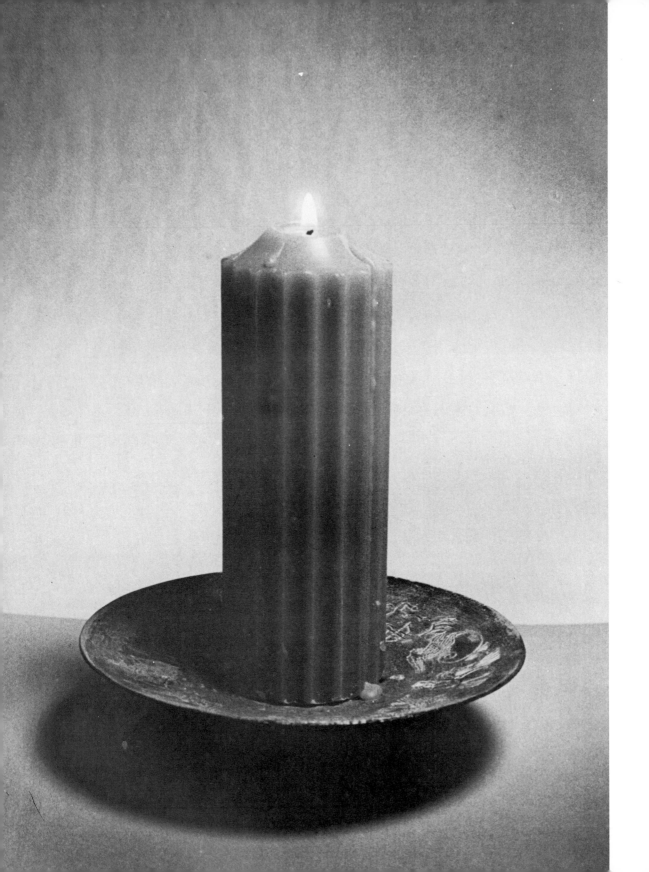

CHAPTER 8

Filters

Whether you add filters to your equipment will depend very much on the kinds of work you do. Many photographers depend on very few filters. Some photographers argue that any glass added to the front of a lens must degrade the image in some way, even when filters are of the highest quality. On the other hand, photographers who shoot color slides and demand accurate color balance may make heavy use of filters. Sometimes they combine several to get the colors they need. The use of filters is much more common in studio work than in field work, although field photographers, too, may work with filters now and then. If you need any filters, you will probably need only a few. In the beginning, it is best if you simply review the filters available and add to your equipment just the ones you need.

Planning your purchases makes good economic sense. If you have the time to look for them and wait for sales, you can usually find the most common filters at close-out prices. Reduced prices are a regular feature at some of the mail-order houses. In addition, camera stores that deal in used equipment often have good buys. Except for scratching and bent screw-in threads, there is little that can go wrong with a filter. Name brands can be found about as often as the off brands. It is not unusual, for instance, for used filters to be reduced to one-third their original cost.

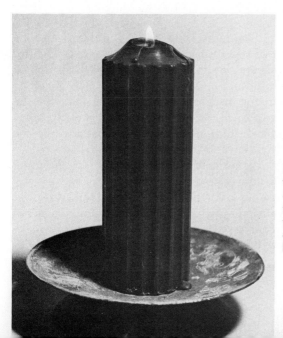

HOW FILTERS WORK

Filters usually screw onto the front of a lens. Unless they are just glass, filters alter in some way the light entering the lens. Sometimes the effect is hardly noticeable. Sometimes the effect is dramatic.

Notice the picture at the beginning of the chapter. It was taken without a filter. The difference in the red candle and blue poster board tabletop is apparent in that black and white shot. The picture shown here was taken through a blue filter. Notice how dark the red candle has become. Also note that the blue poster board has turned the same shade of gray as the white background.

Terms to Learn

color compensating (CC)
 filter
color correcting filter
color polarizing filter
diffraction gratings
filter factor
fog filter

neutral density filter
multi-image attachments
polarized light
polarizing filter
skylight filter
split-field filter
soft-focus filter

star filter
UV filter
vignetting filter

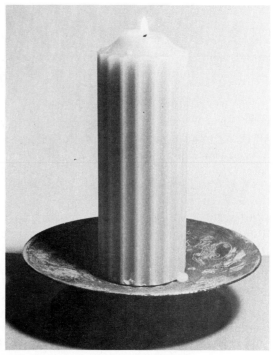

This is the same subject as in the first two photos, but this shot was taken with a red filter. The red candle has turned almost white—to the point where in some places it blends into the white background. The blue poster board, however, is visible again.

Light Reduction

The light reduction of a filter may be expressed in either of two ways: As a **filter factor** or simply in the number of stops an exposure must be increased. A filter factor of 2, for instance, means you must double the exposure, or increase it by 1 stop. A filter factor of 4 means you must quadruple the exposure, or increase it by 2 stops.

Light meters don't always give accurate readings behind color filters. The safest way to use color filters is to meter the scene and then adjust for the filter factor. To avoid constant computing, you may want to make exposure tests and then compare meter readings to filter-factor computations.

Some filters are tinted to correct light that isn't quite the right color for a particular film. Some are a neutral gray and cut the amount of light entering the camera by one or more stops.

UV—ultraviolet—filters have little effect on most pictures.

Size

The size of a screw-in filter is given in millimeters. The number refers to the *diameter* of the front of your lens. Common filter sizes include 48 mm, 52 mm, and 55 mm for normal lenses. If you have several lenses and the diameters vary moderately, buy filters to fit the largest lens. Then you can use adapter rings so that the filters will fit all your lenses. The only exception might be when you have long telephotos or particularly short wide angles, and the largest filters would be impractical. Gelatin filters, which have the look and feel of plastic, can then be used for the larger lenses.

TYPES OF FILTERS

Most filters fall into the following groups: UV (ultraviolet) and skylight, polarizing, neutral density, color correcting for both black and white and color films, color compensating, split field, and color polarizing. Special-

effects attachments, although not strictly filters, overlap some of the functions of filters and may be discussed under the same heading.

UV and Skylight Filters

The most common filters are probably the UV and skylight filters. Neither requires exposure adjustment. The UV, or haze, filter is colorless. The skylight filter has a slight amber cast. The effects of both are quite subtle. The **UV filter** absorbs ultraviolet light. Ultraviolet light is invisible to the human eye, but it exists in sunlight. Film is sensitive to it. The **skylight filter** warms up the strong blue cast of open shade and overcast skies. The effect is slight.

Some photographers leave a UV or skylight filter on their lenses primarily to protect the front element of the lens. Others argue that the protection is unnecessary. If the filter is of low quality or dirty, it can reduce the

129

Petroleum jelly can be applied to the front of a filter for a soft-focus effect. In this shot, a clear area was left in the center of the filter, so the effect is more pronounced at the edges of the picture. The technique is messy, but it's versatile and virtually cost-free. You can apply as much or as little jelly anywhere you like on the filter. Different amounts create different effects.

sharpness of a good lens. If the filter breaks, the possibility of damage to the lens may actually increase. On the other hand, a scratched filter is cheaper to replace than a scratched lens. It is also easier—and less stressful—to clean splashes of mud off a filter than off a lens.

Some photographers also use the UV or

Most light entering a polarizing filter vibrates in all directions (left). The filter (center) acts something like a venetian blind, admitting only light that vibrates in a specific direction (right). Since polarized light vibrates in a specific direction, it will be admitted through the filter when the filter is aligned to permit its passage.

Shot without a polarizing filter, this car hood shows bright reflections. Notice especially the lines coming from the lower left and upper right-hand corners of the picture.

skylight filter as a base for special effects. Petroleum jelly, for instance, may be smeared around the outer front edges of the filter. Pictures taken through a filter prepared in this way have sharp centers yet are quite diffuse around the edges. If the petroleum jelly is smeared completely across the front of the filter, soft-focus effects may be obtained. Different colored gels may also be taped to the front of the filter. If a piece of window screen is fitted inside the ring, a starburst pattern may be achieved.

Polarizing Filters

Polarizing filters give a variety of effects. They may be used for both black and white and color films. They are probably more effective with color films.

The polarizing filter is a screen with invisible crystals aligned in parallel rows. These parallel rows admit only the light that· "fits" between them. Light moving in other directions is blocked. The polarizing filter rotates in its ring to control the effect.

To picture how polarizing filters work, imagine a straight line traveling from a light source to the camera. This line represents a light wave. Now imagine that the line vibrates, in all directions, at right angles to the direction of travel. Not all light, however, vibrates in all directions. Some light, usually reflected light, vibrates only in one direction. This is called **polarized light**. Light reflected from nonmetallic surfaces, such as glass, glossy paints, and water, is polarized.

The polarizing filter can cut light by rotating to block waves traveling in that specific direction. The light is stopped by the filter's rows of crystals and cannot reach the film. In some cases, the resulting effect of a polarizing filter is deeper blues in the sky, a reduction in haze, muting of reflected highlights and glare, and cutting the reflections of glass and water.

The effects of a polarizing filter are visible. The easiest way to see them is to look through the filter at a car or truck where your own reflection can be seen. Then rotate the filter

With a polarizing filter, the glare is reduced.

in its ring. Notice that some of the reflections are blocked while others are not. As the filter rotates, the highlights seem to move about the vehicle. The result is an enrichment of the colors that would otherwise have been whitened by the highlights. There is some light reduction, however, and a stop or stop and a half more exposure is needed.

Again, the effects vary from case to case. You need to experiment to get comfortable with the filter. When the effects are pronounced, you may have to choose just how pronounced you want them to be. Sometimes the lack of highlights introduces an artificial note to pictures. In some cases, you may prefer to allow some of the highlights to show.

Neutral Density Filters

Neutral density filters are designed simply to cut the amount of light reaching the film.

They are a neutral gray and come in several strengths. They are handy whenever you need longer exposures—to show motion, for instance—or wider apertures for reduced depth of field. If you find you consistently have too much light for the pictures you want, you might consider switching to a slower, finer grained film.

Color Correcting Filters

Chapter 4 discussed several of the **color correcting filters**—specifically those for fluorescents and for use with tungsten film outdoors and daylight film under incandescent light.

Color correcting filters are available both for color and black and white work. In black and white work, yellow and red filters have pronounced effects on the contrast between clouds and skies. A run-of-the-mill scenic shot with clouds might be made spectacular

A red filter darkens the sky.

with the addition of the right filter. With a wide range of filters, fine adjustments in contrast may be obtained.

Color Compensating Filters

Color compensating (CC) filters are a special kind of color-correcting filter. They come in varying densities for the three primary colors and for the three complementary colors. The three primary colors of light are red, blue, and green. (Primary colors of light differ from the primary colors of paint.) The three complementary colors are cyan, yellow, and magenta. Each primary color blocks the two other primaries. For instance, a red blocks blue and green. Each of the complementary colors blocks a primary: Cyan blocks red, magenta blocks green, and yellow blocks blue.

With the CC filters very fine color adjustments can be made. Complete sets of CC filters are much less expensive when obtained in gelatin rather than glass form.

Split-Field Filters

Split-field filters are for special effects. One half of the filter does one thing and the other half does another. Some are similar to bifocals in that they provide a clear area at

The star filter turns points of light into stars.

the top for long-distance focusing and magnification at the bottom for close-ups. These filters allow you to focus on a mountain range in the background as well as a leaf in the close foreground. Other split-field filters have a single color over half the filter and a clear area for the remainder. With blue as the color, a drab sky might be enhanced, while the foreground beneath the horizon remains natural. Sometimes, split-field filters have two colors. Colored split-field filters may be prepared at home as well as obtained commercially.

Color Polarizing Filters

Color polarizing filters can be an inexpensive substitute for regular color filters because a variety of colors are available with a single filter. As color filters do, they change the color of light. But a single color polarizing filter, when combined with a regular polarizing filter, offers a *range* of colors. A red-blue filter, for instance, will change from red to magenta to blue—depending on how the regular polarizing filter is turned. A red-yellow would vary from red to orange to yellow. Exposure compensation ranges from two to five stops. Light loss is usually less with a single-color filter.

Special-Effects Attachments

Special-effects attachments can do many things. **Star,** or cross-screen, **filters** turn points of light into stars giving off streamers

A nylon stocking over the lens provides a soft-focus effect. Characteristics of the technique include the fading of detail around the edges and low contrast.

of light. These filters come in four-, six-, and eight-point versions. **Diffraction gratings** give a similar effect, but the "stars" are broken into a rainbow of colors.

Fog and **soft-focus filters** introduce a mist or haze to pictures. Bright materials, especially against a dark background, can be given a halo effect. The fog and soft-focus filters introduce a romantic quality to pictures. They are also sometimes used to reduce wrinkles and skin blemishes in portraits. A variation of the soft-focus filter is the **vignetting filter**. It is clear in the middle but diffuses the light around the edges. The resulting picture is sharp in the center with increasing haze toward the edges. The strength of fog and soft-focus filters varies from manufacturer to manufacturer. Check the effect of the filter before buying.

You can also create your own soft-focus and vignetting effects. A nylon stocking stretched over the lens produces diffusion. Different-colored stockings offer different effects, especially in color. A hole the size of a nickel or quarter may be cut in colored construction paper—the kind used in elementary classrooms—to give color diffusion. The effect is better when the paper is held an inch or so in front of the lens so that the paper may pick up light.

With special-effects filters—both the commercial and homemade versions—be sure to use a wide aperture or to check the effect with your depth-of-field preview button. Small apertures can change the effect you see through the viewfinder. At smaller apertures, the effects are often less subtle.

Multiple-image attachments are also available. There are several kinds. The most common are the radial and the parallel. The multi-image radial attachment groups images in something of a circle. The multi-image parallel attachment breaks the image into parallel patterns. Effects vary not only with different apertures, but with different lenses as well.

To some people, all special effects are considered cheap tricks. A hint to the wise should be sufficient: The more unusual the effect, the less often it should be used. Even then, it should be used to help the photographer make a point. A multi-image parallel attachment, for instance, might be used to illustrate a point about mental health problems.

135

Multiple-image radial attachments group images in a circle.

Special effects do seem to take on a life of their own when the resulting pictures are used as illustrations. An effect that might be obnoxious in a picture that hangs on a wall could look perfectly at home in an audiovisual program or in a brochure. In a program or brochure, the effects are often used along with more conventional pictures and can enhance a point that needs to be made.

SUMMARY

It is a rare photographer who needs all the equipment mentioned in the chapter. However, you should be familiar with the range of filters and attachments available.

Filter light reduction is called the filter factor. Sizes of filters are scaled to the diameter of your lens.

The UV and skylight filters absorb ultraviolet light. Polarizing filters block reflections. Neutral density filters cut light intensity. Color correcting and compensating filters enhance or block colors. Split-field filters give two different effects. Color polarizing filters offer a variety of colors when combined with a polarizing filter.

Special-effects attachments can do many things such as turn points of light into stars, add haze, blur picture edges, and create multiple images.

Discussion Questions

1. Neutral density filters are _____ in color. They _____ the amount of light entering the lens.
2. What is a filter factor?
3. Filter sizes are given in _____ and the number refers to the _____ of the lens.
4. In black and white work, yellow and red filters have pronounced effects on the _____ between clouds and skies.

5. A red filter blocks _____ and _____.
6. _____ or _____ filters are sometimes used to reduce wrinkles and skin blemishes in portraits.
7. With special effects filters, be sure to use a _____ aperture or _____ the effect with your depth-of-field preview button.
8. How does a polarizing filter work?
9. Describe a split-field filter.

Assignments

These assignments, as you may have noticed, are intended to improve your performance not only with your camera and other tools, but with your selection and use of subject matter as well. Ideally, you are taking pictures in addition to those assigned. In the later chapters, subjects have *not* been assigned so that you may explore you own personal choices.

If you are having any trouble finding good subjects, discuss the matter with your classmates and instructor. Again, informal portraits and people involved in activities are rich sources of interesting subjects.

In addition, your treatment of subjects should be steadily improving, except when you may have attempted a technically difficult shot and failed. These failures are part of learning. Take them in stride. When you can, try the same shot again, and see if you can correct any problems.

1. With filters or with homemade materials, create at least three special effects. If you like, take conventional pictures of the same subjects and compare the differences.
2. Review earlier pictures you've taken and determine if any of the those could have been improved with filters.

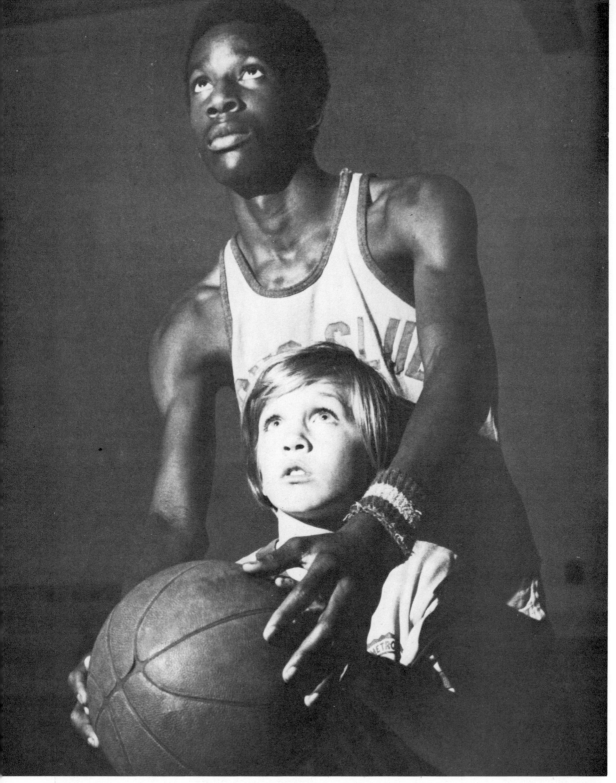

CHAPTER 9

Controlled Lighting

Light comes in many forms. So far, you've worked primarily with "found" light or available light: Light from the sun and from artificial sources that were not designed specifically for photography. For most photographers, the time comes when found lighting just isn't enough. In this chapter, you will learn how to use light designed for photographers.

Not all light designed for photographers is good. The flash that most amateurs use is designed for one thing—to get enough light on the subject to properly expose the film. The light from a direct flash is harsh, unnatural, inelegant, and usually inexcusable. In a few cases, it also happens to be unavoidable. Wedding photographers depend on flash, and most of the time they have only a few techniques to avoid the very worst of its lighting. News photographers, especially when they are shooting outdoors at night, may also have few alternatives. Sometimes the compelling nature of a subject demands that it be photographed, and sometimes the only reasonable way to picture it is with flash.

Not all flash is bad. Most photographers have a flash unit or two for events that don't lend themselves to available-light shooting. Studio photographers use flash all the time. When they do, it doesn't look like flash.

Good flash technique takes a bit of care and basic understanding of photography before it makes sense. That is why it has not been discussed until now. A dependence on direct flash can get in the way of learning about light. The best way to understand photography is to first become familiar with light and then see how flash can enhance what you've already learned.

In this chapter, you will also see how to set up multiple-unit lighting arrangements. You will learn how several lights work together to create the effects you've seen in studio pictures. You will see how to make a single light do the work of several. Finally, you will get a look at handheld light meters and how they work. For most students, the TTL meter will be sufficient for the time being. A few students, however, may need one or more of the meters covered, and all should be aware of what's available.

FLASH

Flash comes in everything from the simple flash cube for amateur cameras to huge and very expensive electronic studio units. For the most part, we will cover the smaller units— ones for the kinds of photography discussed throughout this book.

Historically, flash bulbs and their predecessors, such as flash powders, have played an important role in photography. Today, elec-

Terms to Learn

background light
bounce flash
color meters
dedicated flash
fill light
flash meters
focal plane
focal plane shutter

guide number
incident meters
inverse square law
key light
modeling
modeling light
PC cord
photo umbrella

red eye
reflected-light meters
spot meters
sync speed
thyristor
zones
zone system

As with all things electronic, electronic flash has grown increasingly complex in its design. Sometimes, that makes it easier to use. At other times, when the conditions aren't "average," the photographer has to outthink the flash. That means photographers have to know enough about how the flash units work to predict their performance under different conditions. Today, even small and inexpensive flash units can be set to work automatically. To get the full use of these units, though, it helps to know how manual models work.

Manual Flash

In the simplest models, low-voltage batteries supply energy to a capacitor. From the capacitor, high-voltage energy is released to the flash tube. With many manual models, the output of light energy each time the flash goes off is the same. The duration of the flash is at 1/1500 second or faster. These facts have importance to 35 mm users.

EFFECTS ON SHUTTER SPEED

The shutter is a curtain—two curtains, actually, that overlap each other. The shutter is at the rear of the camera, near the **focal plane** where light focuses on the film. Since the shutter is near the focal plane, it is called a **focal plane shutter**. (The other type, a leaf shutter, is found in or near the lens.) Almost all SLRs have a focal plane shutter.

At the slower shutter speeds, one of the shutter curtains opens and lets in light. The second curtain then follows, cutting off the light. At faster speeds, above 1/60 to 1/200 (depending on the camera model), the second curtain begins closing before the first has finished its travel across the film. There is never a point in time when the shutter is completely open. In other words, at faster shutter speeds, the film is exposed by a mere slit of an opening that travels across the film. That works fine with available light.

With a flash, however, the shutter must be

tronic flash is used by professionals. In fact, one of the prime advantages of electronic flash—its lower cost-per-flash—has helped increase its use even in the amateur markets. Some cameras now come with a built-in electronic flash.

Anytime you're close enough to your subject, flash gives you enough light to get the picture.

At less than sync speed, a focal plane shutter is never completely open. The first curtain (right) begins to open. Then the second curtain (left) begins to follow. The film is exposed by the open, traveling slit (center) as it crosses the film. If the light is continuous, as it is with daylight or incandescent light, the whole frame is exposed. But electronic flash, a light that lasts 1/1500 second or less, simply isn't on long enough for the slit to travel completely across the film. Thus, only part of the frame is properly exposed at less than sync speed.

completely open when the flash fires for the light to register on the film. Otherwise, only that mere slit is properly exposed. The fastest speed at which the curtain is completely open is called the **sync speed**. The sync speed is usually shown on the shutter speed dial with an *X*. Since the duration of the electronic flash is 1/1500 second or shorter and the shutter must be completely open during that time, you must use shutter speeds no faster than the sync speed. Any faster and the second curtain begins closing, cutting off the exposure. Slower speeds can be used.

Therefore with flash you lose one of the controls you usually have over light. The effect of the shutter speed changes. It is the intensity of the flash, not the shutter speed, that controls the exposure.

The Observer

In a camera with a focal plane shutter, the shutter must be completely open when the flash fires for the film to be properly exposed.

Imagine a subject in total darkness. The shutter speed is set at sync speed or slower. The shutter opens. The film is exposed by the flash. The shutter closes. In total darkness, once the exposure is made by the flash, it makes no difference how long afterward the shutter remains open. In other words, in total darkness with electronic flash, you can't increase the light hitting the film by slowing down the shutter. All the light, which is just the light from the flash, is either there or it isn't. The only practical control on the camera that regulates the amount of flash hitting the film is the f/stop ring. However, with the manual flash unit, you can control the amount of light another way.

CONTROLLING THE LIGHT

Another control over the light is changing the distance between the subject and the flash. You can either increase or decrease the distance.

The relationship between distance and brigtness may be expressed in a formula called the **inverse square law**: The intensity of light on a subject is inversely proportional to the square of the distance between the light source and the subject. For example, let x

represent the intensity of light hitting a subject at a light-to-subject distance represented by d. At twice the light-to-subject distance, $2d$, the intensity equals \sqrt{x}. At half the distance, $1/2d$, the intensity equals x^2. (It is perhaps natural to expect $1/2x$ and $2x$ instead of the square root and square of x.)

That all sounds more complicated than it is. Let's say you have a point source of light. It's focused on 1 square yard of white wall and the light source is only 1 yard from the wall. When the light is moved 2 yards from the wall, it lights up 4 square yards of wall. So the brightness of each square yard of wall is reduced by one-fourth. At 4 yards from the wall, the light shines on 16 square yards of wall. The brightness of the wall is reduced to one-sixteenth its original level.

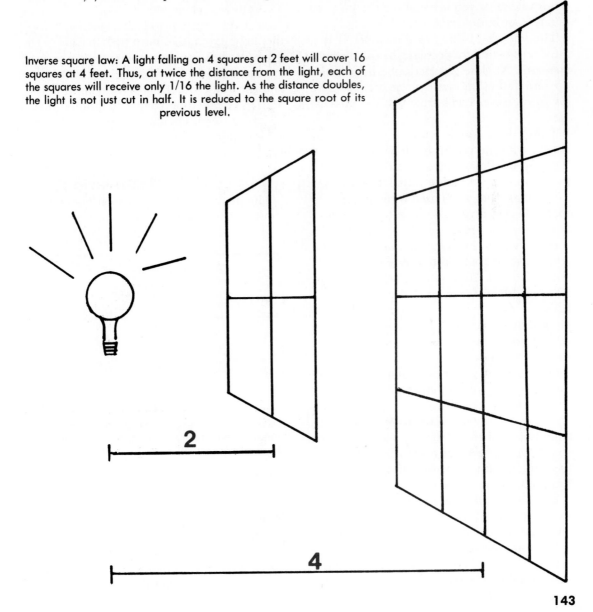

Inverse square law: A light falling on 4 squares at 2 feet will cover 16 squares at 4 feet. Thus, at twice the distance from the light, each of the squares will receive only 1/16 the light. As the distance doubles, the light is not just cut in half. It is reduced to the square root of its previous level.

Without thinking, it's easy to make the following mistake: "Well, if I double the light-to-subject distance, that should cut the light level in half." As you've just read, that's not so. When you double the light-to-subject distance, the light level is cut to one-fourth. Though most photographers don't get into it, the inverse square law allows you to make many exact calculations of light and distance ratios whenever you like. On a calculator, the square root button makes the figuring easy.

The important thing to remember is that the intensity of light decreases as the distance increases. At close distances, the light build-up and fall-off is quite dramatic. At long distances, the changes are much less noticeable.

Those who use a manual flash usually receive with the unit a simple version of this formula to follow. It involves a figure called a guide number. A **guide number** is a rating for the flash when it is used with a given film speed. If you divide the flash-to-subject distance into the guide number, you get the correct f/stop to use. Let's say that for the film you're using, your flash is rated at a guide number of 40. Your subject is 10 feet away. Dividing 40 by 10, you get an aperture of f/4. Let's say the subject is 5 feet away. The 40 divided by 5 gives you f/8. A practical version of the complete guide-number formula is shown on this page.

Of course, if you change films—and ISO ratings—the guide number changes. Many flash units have guide numbers for common film speeds printed on them. Many have an adjustable dial that does the calculations for you. You set the focus on your subject, read the distance off the focusing ring, and set the f/stop according to the dial.

You can confirm a guide-number rating with exposure tests. Set up a subject at a known distance. Make exposure tests at several f/stops and keep a record of which exposure is which. When you get a correct exposure, multiply the f/stop by the distance and

you will have an accurate guide number. Or, if you have a particular f/stop you want to use, divide the f/stop into the guide number; you'll get the flash-to-subject distance needed for a proper exposure. The latter technique is handy when you want to combine flash with available light. At sync speed or less, find the correct stop for the available light. Divide that f/stop number into the guide number. The answer gives you the correct flash-to-subject distance so both available light and the light from the flash will balance. For example, let's say your meter says a proper exposure for the available light is 1/60 at f/16 and the guide number for your flash is 160. The 160 divided by 16 (guide number divided by the f/stop) equals 10. So at a flash-to-subject distance of 10 feet, the flash and available light will balance.

Automatic Flash

The main difference between manual and automatic flash is that automatic units have a

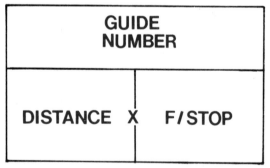

This diagram graphically illustrates the guide number formula. Treat the guide number as the numerator (the top number) of a fraction. When the guide number is divided by distance, your answer is in f/stops. When the guide number is divided by f/stops, you get distance. Moreover, by multiplying the lower two figures—distance and f/stop—you can obtain the guide number. Thus, when you know any two of the figures, you can establish the third. Put mathematically the three formulas are as follows: 1) Guide Number ÷ Distance = F/Stop. 2) Guide Number ÷ F/Stop = Distance. 3) Distance × F/Stop = Guide Number.

Sometimes you don't want available light to influence the exposure on your flash pictures. Notice the upraised arm of the player on the left. At his shoulder and wristband, to the left of his arm, you can see a "ghost" image. As you know, the sync speed on most SLRs is relatively slow. It's slow enough that fast-moving subjects have a tendency to blur. If the available light is bright enough to make an exposure, a ghost image will occur. Usually, the ghosting is undesirable.

light-reading capability. Either a built-in cell on the flash or sensor within the camera reads the light reflected from the subject. When the light on the subject is sufficient to expose the film, the flash shuts itself off.

When the flash uses light sensors within the camera to shut off the light, the unit is called a **dedicated flash**. Many models use a **thyristor**, a fast-acting electronic switch. It shuts off energy to the flash head when the light-reading cell says enough light has reached the subject.

These units are extremely easy to use. The ease of use has begun to make the units popular in the amateur markets. On many units, you can set your f/stop, put the flash on automatic, and, ideally, the flash will give the

right amount of light for any subject within a given distance range. All the photographer has to do is focus and shoot.

Automatic readings can give problems. With exceptionally dark or light subjects, the readings shouldn't be trusted. However, for average subjects in average settings, the automatic flash units can be a pleasure to use.

Automatic flashes are also popular because of the cost. Mass production and competition have kept prices down. Prices go up in relation to the number of features on a unit. Some units allow you to choose among a number of f/stops. The light output is adjustable. Some have tilting heads. Some have focusing heads that diffuse or focus the light depending on the lens you happen to be

An automatic flash cannot do everything. The players' shoes are overexposed, while their hair is underexposed and tends to blend into the background.

ored filter kits, and units called "slave triggers" that may be mounted on a light stand and fired from the light of another flash.

A choice of flash is probably more personal a matter than most other choices you make about equipment. On a small scale, remarkable effects can be created with some very inexpensive equipment. Other very basic effects, however, can depend on the more costly units. You need to give careful consideration to the demands you are likely to make on a lighting system. The best way to do that is to understand how flash can affect your photographs.

Making Flash Work for You

Some photographers—those who shoot such things as weddings and informational

using with the unit. Some have accessories that allow you to build a rather extensive lighting system. You can get battery packs, remote light-sensing adapters, different kinds of batteries, battery-charging units, col-

In some cases, direct flash is necessary. The blur in player No. 8 is a subtle, but still undesirable, ghosting effect.

news pictures—depend heavily on basic flash techniques. At a wedding, there is usually no time to set up fancy lighting, and available light just may not be available enough. News editors may demand a certain picture, and they may not care what technique the photographer uses to get it. In these cases, subject is more important than treatment. Direct flash may be a necessity.

CONTROLLING DIRECT FLASH

When you *must* use direct flash, try the following:

• Avoid **red eye**, a problem you have probably seen in color snapshots that were taken with flash cubes. The subject is usually looking toward the camera, and the flash is very near the lens. The light from the flash reflects from the retina of the eye and gives the subject's pupils a strange, red glow. When the flash is near the lens, don't let the subjects look directly into the camera. When possible, get the flash farther from the lens.

• Keep the subject in range. You may have seen football fans fire flashcubes toward the field from the second tier of a football stadi-

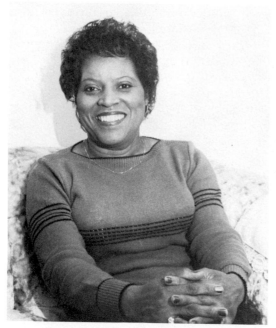

With a detachable bracket and PC cord, you can hold your flash above and to the side of a subject for better modeling. The light is still somewhat harsh, but is almost always more attractive than direct flash.

Bounce flash gives you the extra power of flash, but because the flash is bounced off the ceiling or a wall, the light is diffused and appears more natural.

um. If they get a picture, it's only because the stadium light was bright. Some flash won't reach any subjects farther than 10 to 15 feet away.

• Avoid shooting directly toward reflective surfaces. A mirror in the background can reflect the light of the flash back into the lens.

• Be careful with slower shutter speeds. As surrounding light levels approach those provided by the flash, you are more likely to get "ghost" images. The burst of the flash freezes the subject, but the subject's motion under the available light may cause a blur on the film.

• When possible, soften the effect of the flash with a handkerchief, facial tissue, or some other diffuser. A diffuser may also be helpful in reducing the power of the flash when you want to move close to the subject. If the flash isn't automatic, you must compensate for the reduced exposure any time you use a diffuser. If you haven't had a chance to run exposure tests, bracket by one or two stops.

A slightly more sophisticated use of flash means getting the flash farther away from the lens or directing it away from the subject. A detachable bracket and PC cord are common among wedding and news photographers. The **PC cord** connects the flash to the camera with the flash removed from the camera body. It allows the photographer to hold the flash above and to the side of the subject. The light, though still somewhat harsh, provides better **modeling**. It gives the subject a more three-dimensional look. When using off-camera flash, keep the subject far enough away from walls and other backgrounds to avoid large, ugly shadows.

BOUNCE FLASH

A better approach when low, light-colored ceilings or walls are available is **bounce flash**. The flash is aimed toward the ceiling or wall and reflected on the subject. With color film, make sure the tint of the walls or ceiling isn't strong enough to tint your pictures. For instance, pink walls reflect pink light.

If you're using manual flash for a bounce flash, calculate the distance from the flash to the reflective surface and then the distance from the reflective surface to the subject. Then, because the light is reflected rather than direct, open up an additional stop. Always bracket.

Some automatic flash units have tilting heads. The head of the flash may be aimed toward the ceiling while the sensor remains pointed at the subject. These units will calculate the amount of flash you need and give it to you.

Some manufacturers offer a bracket that can be fitted on the flash head and into which a reflective card may be inserted. The head is aimed up, and the card—which is angled toward the subject—reflects light onto the subject. A 3 × 5 file card may be attached to the flash head with a rubber band for a similar effect. Some brackets may tilt the entire unit. These take practice in handling.

One photographer tells of his first experience with bounce flash for slide shows. "I had done many kinds of photography before. This was the first time, though, that I needed 60 or more pictures to all work together. Many of the indoor shots were under fluorescents, so I couldn't depend on available light. I tried both direct flash and bounce. When the slides started coming back, I noticed the incredible difference between the bounce flash pictures and the ones taken with direct flash. There was nothing 'wrong' with the direct flash. The exposures were good. The pictures showed what I wanted them to. But the look was all wrong.

"The bounce flash pictures looked so much more professional. There was something about that light falling on the subjects from the ceiling. It looked natural. It looked real. It actually looked like I had taken great pains with them.

"The direct flash pictures just didn't fit in

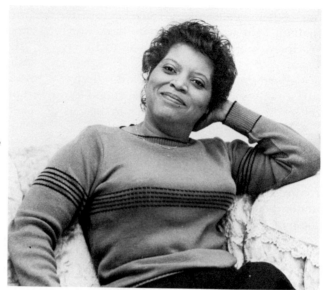

Bounce flash is quite effective with low, white ceilings.

A photo umbrella, used either as a diffuser or reflector, offers a very pleasing effect. The light is soft and even.

with some very nice location shots I'd taken. I decided then and there that I would have to limit myself to the bounce flash—and that was much easier to do than I expected."

For studio-quality effects, the flash may be used with a light stand and a **photo umbrella**. The umbrella looks like a rain umbrella. It may be white, silver, or gold fabric. The flash is often fired into the umbrella, and the subject is lit by the reflected light. The white umbrella is a translucent cloth and may also be used as a diffuser. In this case, the flash is fired through the umbrella toward the subject.

Because they reflect or diffuse the light, umbrellas reduce the amount of light reaching the subject. Generally, umbrellas are used with the more powerful on-camera kinds of flashes or with electronic flash heads specifically designed for studio use.

Despite the light reduction, umbrella lighting is also a pleasure to use. It offers effects quite close to those of the best available light. The techniques are not difficult. Because the light is diffuse, the light placement is not as critical as it is with point source lighting. The

UMBRELLA

For better lighting, a light is shone into the umbrella and reflects onto the subject. Seen from the top in this drawing: the subject, a small light shining into the umbrella, the reflection of the light from the umbrella onto the subject, and the camera aimed at the subject.

reduction of light can usually be prevented simply by using more powerful flash equipment.

If you want to experiment with umbrella techniques, you can rather easily work with white poster boards. The flash, or even incandescent light, can be bounced off a poster board. Another board may be used as a reflector to fill in shadows.

MULTIPLE-UNIT LIGHTING

In a sense, you have already been using more than one light source in your pictures. Most interiors are lit with more than a single light. Many shots, even outdoors where the sun is the main source of light, can be said to be done under multiple-unit lighting. The sun provides the main light, but reflected light also contributes. In effect, the reflected

light often amounts to a totally separate light source.

Multiple-unit lighting may be set up with several different kinds of light. You can use incandescent lights. You can use the units designed for work in the field—the manual and automatic flash units we have already discussed. You can also use studio flash units. Field and studio units differ in several ways. Field units are usually battery powered. The studio lights come with heavy power packs that are dependent on AC power. Studio flash units have an electronic flash tube, but the effect of the flash (its direction and relative intensity) is represented by a low-powered incandescent light that burns continuously. This low-powered light is called a **modeling light**. Field units don't have a modeling light.

When the flash is used as a point source of light, it is best to use a modeling light. On studio units, the modeling light is encircled by the flash tube. Both the modeling light and the flash use the same reflector, so the effects can be tightly controlled.

With the modeling light, the photographer can see what the effect of the flash will be. Essentially, the modeling light allows a preview of the flash. Also, during setup, it lets the photographer avoid the heat of the incandescent lights powerful enough and of the right color balance to shoot by.

A disadvantage of the field flash unit, especially when several are set up together, is the photographer's inability to tell exactly what the final effect will be. The problem increases when a reflector is involved. It's hard to tell what a reflector will do unless you can see the effect.

A similar problem occurs with umbrellas. With umbrellas, however, the problem can be solved. Both a field flash and an incandescent lamp can be shined into the same umbrella. Because the umbrella diffuses the flash, the flash and lamp don't have to shine into the umbrella from exactly the same point.

With a white umbrella, the light source may also be shown through the umbrella. In this case, the umbrella acts directly as a light diffuser.

The most expensive way to get into multiple-unit lighting is with studio flash. Similar effects, however, can be obtained with household light bulbs and inexpensive reflectors from hardware stores. Some of the reflectors—and these are light fixtures, not the poster boards mentioned earlier—come with spring clamps. The spring clamps may be attached to bookcase shelves and other thin things found around the home. Especially for tabletop, close-up work, you can substitute desk lamps with their reflectors for the hardware-store variety. You can also buy light sockets with clamps and use self-reflecting spotlights designed for the household or the back porch. These spotlights can be found in the lighting section of department stores.

The variety of multiple-unit setups is infinite. Two approaches will be covered now. They should give you an understanding of how multiple lights work together to create the effects you've seen in many studio pictures. The approaches are quite powerful. They are also basic. One uses several light sources and the other uses a main light and a reflector. Variations are not hard to achieve. And once you've learned these two approaches, you will find your control over light has increased immensely.

The Four Light System

Earlier you learned about the four basic lighting directions: front, side, back, and overhead. We now add one additional direction—three-quarter lighting. A three-quarter light shines on the subject from a point halfway between a front light and a sidelight. In the four-light system, all lights work together to create a unified effect. The four lights we'll be looking at are the following: the key light, fill light, rim light, and the background light.

1. The **key light** is the main light. It is generally the brightest of the four. (Remember that brightness has quite a bit to do with the light-to-subject distance. The four lights themselves may well be equal in strength.) Your light reading is based on the brightness of the key light on the subject.

The key light is often a harsh light. It usually comes from above the subject, often in the three-quarter position on the right or left side of the camera.

2. The **fill light** supplements the key light. It softens the shadows and fills them in. It lightens up the dark side of the subject. The

SAFETY REMINDERS

Electricity can kill in an instant. Read the following precautions and, if you have any questions, get the answers before using equipment or supplies with which you are unfamiliar.

- Anytime you use incandescent bulbs, remember that bulbs get hot, and they remain hot for a while even after they're turned off.
- Read the caution notices on any photo supplies and equipment you buy. Some light bulbs, for instance, are designed for special sockets. Even sockets you buy through photo outlets may have cardboard in the lining. Some of the higher wattage bulbs, though they physically fit the sockets, require special sockets with no cardboard to handle the heat of the light.
- When using more than a few household bulbs, be sure the circuits are designed to carry the power you need.
- If you blow a fuse or trip a circuit breaker, you can be pretty sure you've overloaded the circuits. Never circumvent the safety features of a fuse. Reduce the demands on the circuit before replacing a fuse or resetting a circuit breaker. If you need help replacing a fuse or resetting a breaker, get help. Don't guess.
- Use three-pronged plugs properly. If your outlets don't accept the three-pronged plugs, make absolutely sure that any adapters you use are properly grounded.
- Never handle electrical fixtures or appliances on damp floors or with wet hands.
- Use only electrical cords designed for the work you intend them to do. Never defeat safety features. Avoid running cords through traffic areas. Any cords that must run through traffic areas should be taped to the floor. Avoid cords hanging loosely from light stands.
- Make sure your light stands are sturdy and stable enough for the loads you expect to put on them. Some light stands are light-duty models and should not be used for the heavier lighting equipment. This point is important enough for your own safety, but if a light stand should topple and cause an injury, you, your parents, or your school may be legally liable.
- Be especially cautious with electrical equipment and supplies around children and pets.
- Allow equipment to cool before storing it.
- Don't shoot in an explosive atmosphere without the proper equipment.
- Don't operate electrical equipment until you are familiar with it and its hazards.
- Do not attempt to repair equipment with which you are not thoroughly familiar.

A basic key and fill lighting setup. The key light provides the main light on the subject. The fill light fills in the shadows. This is the fundamental setup on which the more elaborate four-light system is based.

KEY

FILL

RIM

BACKGROUND

KEY

FILL

This is a four-light arrangement. The key light is the main light and is usually the brightest of the four lights. The fill light fills in the shadows. The rim light shines onto the subject from behind and separates the subject from the background. The background light illuminates the background. The background light is placed low enough to be hidden from the camera's view.

fill light is almost always less bright than the key light. It never overpowers the key light. Sometimes the fill light is diffused and softer than the key light. The fill light is often placed near the three-quarter position on the side of the camera opposite the key light. In addition, it may not be placed quite as high above the subject as the key light is. The fill light frequently overlaps the key light. When it does, you need to take the light reading from the key and fill lights combined.

3. As you learned in Chapter 4, the rim light is backlighting. Its purpose is to provide a halo around the subject. The halo helps separate the subject from the background. Sometimes, the rim light is brighter than the key light.

4. The **background light** illuminates the background. It is often placed directly behind or behind and to one side of the subject. Obviously, it is aimed toward the back-

ground. It, too, should be less intense than the key light.

As you can see, the four different lights do four different things. You don't have to use all four all the time. It isn't unusual to do a job with just the key and fill lights.

Any time you work with more than one light, you should think in terms of the key-and-fill arrangement. Two key lights tend to compete with each other. They leave conflicting shadows. The effects are strange. If you're looking for a strange effect, that's one thing. Usually, you will want one light to dominate the other.

The height of the key and fill lights is important. A problem that occasionally develops is shadows on the background. Increasing the distance between subject and background is one solution. Keeping the lights above the subject is another. On the other hand, you don't want your key and fill

REFLECTOR

KEY

With a key light plus a reflector, many attractive setups can be done. The key light may be either artificial or it may be sunlight coming in a window. The chief requirement for the reflector is that it reflect light. Thus, it may be anything from a wall or a large cloth mounted on a frame to white poster board. The reflector acts as a fill light.

lights to be so high they create shadowed eye sockets and other unsightly effects on your subjects. If you lights are too high, increase the subject-to-background distance. Move the subject, the background, or both.

Whenever you work with two or more lights together, remember that you can vary the effective intensity of your light sources by adjusting light-to-subject distances. The inverse square law comes in handy when you're working with several lights of the same brightness. Once you've established light-to-subject distances mathematically, many times you simply have to recall the distances for similar effects later on.

One Light Plus a Reflector

On occasion, you may prefer a single light plus a reflector for a two-light approach. As mentioned earlier, reflectors are handy even when you're working in sunlight. In studio lighting arrangements, one light plus a reflector is a common setup. The light acts as a key light. The reflector functions as a fill light. Background or rim lights may be added as desired.

Just as with two or more lights, varying the distances between the subject and both the light and reflector can change the effects. The greater the distances, the less the light intensity.

Reflectors, even in the studio, are often homemade. They include large painted surfaces, white theatrical flats, poster boards, and other similar items. A flat surface may also be covered with crumpled aluminum foil for a slightly harder light and more reflectance. Manufacturers make a wide variety of reflectors, but their cost is usually justified only in a working studio or with regular use.

HANDHELD LIGHT METERS

Eventually many photographers find a need for one or more of the many different handheld meters on the market. Much can be done with a through-the-lens meter, but you should also be acquainted with some of the handheld versions. There are five major types of handheld meters: reflected-light meters, incident meters, spot meters, flash meters, and color meters.

Reflected-Light Meters

Reflected-light meters include the TTL meter in your camera. They take in a scene and recommend an exposure based on the overall brightness in a scene. Most are designed to show you a variety of f/stop and shutter speed combinations that will work on the scene. With a gray card, they can—in effect—read the light source itself.

Incident Meters

Incident meters read the light source itself —the light "incident" on the subject—instead of the light reflected from the subject. Inci-

155

dent meters have a translucent hemisphere covering the metering cell. From the subject's position, the meter is pointed toward the camera. Incident light readings are quite handy when you know you will have subjects of unusual brightness or darkness in the frame, and you want them to *look* bright or dark. The incident meter reads the light and not the subjects. Because the light is gathered through the hemisphere, it doesn't matter whether the light is lighting the top, side, or front of the subject.

Spot Meters

Spot meters work like a reflected-light meter, but they read only a very small portion of the scene. As long as you follow the meter's recommendation for exposure, whatever the reading is taken from will be reproduced as a medium tone. True skill with a spot meter depends on several things, among them your awareness of the range of tones your film will accept. This range of tones is probably best understood in terms of photographer Ansel Adam's "zone system."

The **zone system** is a method whereby the photographer can evaluate—and usually exactly control—the exposures obtained. The zone system divides the tonal range of a scene into ten values, or **zones**. These range from deep black to white, with eight different values in between. By taking a reading from any part of the scene and shifting exposure accordingly, the photographer can help ensure the exposure desired. Moreover, each part of the scene may be checked separately.

The system is most effective with black and white sheet film, where each sheet is developed separately for maximum control. The basics of the system, however, can be applied even to color slide film where the photographer has little or no control over development.

Flash Meters

Flash meters are designed to read elec-

tronic flash. The meter can be aimed from the subject's position toward the flash. The flash is fired, and the meter gives an incident reading. Flash meters are much more common in studio work than elsewhere. They tend to be expensive, but when several flashes are used, they give information that is quite difficult to calculate or measure any other way.

Color Meters

Color meters in their basic form are designed only for a continuous-spectrum light. Continuous-spectrum lights include sunlight and incandescents. A few meters may be used in lights with a discontinuous spectrum, such as fluorescents.

Color meters' readings suggest filtration for particular types of color films. They help the photographer select filters to correct color balance. The meter readings indicate—by color temperature—which filter will cool or warm a particular scene. The few meters that will suggest appropriate filtration for lights of a discontinuous spectrum can take two readings, one a red-blue ratio and the other a red-green ratio. Since these meters are very expensive—in the $500+ range—it is important for the moment only that you know they exist.

SUMMARY

Electronic flash has generally replaced bulbs. The flash may be manual or automatic. Electronic flash limits shutter speed. The fastest speed at which the shutter is completely open is the sync speed.

The inverse square law and the guide number formula help you calculate exposures. A guide number divided by distance gives you the f/stop to use. A guide number divided by an f/stop gives distance.

Efforts should be made to control unpleasant effects of direct flash. Use of photo umbrellas is one method. Bounce flash gives a more natural look with flash. The flash-to-

subject distance must include the full travel of the flash—from flash to ceiling plus ceiling to subject.

One multiple-unit lighting setup involves four lights: a key light, a fill light, a rim light, and a background light. The key light is the main light. The fill light fills in some of the shadows caused by the key light. The rim light provides separation of the subject from the background. The background light illuminates the background itself. With one light plus a reflector, the single light acts as a key light. The reflector provides fill light. Model-

ing lights are used to represent the effect of flash.

Handheld light meters measure light reflected from the subject or light falling on the subject. Spot meters measure a very small portion of a scene and are used for exact exposure control. Spot meters may be used with the zone system. Incident meters read the light source itself. Flash meters are designed primarily for studio work and give an incident reading. Color meters suggest the corrections needed for color balance in a scene.

Discussion Questions

1. The fastest shutter speed at which a focal plane shutter is completely open is called the _____ speed.

2. In total darkness with electronic flash, what is the effect on exposure of increasing the shutter speed from 1/60 second to 1/2 second?

3. If you double light-to-subject distance, the light level on the subject is cut to _____.

4. With a guide number of 110 and a flash-to-subject distance of 10 feet, the f/stop should be set at f/ _____.

5. The fill light should never overpower the _____ light.

6. A rim light separates the _____ from the _____.

7. What is an incident meter? How does it differ from a reflected-light meter?

8. What is a photo umbrella?

9. Name the four lights in a four-light system.

10. What is a modeling light?

Assignments

Select an appropriate subject and do *one* of the following:

1. Take a series of pictures under direct flash. Whenever possible, modify the effects of the direct flash.

2. Take a series of pictures under bounce flash. Vary the camera-to-subject distance.

3. Take a series of pictures under at least a two-light setup. Include at least one picture under a four-light setup. Experiment with different combinations of intensities.

CHAPTER 10

Close-Ups

The easiest and least expensive "oohs" and "aaahs" you'll get from your pictures may come from close-ups. Why close-ups? In the kind of pictures we're interested in making—the kind people will linger a while to look at—the close-up gives a fresh point of view. It's another way to present the subject, and the viewer gets a new look at something old.

Most collections of pictures benefit from a close-up or two. Close-ups can add to a school paper or yearbook. Even in a family album, there is room for a tight shot of a rose from the family bush. For slide shows, any title slides are more easily made if you can get in close to the artwork.

More pictures than you might expect *are* close-ups. Look at any catalog. Look at ads. Any item smaller than a dinner plate may well have been shot with close-up techniques.

You learned about micro lenses in Chapter 7. Now this chapter will present other, less expensive ways you can become involved in close-up photography.

CLOSE-UP ADAPTERS

The most elaborate equipment for close-up work costs a small fortune. Fortunately, a great deal can be done with very little. For example, in a pinch, you can use a magnifying glass. Almost as inexpensive are screw-in, **close-up adapters**. The adapters, sometimes called "lenses," screw into the front of the prime lens just as a filter does. As a matter of fact, the adapters look like filters.

Adapters come in different strengths called **diopters**. The stronger the diopter, the bigger the image and the closer you can focus.

These adapters are an inexpensive way to get into close-up work. At smaller f/stops, they are also quite effective.

Terms to Learn

adapter ring
bellows
cable release
close-up adapters
copy stand
diopters

extension ring
monopod
pan head
stop-down metering
tripod

Typical adapter sets are made in +1, +2, and either +3 or +4 diopters. The higher the number, the stronger the adapter. If you have a choice, pick the +4 over the +3 because you don't really need the +3. The adapters may be used alone or in a series of several screwed together. Therefore the +4 adapter will give you a wider range of strengths since the +1 and +2 can be used together to equal a +3. The +1, +2, and +4 combination will give you a +7, while the +1, +2, and +3 only add up to a +6. When combining several adapters, attach the stronger ones closer to the prime lens.

There is virtually no light loss with these adapters. There is a quality loss, though, that is apparent at the edges of the frame. The more adapters used together, the greater the loss, and the loss is most visible at wide apertures. But no matter how you do close-ups, the closer the lens-to-subject distance, the less the depth of field.

The aperture of the prime lens is usually stopped down for the greatest depth of field possible. When adapters are used at smaller apertures, much of their quality loss disap-

The +3 adapter with the 50 mm lens gives you a reasonably sharp close-up, especially at smaller apertures.

Combining all three adapters permits closer views. Put the strongest adapter nearest the lens.

pears. For an occasional close-up picture, especially when the picture will not be enlarged a great deal, the adapters are quite adequate.

Remember, at great magnification, any movement of the subject or camera is intensified. Outdoors under a long exposure, a light breeze will ruin a flower picture.

Three adapters plus the normal lens give you approximately half a life-size image. Added to long lenses they increase strength, and with moderate to long telephotos, larger than life-size images may be obtained.

Despite the quality loss, the adapters offer close-up work at reasonable prices. If you watch for sales and shop around, you should be able to find a set at a reasonable price.

Normal Exposures with the Adapters

As you have learned, the nearer a subject is to the lens, the less the depth of field. But light can become a problem because of the small f/stops needed. One solution is to rest the camera on a stand. Then you can slow down the shutter to make up for the smaller f/stop and avoid camera movement.

Other solutions include using fast films and more light. With fast films and strong light—sunlight or even household bulbs moved close to the subject—you may not need a support for the camera.

Longer Exposures and Larger Images

Let's say, though, that you want to take 1 second or longer exposures now and then. Or you may want to do a life-size or larger than life-size image from time to time. What then? The tripod, 2X extender, longer lenses, and some intensified light will help.

TRIPODS

A **tripod**, a stand that braces and steadies the camera for long exposures, is probably a must. For long exposures with a tripod, use a self-timer or a cable release to trip the shutter. The **cable release** attaches to the shutter button and allows you to trip the shutter for an exposure without touching the camera.

EXTENDERS AND LONGER LENSES

If you are using a 50 mm lens, the 2X extender is a great help. The 2X extender

With a 2X extender between camera and lens, magnification is doubled. This picture was taken with the 2X and three adapters. As you can see, it is no longer possible to get a whole stamp in the frame.

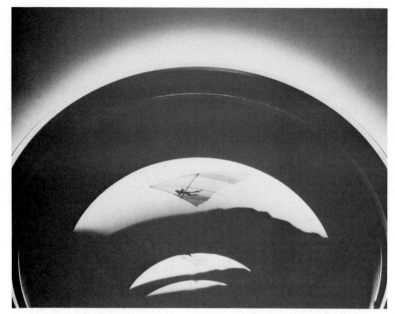

An adapter ring fits between the camera and the lens. The lens is screwed, backside out, into the ring. This enlargement is of the photograph on the cover.

doubles magnification. If you have an extender, use it whenever you're using adapters. It may allow you to avoid combinations of adapters or it may let you use a weaker adapter. In both instances, quality loss in the image will be reduced. Longer lenses may be substituted for a 50-mm-plus-2X-extender combination.

INTENSIFIED LIGHT

Some beautiful work has been done with window light and a reflector. Poster board or some other light-colored, reflective surface is placed close to the subject but outside the frame and opposite the window. Remember the key-plus-fill light combinations from the last chapter.

If you need more light, you can get 150W reflector floods from a department store. These can be obtained with bases that fit standard, household sockets. Desk lamps and other adjustable lamps allow you to create studio effects on the kitchen table.

Black and white film will let you light your subject with household bulbs. For slides, use tungsten film and blue photo floods. Blue photo floods get very hot, so watch your fingers and hair. Also, especially with color film, check your data sheet and compensate for reciprocity failure.

Electronic flash is another possibility, but with automatic flash you must check the instructions for the minimum flash-to-subject distance. Many automatic units won't function predictably at close distances, and some require a special sensor for close-ups. Manual settings may be necessary. Also, to be able to use the best f/stop, you may have to add a PC cord and get the flash unit farther from the camera.

ADAPTER RINGS

Approximately life-size images may be had with a normal lens and an inexpensive device called an **adapter ring**. The ring attaches to the camera just as a lens does. The lens is then screwed, backside out, into the ring. In short, the ring allows you to reverse the lens, to put the back lens element to the outside. It is like looking backwards through a pair of

binoculars. A larger than life-size image may be obtained with the ring and a wide angle lens.

The adapter ring and a lens provide better image quality than close-up adapters. You do, however, have to use stop-down metering—a technique that will be discussed later in this chapter. In addition, you don't have much control over image size. A single plane is in focus, and you're generally lucky if the subject happens to fit the frame. On the other hand, the ring is quite inexpensive. You should easily be able to find one for under $10. Certain small subjects fit the formats obtainable with these rings quite well.

EXTENSION RINGS

Extension rings fit between the camera and the lens giving more distance between lens and film. When the lens is moved away from the film, magnification is increased.

However, as the camera lens is moved away from the film, the light reaching the film is reduced, so exposures have to be increased. This exposure increase is in addition to increases needed for the small f/stops that give greater depth of field. With TTL metering, the camera's meter will often show the amount of increase necessary. Since the reading is taken from behind the lens, the meter is not affected by the greater lens-to-film distance. When, however, the photographer uses a handheld meter, significant changes are needed. Images two and three times life-size may require exposure increases of two and three stops beyond what the meter says is necessary.

Adjustments are also necessary when flash units and guide numbers are involved. Unless you have a flash unit designed for automatic use at close range—a dedicated flash—you will have to make the adjustments yourself. Especially with the smaller automatic units, many photographers prefer to put the flash unit on the manual setting. Adjustments using the guide numbers allow more control than relying on the flash sensor.

Extension rings are available in several sizes. Some allow the lens to be coupled with the camera's metering system. As with the adapters, the rings may be combined for various strengths.

Images two and three times life-size may require exposure increases. This is a small section of the stamp you saw earlier in this chapter. Even at f/16, depth of field is minimal. The object in the upper left is a pencil point. It is out of focus because the pencil is closer to the lens than the stamp.

With a bellows between camera and lens, metering must be done with the lens stopped down to the working aperture.

The TTL meter indicates proper exposure when the correct f/stop is reached. An advantage of stop-down metering is that you don't have to use the depth-of-field preview button to check your depth of field. The depth-of-field changes are visible in the viewfinder as you open and close the aperture.

CLOSE-UP COPYING

Some photographers are interested in close-up techniques for copying documents, artwork, or slides. Documents and artwork are most easily done on a copy stand. A **copy stand** has a device for mounting the camera at various heights above the work. It may also have its own ready-made lighting system. Often, four lights are mounted on brackets and aimed at the baseboard on which the work to be copied is placed.

Slide copying can be done under a variety of setups. The simplest involves using a bellows with a frosted plastic or glass mounting device in front of the lens. The slide is placed between the frosted material and the lens and the whole unit is aimed at a window or the sky. The window or sky provides the light source. The same set up may also be used with an electronic flash as the light source.

More elaborate units have their own built-in light source. Many times, the light source has a filter system so that colors may be adjusted. The light source itself may be either electronic flash or tungsten. Because of the short flash duration, the electronic flash units may demand special films and adjustments for reciprocity failure. With tungsten units,

BELLOWS

For serious close-up work, a bellows may be desirable. The **bellows** fits between camera and lens and is built like an accordian so it can be compressed and lengthened. Extension rings are of a fixed length. To significantly change the lens-to-film distance with them, you must change rings or combinations of rings. The bellows itself is adjustable. Some bellows units allow tilts and swings of the lens for fine focus. This makes them more expensive.

Because the lens-to-camera distance changes, a bellows cannot usually be connected to the camera's metering system. However, the TTL meter can be used with what is known as **stop-down metering**. Stop-down metering involves taking your light measurements with the aperture stopped down. You make focusing adjustments with the aperture wide open. This obtains the most accurate focus. Then, to take the light reading, you close down the aperture, and the viewfinder grows darker.

As the name implies, a tripod is a three-legged stand. It supports the camera with a steadiness far beyond the ability of human hands.

Some tripods have a reversible center post. The reversible post is useful both for copy work and for low-angle pictures.

reciprocity failure isn't a problem, but a special slide-copying film is advisable. Increased contrast is a feature of any picture copying, so measures have to be taken to avoid unpleasant contrast buildup in the copy. Most of the slide-copying units with their own light sources allow you to enlarge portions of a slide and to add special effects for slide shows.

Close-ups any larger than 20 to 35 times life-size, such as laboratory photos, are more conveniently done under a microscope with a camera attached than with the techniques just described.

TRIPODS

Although the use of tripods is not limited to close-ups, they are often needed for close work to hold the camera steady. Tripods can be adjusted several different ways, some of which you might like to be aware.

A tripod, as the name implies, is a three-legged stand. The camera is mounted on top. Usually the legs will fold for carrying, and there is an upright, center post that may be adjusted higher or lower for different shooting levels.

Some tripods have a reversible center post. With the post reversed, the camera hangs beneath the legs for low-level shooting. Such an adjustment can be useful for close-up work. Many tripods have a **pan head**. The head may be unlocked and the camera swung horizontally to follow a moving subject. Some tripods are built so the legs may be spread at

165

Adequate close-ups may be obtained with relatively inexpensive equipment.

a wider than usual angle. The camera may thus be lowered nearer to the ground or floor, and the extra spread of the legs provides increased support.

Tripods should be sturdy enough for your heaviest equipment. It helps if they open and fold easily and if they lock securely into place at any level you wish.

As you may have already gathered, too heavy a tripod may be almost as bad as no tripod at all. When the tripod is too heavy to carry easily, some photographers tend to leave it behind. You need enough support for your equipment and no more. Fully extended, it must do what it has to do. Beyond that, it should be light enough that you're willing to take it with you. It is good to test a tripod before buying.

Costs range from fairly inexpensive to expensive. Good sturdy tripods are available at a reasonable price. If you can find a used one at a better price, check it to make sure it does what you want, and buy it if it does. A tripod is one item of equipment that you can test yourself, and sales and used versions can often save you money.

Miniature tripods can be useful for tabletop and close-up work. They can also be handy for low-level shooting. A variation of the tripod is the **monopod** (also known as a unipod). These have a single—usually telescoping—leg, and they are often used by sports photographers when a three-legged stand would be too cumbersome.

SUMMARY

For general work, close-up adapters and a 2X extender, used with a tripod, may be all you need for close-ups. The adapters come in several strengths, and the more powerful ones should be used closer to the prime lens.

Other close-up equipment includes lens-reversing adapter rings, extension rings, bellows, and tripods.

Tripods provide steady support for cameras. Special features include reversible center posts, pan heads, and legs that spread to wider than usual angles.

Adapter rings allow the lens to be reversed and give better image quality than adapters. Extension rings and bellows fit between the lens and the film. A bellows requires stop-down metering.

Slide and document copying is done on a copy stand. Some stands have their own light units.

Discussion Questions

1. What does a cable release do?

2. What safety hazard is caused by blue photo floodlights?

3. What are the different strengths of adapters called?

4. What are the disadvantages of using an adapter?

5. How is an adapter ring attached to the camera and lens?

6. How are extension rings and bellows alike? How are they different?

7. Explain stop-down metering.

8. What is a copy stand?

9. Why are tripods often needed for close-ups?

10. On a tripod, what is a pan head?

11. What points should you consider when buying a tripod?

Assignments

Select an appropriate subject and shoot a series of pictures that include one of the following:

1. A close-up.

2. A tripod shot.

Try to set up the assignment so that the close-up or tripod shot challenges your equipment and ability.

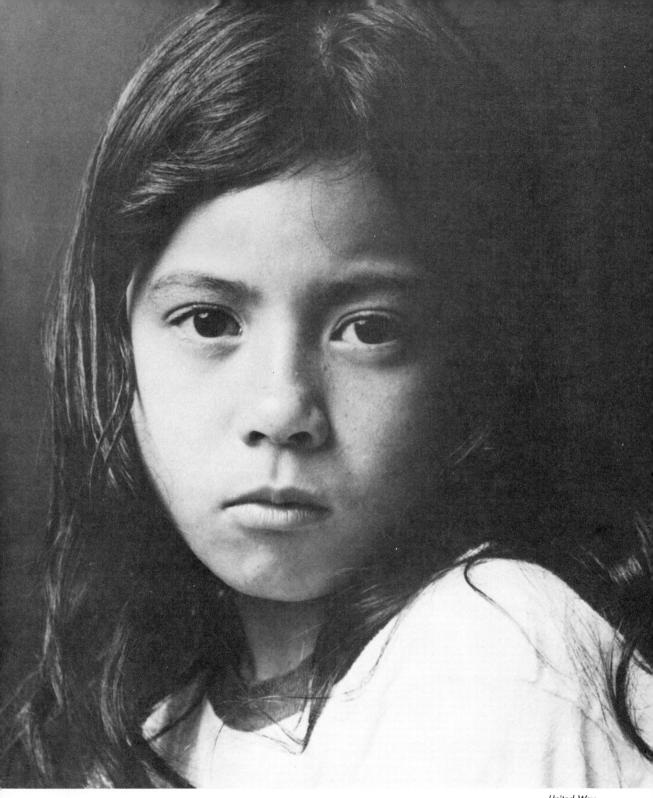

CHAPTER 11

Film Processing

Many photographers choose not to do their own processing—and they can cite several reasons. Some professional photographers work on too tight a schedule. They just don't have the time. For example, in order to meet a deadline, a photojournalist working in the field may ship film by air to an agency for processing and printing. Some photographers don't want the responsibility. When photographers who do their own processing choose to print one negative over another, they become their own picture critics—and critics who are not photographers sometimes argue that photographers are not the best judges of their own work. Quality control and efficiency are also factors. In many instances, photographers can spend their time more profitably shooting rather than working in the darkroom.

On the other hand, there are things to be said for photographers having at least some processing experience. Many picture problems can be traced to the darkroom. It's best if you know—from practical experience—just what can be done in a darkroom and what can't. Then, when you have to call on a lab, you will know exactly what you can expect and demand. Also, some photographers need their own darkrooms to meet deadlines. Others need them to cut costs. Whenever a photographer has more time than money to spend, darkrooms can generally be made to pay for themselves. There is also the question of quality prints. Most photographers enjoy squeezing the last bit of quality from their own negatives, and custom prints from a lab can be quite expensive.

BEFORE YOU BEGIN

This chapter covers the setup and use of a film-processing operation. It includes the variety of choices you have and a discussion of what those choices mean to you. The essentials are not complicated. They can be—and have been—printed in less than 2 inches of space inside a film box.

Film may be processed in many, many different ways and with many different chemicals. This chapter will discuss the basics of black and white film processing. Color work is similar and only a bit more exacting. Black and white film processing requires temperature control within a few degrees Fahrenheit. Color processing requires control within half a degree and involves a few more steps.

But before we get into details, first a word about how processing works. When light enters your camera at the time you take a picture, it alters some of the silver bromide crystals in the film emulsion layer. This change is not visible. During processing, the **developer** (developing solution) changes the

Terms to Learn

developer
developing tank
fixer
hypo
hypo clearing agent
stock solution
stop bath
wetting agent

opaque or "dark." Where light didn't hit the film, the film is clear. The film is then "fixed," so it will no longer be light sensitive, and washed to remove all traces of solution.

During processing, timing and temperatures are important. Working patiently and cleanly is a necessity.

The processing operation may be broken into several major jobs, which will be covered in this chapter. Not all of the jobs are necessary each time you process film. For example, once you have obtained the basic equipment, all you need do is check your supply of chemicals and perhaps occasionally add a new piece of equipment. If you have sufficient stock solutions mixed and stored, you don't have to mix chemicals every time. The remaining steps become almost automatic once you've been through them a few times.

THE DARKROOM

The layout of any darkroom should allow for a "wet" side and a "dry" side. Processing solutions that are essential for certain steps

altered silver bromide crystals into areas of varying degrees of opacity. A **stop bath** is used to stop the effects of the developer. The **fixer**, or **hypo**, clears the areas of the film not exposed to light. As a result, where the light hit the film, the film is now more or less

Mentally divide your darkroom into a wet side and a dry side. The dry side is for any darkroom task that would be hurt by moisture—loading film, storage, etc. The wet side is for the actual processing. You may put the dividing line anywhere that is practical for you. The idea is just to protect your film, dry chemicals, and equipment from the contamination of moisture and liquid chemicals.

DEVELOPER

STOP

FIXER

Processing film involves three stages: the developer, which changes the silver bromide crystals into varying degrees of opacity; the stop bath, which stops the action of the developer; and the fixer, which fixes the changes and makes the film insensitive to further exposure to light.

SAFETY REMINDERS

Darkrooms, whether for film developing or printing or both, have their own safety requirements. Again, darkness itself can create problems.

- Make sure pathways are clear of obstacles.
- Keep floors dry, both to avoid slipping and because you will sometimes be working with electrical equipment.
- Keep electrical equipment on the dry side of the darkroom and handle it only with dry hands. Towels are a must.
- The well-designed darkroom is well-ventilated. If you must work in a darkroom with marginal ventilation, open the door occasionally for fresh air. If strong chemicals should spill, get out of the darkroom until the air clears.
- Avoid glass containers in the darkroom.
- *Always* read caution labels on chemical and equipment packaging.
- Avoid creating dust when handling dry chemicals; avoid breathing any dust that you do create.
- If you have allergies, check with your physician before handling photographic chemicals.
- Whether you have known allergies or not, avoid immersing your hands in chemicals. Though this caution appplies primarily to print processing, you not only risk contamination of the chemicals, but rashes sometimes develop in people who have handled photo chemicals with unprotected hands.
- Take note of which chemicals may react unfavorably with others. Mixed chemicals can sometimes have surprising reactions ranging from smoke to explosions.
- Be particularly careful with glacial acetic acid, which is used for the stop bath. Like all acids it can be dangerous. Always pour acid into water. Water should not be poured into acid because it can cause the mixture to bubble and spatter, possibly resulting in acid burns on your hands and face. Besides being corrosive, glacial acetic acid is very pungent. (You should be aware of the technique for smelling strong chemicals: Hold the open bottle in your left hand away from your face. Gently wave your right hand across the bottle opening and sniff the aroma that will move toward you. Never stick your nose over a bottle opening and inhale.)
- Dispose of chemicals properly. (Silver can be recovered from used fixer and you may be able to find a commercial lab interested in the recovery.)
- Take note of manufacturers' recommendations of the action you should take if an accident occurs.
- Keep chemicals out of the reach of children and pets.

must not be allowed to contaminate others. Effective darkroom setups can be put temporarily in kitchens, bathrooms, and even motel rooms. Some of the pictures in this book were shot, processed, and printed in a kitchen.

Keep in mind, though, that what may suffice for an occasional job could prove totally unacceptable for frequent work. Space for working and the lab person's comfort become very significant in a regularly used darkroom. The availability of water is important. And there are other concerns. Can the temperature be regulated? Is there adequate sink space for film and print washing? What about the heating and cooling of processing solutions? Is there proper ventilation? What

Film developers come in powders and liquids. It's usually more economical to buy the largest package that you will use over the two to six months' life of a mixed developer.

about the disposal of chemicals? Over a period of time, undiluted photographic chemicals can destroy plumbing. Be sure you have considered all these factors before you begin.

CHEMICALS AND EQUIPMENT

It is probably a good idea to make a copy of the following list, leaving yourself room to make a few notes. Before shopping you should go through the list. Note what you have and see what else you need to get.

The chemicals you need for processing may include the following.
- Developer
- Stop bath (possibly optional)
- Fixer
- Hypo clearing agent (optional)
- Wetting agent (optional)

You should also have the following equipment and other supplies. (Use substitutes when necessary.)
- Instructions for mixing and using chemicals
- Bucket for mixing chemicals
- Towels
- Stirring paddle
- Photographic thermometer
- Graduated beakers
- Funnel
- Storage bottles for chemicals
- Developing tank and reel
- Changing bag (if darkroom or closet is unavailable)
- Bottle opener
- Scissors (possibly optional)
- Timer
- Clothespins or clips
- Film drying device (could be wire clothes hanger)
- Sponge or film tissues (possibly optional)
- Soft brush and/or compressed air
- Film storage containers
- Record book (possibly optional)

Developer

Using a general-purpose developer for your first rolls of film will give you a good basis for comparison should you later decide to try fine-grain developing or push-processing. The first time you process film,

172

you may want to select a single brand of chemicals. You may also want to choose the same brand as that of the film you used. With Kodak's Tri-X or Plus-X, for instance, Kodak's D-76 may be a good choice for a film developer.

Stop Bath

There are several stop baths on the market. Glacial acetic acid is one and will be satisfactory. It should be mixed according to directions. If you really must cut costs, a diluted form of fixer will also work as a stop bath, or you may use a water bath instead. However, for more than occasional processing, a stop bath is best.

Fixer

The fixer may be either slow or fast acting. For convenience, especially if you will be processing many rolls of film, a fast-acting fixer is nice. The fast-acting fixers, which often have the word "rapid" in the brand name, are a bit more expensive than slower ones. Although overfixing is more destructive to printing papers, neither film nor paper should be overfixed. Some photographers use a fast-acting fixer for films and the slower ones for papers. If you are processing only a few rolls, the slower fixer may be used for both film and paper.

Hypo Clearing Agent

Until it is washed, a developed film retains fixer that must be removed before the film is stored. Any fixer left on the film shortens the life of the negative. Normal washing times are generally given as between 20 minutes and 1 hour. A **hypo clearing agent** greatly reduces the necessary washing times. It can cut wash time to as little as 5 minutes. After fixing, the film is given a 30 second rinse with water, immersed and agitated in the clearing agent for 1 or 2 minutes, and then washed.

Fixers for film also come in either a liquid or powder form. Kodak Rapid Fixer is a fast-acting, liquid fixer. The powder form, which is slower and usually less expensive, may be used both for films and printing papers. Fixers are acids, so handle with care.

For mixing chemicals, the following items are useful: a funnel for easy pouring of chemicals into storage bottles, a stirring paddle to ensure complete mixing, and a measuring container. You will also need access to a photo thermometer to check required temperatures.

Wetting Agent

After washing, film must be either wiped dry with a viscose sponge or photo tissues or immersed in a working solution of wetting agent. A **wetting agent** breaks down the surface tension of the water that remains on washed film so the water won't leave spots. The working solution must be mixed properly or it can cause water spots.

Equipment for Handling Chemicals

Choose your containers carefully for the darkroom. Glass containers can break. Plastic containers made for the darkroom are better to use than plastic ones made for other purposes. If you use containers other than those designed for photographic use, make certain they are thoroughly cleaned and watch for any chemical reactions. Wash used containers twice with soapy water, then rinse three or four times. Light can affect the shelf life of some chemicals, so dark bottles are preferable to clear ones.

For mixing gallon-size quantities of chemicals, it helps to have a wide-mouthed mixing container, such as a plastic bucket. Some people mix their chemicals in the containers in which they plan to store their stock solutions. A **stock solution** is the mixture of chemicals minus the water that is added when the chemicals are used. Stirring paddles, used to make sure the chemicals are properly dissolved, are handy. Any plastic or glass rod will do.

Because chemical temperatures are important, a reliable photographic thermometer is a good investment. For color work, accuracy is crucial.

You will also need containers that allow you to measure various solutions. You'll be measuring at two different times: when you mix the chemicals and when you measure them before actual processing. Graduated beakers are useful. If you trust glass in your darkroom, you may be able to find what you need in your kitchen. Containers for measuring can be nothing more than glass jars. A simple trick: Take your developing tank and pour in water equal to the amount of chemical it holds. Pour the water from the tank into the glass jar. With a piece of masking tape, mark

the level of the water. Later, when you're measuring chemicals, simply pour the chemical into the jar up to the masking-tape mark.

Other household containers may also be used for measuring. Be sure they are graduated for the quantities you need. Also be sure that any containers you use are thoroughly cleaned when you're finished with them and before they are returned to household use. Ideally, any containers you adopt for darkroom work should remain in the darkroom.

A funnel may not be essential if your storage containers have wide mouths, but a funnel is usually handy to have around. Substitutes for funnels may be made from the tops of small-mouthed, plastic bottles. Cut the bottle in half and the inverted top becomes a funnel.

Storage bottles for chemicals may be bought from photo stores or obtained from a variety of sources. For safety's sake, plastic is usually preferable, especially for gallon sizes. Free developer bottles may sometimes be obtained from newspaper engraving rooms

and print shops. Plastic milk bottles may serve if they are stored in the dark. Thoroughly clean any used bottles. If you buy equipment, consider collapsible bottles in which air doesn't collect. Oxygen is destructive to chemicals, especially developers. A full bottle of developer may last six months; a half-full bottle containing trapped air, two months.

Equipment for Handling Film

The container in which the solutions and roll of film are held is called a **developing tank**. A reel onto which the film is wound fits inside the tank. There are several choices of tanks and reels. If you expect to be doing much film processing, it is worthwhile to consider a tank and reel of stainless steel. Though more costly and more difficult to use at first, the stainless steel tanks and reels last longer. In the long run, they are faster and less likely to cause problems.

Light-tight tanks may be used in daylight. They do, however, have to be loaded with

The item that looks like a shirt without a neck is a changing bag. The changing bag is light-tight and permits film processing just about anywhere. To use a changing bag, load it through the zippered opening with the equipment shown. Your arms go into the sleeves so you can work inside the bag. Clockwise from the lower left corner, items needed are scissors to trim the leader off the film; the film cassette; tank; baffled lid with cap; can opener; and, in the center, a spiral, stainless steel reel.

film in the dark. They can be loaded in a changing bag, which keeps out the light, or in a totally dark room or closet. Before using a darkened room or closet, check for light leaks. If the sole source of leaking light is a crack under the door, cover the crack with a bath towel.

You will need a bottle opener for opening film cassettes, and scissors for trimming the film before it is loaded onto a reel. The best scissors for the changing bag are the kind with rounded points children in elementary school use. Sharp-pointed scissors can damage the bag.

The timer can be the most costly item for film processing. In photo stores, you will usually see two different kinds of timers—those that may be set for a maximum of 60 seconds and those that may be set for 60 minutes. The latter is designed for film processing, the former for enlarging. Film processing usually takes well over a minute—8 to 12 minutes is about average. While a timer for processing can usually be used for enlarging, the reverse is not generally true.

What should you do for your first timer? If you expect to do much processing, consider a good one. In black and white work, the timer is more important for film processing than for enlarging. In a pinch, three substitutes are possible.

1. With daylight tanks, use a wristwatch that indicates seconds as well as minutes. However, a watch is awkward to use. The first time you process, you should probably begin at a 5-minute mark and write down your finishing time so you won't forget it.

2. Use a kitchen timer. The chief disadvantage of most kitchen timers is that seconds can only be estimated. For longer processing times—over 6 or 8 minutes—the seconds are not quite as critical. The kitchen timer, too, is usually only workable with daylight tanks.

3. Use a tape recorder. Make a tape of yourself counting off the minutes in 15-second increments. Name the minutes and seconds as they pass: "15, 30 . . . 3:15, 3:30," etc. Record 15 minutes of tape. After the tape is made, check it for accuracy. A tape recording may be used both in the darkroom and with daylight tanks. Be sure it is fully rewound before you begin processing. Timing of the stop bath is not as critical as the timing of other solutions, so the tape can be rewound when you begin the stop bath. Then it can be used again for timing the fixer.

Film should be hung to dry. Any dust-free arrangement, with the film held so it doesn't curl, is acceptable. To prevent curl, the film can be clipped top and bottom. Support for the film can be as simple as a clothes hanger hung over a door frame. Many photogra-

Kitchen timers can be used for film processing with daylight tanks. The best choices are those that accurately time both minutes and seconds.

Filing your negatives does not have to be complicated or, for that matter, even time-consuming. The best records are easy to keep up, and they allow you to find the negative you want when you want it. Take a standard school notebook and a negative sleeve (shown to the right of the notebook). Mark a roll number on the sleeve and mark the same number in the margin of a notebook page. Next to the number, describe the subjects found on the roll of film. Most rolls can be described in three to eight lines.

phers wipe off excess moisture with photo tissues or a soft chamois or sponges. Care must be taken that the film is not scratched when wiped.

A soft brush and/or compressed air is often used to clean the dust off a strip of negatives after they are dry and before they are enlarged. It is best to store negatives in as dust free a way as possible.

Equipment for Storage

Your film storage and record keeping do not have to be complex. At the same time, most photographers should keep records from even their first rolls of film.

Record keeping and storage for your first hundred or so rolls can be quite simple. Most photo stores sell glassine storage envelopes that will hold a roll of film after it is cut into strips of six negatives each. Those work best. In humid climates, plastic sleeves can present problems with sticking. Mailing envelopes, because of their composition, can adversely affect negatives over long periods of storage.

Full rolls of film, uncut, may also be stored in their original containers. The film, however, should be rolled emulsion side out (dull side out) to prevent curling. Number the rolls or their containers starting with 1. Then in a spiral notebook, record the numbers, dates, and locations for each roll.

MIXING CHEMICALS

Mixing is relatively simple. However, nothing is quite so frustrating as being in the middle of mixing or processing and finding that you're missing a chemical or a necessary piece of equipment. Before you process your first rolls, mentally review the whole process. Make sure you have all chemicals and tools in the proper place—in order and ready to use. If your processing will be done in a darkroom, make sure you can find everything by touch. It doesn't hurt, even after you're experienced, to use a checklist to be sure you have everything.

The main point to remember when handling the chemicals is that developers and fixers should be kept separate. One kills the action of the other. The best practice is to not

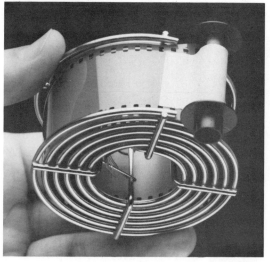

For daylight-tank processing, film is loaded onto the spiral reel. The reel is designed so the surface of the film touches nothing but the liquid chemicals during processing. A 20-exposure roll, when loaded, looks the way you see it in the picture. Note, at the top of the reel, how the ends of the two wires point to the right. When you're loading a roll of film, keep the film in your right hand and the reel in your left. Feel the reel so that you know the wire ends point in the direction shown in the picture. The next two photos show how to wind the film on the reel.

use the same container for both. The action of fixers on developers is more destructive than developers on fixers. Thus, if you must mix a developer and a fixer in the same bucket, start with the developer first. Before you mix anything, the bucket should be washed with soapy water to remove any remaining acids from earlier use. If the fixer is to be mixed in the same container after the developer, again wash the bucket. Then neu-

tralize any remaining developer with a cupful of water and a capful of glacial acetic acid.

When mixing, follow directions. Watch temperatures. Mix thoroughly as directed. Any black and white film you buy should have instructions for processing included. Mixing instructions for the chemicals should also be printed on the package or bottle label. If instructions are limited or missing, consult a darkroom guide or the manufacturer for supplemental information.

LOADING THE FILM

Loading film is usually the most troublesome step for beginners, probably because it must be done in complete darkness. Nothing in the darkroom creates quite the same feel-

To load the film, squeeze it gently so it curls, and insert it into the opening in the center of the reel. Keep the thumb and forefinger of your right hand in contact with the reel, and slide the film into place. Your left hand guides your aim.

Keeping the thumb and forefinger of your right hand in contact with the reel, rotate the reel with your left hand.

ing of panic as a roll of film that refuses to fit on the film reel. It is best to practice in the light with an old, unwanted roll of film until you know the kinds of problems you're likely to encounter. Learn to solve the problems. Then practice in the dark. If possible, have an experienced partner with you the first time in the darkroom.

1. Before you start, give yourself plenty of time and make sure you have film, tank, tank top, reel, scissors, and bottle opener handy. If you're using a changing bag, put all those things in the bag.

2. In the dark, hold the film cassette nipple end down, just as it is positioned in the camera.

3. Remove the flat end with the bottle opener. Of course, with reloadable cassettes, don't use a bottle opener. If the top unscrews, unscrew it. If the top is a pop-off kind, rap the bottom of the cassette on a hard surface. The top will pop off.

4. Remove the film spool from the cassette and trim the leader off the roll.

5. Feed the film onto the spiral reel, holding the film only by the edges. Cut the spool off the end of the roll and shut the film and reel in the tank. A scissors should probably be used with your first rolls of film. However, some people simply tear off the leader and the spool at the end of the roll. That means one less tool to worry about.

6. If you are using a daylight tank, you can turn on the lights once the film is loaded and the tank is tightly closed.

Once you've begun loading the exposed, unprocessed film rolls, refuse to panic. Don't be afraid to trim the end of a roll if it becomes crimped. If you have to, flip the film end for end and load the tail-end first. Finally, if you must, go ahead and process an improperly loaded roll. Most of the frames will probably come out. Only the film touching other parts of the roll will be ruined, and it is better to lose a partial roll than to give up completely and lose everything.

PROCESSING

Before you begin processing, be sure you have read the recommendations for processing included in your film package.

1. Mix working solutions of the chemicals. Check the temperature of each chemical and compare to the temperature chart. If temperatures are not within the necessary range, correct them by partially immersing the container in a heating or cooling water bath. This may be done in a sink or tub.

2. Check your time and temperature chart. Set the necessary time for developing on the timer. Do not start the timer yet.

3. Carefully pour the developer into the developing tank and immediately start the

Once the film and chemicals are in the tank, regular agitation is required. Agitation with tanks and reels is simply a matter of inverting the tank. If, for instance, the chemical you're using requires agitation for five seconds every half minute, flip the tank upside down and back three times during the five seconds.

timer. Daylight tanks have a lid that is light tight so the tanks can be filled and emptied in light.

4. Gently tap the tank on a hard surface to dislodge any air bubbles and shake it gently.

5. Agitate at recommended intervals.

6. During the last 10 seconds of development time, pour out the developer.

7. Pour in the stop bath. If you're using a timer, reset it to the recommended time—usually from 30 seconds to 1 minute. Start the timer. Tap the tank and agitate.

8. During the last 10 seconds for the stop bath, pour out the stop bath and reset the timer for the minimum recommended fixing time.

9. Pour in the fixer. Start the timer. Tap the tank and agitate at recommended intervals.

10. When the timer goes off, pour out the fixer. Although overfixing can damage film, fixing times are usually given as a range (e.g., 2 to 4 minutes for a fast-acting fixer) rather than as a specific time. Anything within the range is usually safe. If the fixer has been

used before, leave the film in for the longer times suggested.

11. Once fixing is complete, the film may be exposed to light. Pour out the fixer. The remaining steps may be performed in daylight.

12. If you're using hypo clearing agent, this is the time. Use as directed.

13. Wash the film for the recommended time.

14. If you're using wetting agent, use it now, as directed.

15. Wipe the film and hang it in a dust-free place to dry.

DRYING FILM

Dust is the most common enemy of negatives. Professional labs use drying cabinets that cut down on stray dust flecks. The drying cabinets have several features in common. You might like to take note of them in the event you ever want to build your own.

Drying cabinets usually have a fan and heating element to speed drying. They also have an air-intake filter, often at the bottom between the heating element and the space

The simplest film-drying method takes a coat hanger and either film clips or clothespins. The hanger may be hung on a shower curtain rod. Don't, however, try to dry film in dusty locations.

where the film is hung. The drying space is tall and has film clips at the top. The top has an opening to allow rising, warm air to escape.

STORAGE

Equipment storage varies from photographer to photographer. Generally, darkrooms are never big enough. Review the space you have available, and do the best you can to make good use of it.

In glassine envelopes, many rolls of film may be stored in a cut-down shoe box. Number the envelopes and then describe each in your record-keeping notebook. Some rolls will require only one or two lines of description. Others will take more. Note the frame numbers of pictures you're likely to print more than once.

As is, such a system will work for your first hundred rolls or so. The notebook can be quickly scanned for the numbers of any negatives you need. As long as the negatives are stored in order in a single place, they will be easy to find. As your collection grows, supplement the system with 3 × 5 filing cards. List and cross-reference subjects and locations. If your card file is kept primarily for negatives you're likely to reprint, it will be easy to maintain.

You may also want to keep contact sheets (negative-sized prints on one sheet) for each of the rolls you take. The contact sheets are in themselves good records of subjects shot. When they are numbered and stored together, they aid your record-keeping system.

Film and chemicals should be stored in a cool, dry, dark place. *Chemicals should be stored out of the reach of pets and children.*

Chemicals should be stored out of reach of children and pets, preferably at eye-level where you can reach them easily.

All equipment should be thoroughly cleaned after each processing session. This goes for darkrooms, too. All splashes and spills should be taken care of immediately. Photographic chemicals are harsh and destructive, and spills should not be left untended. Equipment should be stored in as dust-free a place as possible.

SUMMARY

The film is usually put through at least three solutions: developer, stop bath, and fixer. The film is then washed and dried. Oftentimes, a hypo clearing agent and wetting agent are used to aid washing and drying. Times, temperatures, and cleanliness are important in film processing.

Containers and work space should be chosen carefully. Both must allow ease of use. Containers used for both developer and fixer must be thoroughly cleaned to prevent contaminating the solutions.

Film should be carefully stored and accurate records kept. *Chemicals must be stored in a safe place away from children and pets.*

Discussion Questions

1. What does developer do to the exposed film?

2. What three basic solutions are used in film processing?

3. What two additional solutions are sometimes used to aid washing and drying?

4. What does fixer do to the exposed film?

5. What things should you consider when setting up darkroom space?

6. Why must film be washed?

7. What is a stock solution?

8. If you plan to mix a developer and a fixer in the same bucket, which should be mixed first?

9. What is a developing tank and reel?

10. How should negatives be stored?

Assignment

1. Process and store a roll of black and white film.

CHAPTER 12

Printing

Printing a picture is often the last step in the photographic process. Once you've made your first print, much of the mystery is gone, but not the excitement. Making the most of your pictures is always fun.

In some ways, printing is easier than film processing. For one thing, you don't have the pressure. If you make a mistake when you're processing film, you may totally ruin a picture. If you make a mistake while printing, you can just make another print. With printing you also have more control over the results. And black and white printing may be done under safelights, so you can see the results as they develop.

In this chapter we will look at two kinds of black and white printing—enlarging and contact printing—and the basic tools and techniques needed for black and white pictures.

HOW PRINTING WORKS

Printing is the process of transferring an image from a negative onto light-sensitive paper. On a negative, dark areas in a scene appear light. Bright areas appear dark. When the negative is printed, the dark areas in the negative prevent the light from reaching the light-sensitive paper and the paper remains light. Light passes through the clear areas of the negative so that on the paper the clear areas will become dark. Because the print reproduces the lights and darks of the original scene, it is called a "positive."

A wide range of tones are captured by a negative. One of the prime goals of printing is to reproduce, as closely as possible, a similar range of tones on the paper. Generally, you will be trying to get whites white, blacks black, and the necessary gradation of tones in between.

Printing papers must be properly exposed to light to yield the best range of tones. As you begin printing, it is very important to realize that the effects of over- and underexposure will be the reverse of what you might expect. An overexposed print is dark. An underexposed print is too light.

After its exposure to light, the printing paper goes through a series of solutions similar to those for film processing: developer, stop bath, and fixer.

Full development is essential. Prints should not be "pulled" from the developer before the development time is up just because they are over-exposed and coming up dark. "Pulled" prints tend to have a muddy look. When a print is overexposed—or underexposed for that matter—make another print. Especially in the beginning, you should use test strips to establish proper exposure.

Terms to Learn

burning-in
contact printing
contact sheet
cropping
developing trays
dodging
easel

enlarger
grain magnifier
paper safe
polycontrast papers
safelight
variable contrast papers

Two basic factors are important in making a good print: exposure and contrast. The exposure is controlled by the amount of light hitting the paper. The contrast is controlled by the selection of the proper grade of paper. With **variable contrast papers** (also known as **polycontrast papers**) the proper filter controls the contrast. As you will learn as you print, a properly exposed and properly processed negative is the first step in making a good print. Good negatives, naturally, are the easiest to print.

CHEMICALS AND EQUIPMENT FOR PRINTING

In addition to materials you already have on hand for film processing, chemicals you need for printing include the following:

- Paper developer
- Fixer (possibly optional)

You will also need the following additional equipment and supplies:

- Instructions for mixing and using chemicals
- Storage containers for chemicals
- Contact printing frame or pane of glass
- Printing paper, graded or polycontrast
- Safelight
- Enlarger

Both this print and the contact sheet underneath are dark and, thus, overexposed. Remember that with prints the effects of overexposure, which means "too much light," may be different than what you expect. Too much light from the enlarger makes prints darker rather than lighter.

186

The first step to a good print is a properly exposed and developed negative.

- Filters (if the paper is polycontrast)
- Printing easel
- Grain magnifier (possibly optional)
- Developing trays (at least three)
- Tongs (possibly optional)
- Timer for enlarger (possibly optional)
- Paper safe (optional)
- Print dryer or substitute (possibly optional)
- Tray siphon (possibly optional)
- Apron (optional)

Make a copy of the list with room for notes. Before shopping or before using a darkroom that is already set up, go through the list. List what materials are available and those you need to get.

Darkroom

Equipment needs for printing are somewhat different than for processing. You do need a darkroom space or equivalent. In a home with heavily curtained windows and no

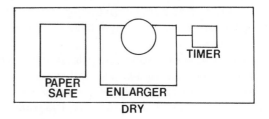

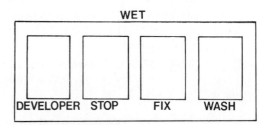

A darkroom for making prints should have wet and dry sides. The exposed paper goes from the developer to the stop bath to the fixer. It is then washed and dried.

On the dry side of the darkroom are found the enlarger, timer, and paper safe. The device on the easel, at the base of the enlarger, is a grain magnifier and is used for fine-focusing the enlarger.

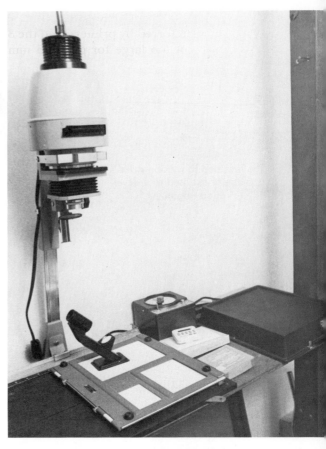

glaring light leaks, processing can usually be done at night in a kitchen or bathroom. If the room is not sealed from light, however, it becomes very important not to leave the printing paper out over any length of time. Remove from the box only the sheet you plan to work with.

Chemicals

Paper developer is different from the developer for films. If you're using Kodak chemicals, start with Dektol. If you're using other brands, go with an equivalent. For a stop bath, add glacial acetic acid to water. If you used a fast-acting fixer for film, you might want to get a regular fixer for papers to cut costs.

You will need instructions for mixing and using the chemicals. These usually come with the printing paper and the chemicals themselves. Processing procedures are also usually covered on the data sheet that comes with your film. Open the paper box in a changing bag or under a safelight and retrieve the data sheet. The equipment for mixing chemicals is almost the same that you need for film. You will need one additional storage container for developer, and another if you're using a different fixer. Take the same precautions during use.

Printing Paper

Printing paper may be either graded or polycontrast. Different grades are for the different levels of contrast. Grades usually come in full-step increments up to Number 6. For polycontrast paper, you must buy filters for the different contrast levels. Papers come in finishes from matte to glossy, in different weights, in a wide range of sizes, in tones from warm to cold, and in a variety of surfaces. Some papers are resin coated. The coating resists water and makes for short processing and drying times. Special drying equipment is not needed with resin-coated papers.

When pictures are to be reproduced in print, a variable contrast, resin coated, glossy surface paper in an 8 × 10 size is worth considering. The variable contrast allows you to stock a single kind of paper. The resin

coating simplifies drying. The glossy surface is sometimes preferred by printers, and the 8 × 10 size is not too large for good 35 mm negatives.

Many photo stores carry samples of different kinds of printing paper. When you buy your first packet, ask to see samples. Although discounts are available when you buy large quantities of paper, you may want to begin with small amounts to allow for some experimenting. At first, avoid exotic surfaces. Be sure to ask how particular papers must be dried.

Safelights

A **safelight** provides light for a darkroom without exposing the printing paper. A safelight has a color filter. The printing paper isn't particularly sensitive to the color light of the filter. As long as the paper is not left under the safelight too long or is not brought too close to the safelight, the paper will not be exposed. For papers, safelights are usually amber or yellow-green. For film, they are dark green. Use of safelights for film is very restricted, and many photographers forego them.

Data sheets that come with papers and film will tell you which safelights may be used and how to use them. Check your paper data sheet for the safelight requirements. Then you should find out how safe your safelights are. There is an informal test to determine this. Lay a piece of printing paper, emulsion side up, on the counter nearest the brightest safelight. Place a coin on the paper. Expose the paper to the safelight for at least as long as paper will ever be exposed to the safelight. Then process the piece of paper. If you can see the outline of the coin after the paper is processed, you may have to make adjustments in the placement of the safelights, such as moving the light farther away.

Safelights range from the inexpensive to the expensive. You may start with inexpensive safelights, such as the Kodak Brownie darkroom lamp kit, and later use them to supplement a more extensive safelight system.

Enlarger

The **enlarger** is the unit used to transfer the image from the negative to the printing paper. The negative is placed in the enlarger

Safelights don't have to be expensive to work. This one has a light bulb inside the plastic case.

The enlarger has a lamp housing, negative carrier, and a lens, all supported on one or two metal columns. The column is attached to the base.

in a carrier beneath a lens. The printing paper is positioned in an adjustable holder called an **easel**. There is also a spot to put a light filter needed for certain papers. Above the lens is a lamp that provides the light source for exposure of the paper. A bellows is between the lens and the lamp.

An enlarger usually has two adjustments— one knob to raise and lower the head, to bring the lens closer to or farther from the paper, and another beneath the bellows to fine-focus the image.

Three factors control the exposure of a negative. One is the f/stop on the enlarger

On the enlarger just beneath the bellows assembly, you can see the lens with its f/stop ring. The knob in the lower right of the picture permits fine-focus adjustments.

Polycontrast filters, which fit in a drawer in the enlarger between the light and the negative carrier, permit the purchase of a single grade of paper. Without the filters, you need to stock paper in several grades of contrast.

lens. Another is the length of time the enlarger light remains on. The third is the distance between the enlarger head and the paper. By adjusting the f/stop or by doubling or halving the time the enlarger lamp is one, you adjust the exposure of the printing paper. Opening the lens one f/stop is the equivalent of doubling the exposure time.

Usually, the enlarger will be your biggest expense. Most enlargers for 35 mm film will also hold 2 1/4-inch film. You do need to consider whether you will eventually need larger formats. Some thought should also be given to future plans for color work. If you expect to use variable-contrast paper, the enlarger should have a drawer for filters—preferably between the light source and the negative carrier. On some enlargers, filters may be used only between the lens and the easel. This means you will need more expensive filters, and the image may not be as sharp.

You should also consider whether your enlarger will ever be used for color work. If so, will it accept a "color head" for color printing, or will it accept filters above the negative carrier?

Careful selection of an enlarger will pay off in the long run. Excellent buys in used equipment are possible. Shop around. Look at equipment in stores. Learn what is available before buying. At the very least, an enlarger should be sturdy, have a decent lens, and give you the size enlargements you want. With less expensive enlargers, make sure the negative carrier allows you to change negatives with ease.

Polycontrast Filters

Make sure your polycontrast filters will fit the filter drawer on the enlarger. Filters come in a series. The Number 1 is for least contrast. Normal contrast is a Number 2, just as the normal-contrast paper grade is Number 2. The filters usually come in sets of seven: 1, 1 1/2, 2, 2 1/2, and so on up to 4.

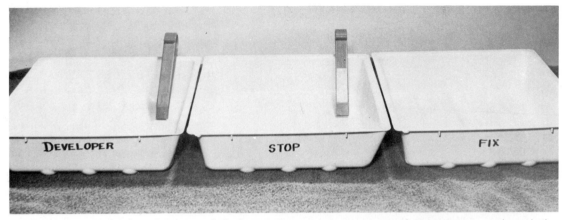

Developing trays hold the solutions in which the printing papers are processed. Papers are run through the chemicals in the same basic order as films: developer, stop bath, and fixer. Afterward, a wash is necessary and other steps may be inserted as desired. Notice the tongs in the first two trays. To prevent contamination of your solutions, the developer tongs should not enter the stop bath and fixer, and the tongs used for the stop bath and fixer should never enter the developer.

Easel

The easel holds the paper during printing. It should be easy to use and allow you to position the photograph so you can print only a portion. The easel could be large enough to handle the largest prints you're likely to make in the near future.

With resin-coated papers, an easel may not be a necessity. The paper may be butted against any square corner, and a carpenter's square will do. The paper lies flat against the baseboard of the enlarger, and the resulting prints are borderless.

Grain Magnifier

The **grain magnifier** enlarges the grain pattern of the negative. A grain magnifier is necessary for accurately focused prints, but you may choose to get along without one initially. When the grain of the negative is in focus on the paper, you know the print will be in focus. The magnifier is placed under the enlarger head on a sheet of paper the thickness of the printing paper. You look through the magnifier as you fine-focus the print.

Developing Trays

Developing trays hold the solutions in which the printing paper is processed. They should be large enough to hold the largest paper you intend to print in the near future. Keep in mind that larger trays take larger amounts of solution. You need one tray for paper developer, another one for the stop bath, and another for fixer. A fourth is handy for print washing.

Tongs

Tongs are used for handling the prints during processing. The chemicals can affect the skin of some people, and the solutions themselves can be contaminated. Tongs prevent this. Tongs for the fixer should not be placed in the developer. It is good to have a set of tongs for each chemical, or at least a set for the developer and one for the fixer and stop bath. Use the developer tongs to transfer the print from the developer to the stop bath. Release the print without letting the developer tongs touch the stop bath solution. From there, move the print from tray to tray with the stop bath or fixer tongs.

Timer

Most darkrooms have a timer for the enlarger. The film-processing timer may be used for enlarging. During printing, you need to time both the exposure of the print and the print's development. With safelights, you can use a watch if you don't have a timer.

Paper Safe

A **paper safe** is used to store unexposed printing paper and to protect it from light. It is usually easier to extract a sheet of paper from a paper safe than from the box of paper itself. Whether you have a paper safe or just draw sheets from the box, it is essential that you make sure the box or safe is completely closed before turning on room lights.

Print Dryer

Print dryers are handy for large quantities of prints made on uncoated papers. Papers with uncoated surfaces will curl when air dried. Resin-coated prints may be air dried.

Common dryers have an electric heating element, a high-gloss surface against which the prints may be faced, and a canvas sheet to hold prints in place. A matte effect may be made from glossy papers by facing the prints against the canvas. Drying may also be done with high-gloss, ferrotype tins (polished metal sheets) and no heating element, but without the heating element, the prints take much longer to dry. Before being placed on a dryer, excess water is removed from the print—either with a roller or a squeegee.

Tray Siphon

If you use a tray for print washing, the tray siphon may be necessary to remove water from the bottom of the tray. Hypo tends to settle at the bottom of the washing vessel and a drain at the bottom of the vessel is advisable.

ENLARGING

Enlarging is simply making enlargements, or blow-ups, of a negative. With the enlarger, the negative image is projected onto the printing paper. The size of the image can be enlarged by raising the enlarger head or reduced by lowering it.

Before making any prints, mix your chemicals. Mixing chemicals for prints is no different from mixing chemicals for film processing. As with film processing, mentally check to see that everything is in place before you begin work. Be sure you do not let the developer mix with the fixer. Wash all utensils thoroughly.

EXPOSURE

There are several times during the printing process that it is handy to have an unprinted —but fixed, washed, and dried—sheet of

Paper safes do exactly what the name implies: They keep your printing paper "safe" from light as long as you always make sure the safe is closed before turning on the lights. Make a habit of checking it each time before you flip the light switch. For making just a few prints, you can draw paper from the box it was packaged in, but you have to be very careful to avoid light leaks. The printing paper is usually wrapped in a paper wrapper before it is packaged in the box. To avoid ruining a box of paper, withdraw only a few sheets of paper from the wrapper at a time.

Handle negatives only by the edges. Some laboratories permit negative handling only with cotton gloves.

printing paper. Once your chemicals are set up, run a sheet through the fixer and wash. Dry the sheet and keep it near the enlarger. Then follow these steps:

1. If you're using an easel, set it on the baseboard of the enlarger.

2. Choose a negative. Check it under room light for dust and clean it as needed. The cleaning may be done with compressed air and a camel's hair brush. Handle negatives only by their edges.

3. Place the negative in the negative carrier and place the carrier in the enlarger.

4. If you're using filters, put a Number 2 filter in the filter drawer.

5. Place the sheet of unprinted, processed paper in the easel and, if necessary, adjust the easel.

6. Make a quick check to be sure all equipment and solutions are ready, turn on the safelights, and turn out the room lights.

7. Your timer may have two switches, one simply to turn the enlarger on and off, and another to turn the enlarger on for the length of time set on the timer. Turn the enlarger on.

8. Open the lens to the widest opening. With the two knobs, bring the negative into focus at the size you want. If necessary, adjust the placement of the easel.

9. Then, with the grain magnifier, adjust the focus using the knob under the bellows.

10. Turn off the enlarger. Remove the piece of unprinted paper.

11. Now take a sheet of printing paper from the box. With scissors, cutting knife, or paper cutter, cut the sheet into four strips. Return three of the strips to the box and *make sure the box is closed*. The strip you've retained will be your test strip to determine the exposure time for the negative in the carrier. Place the test strip on the easel.

TEST STRIP

When printing, it is best to make test exposures with a test strip. Once your negative is in the enlarger and focused, cut a strip of printing paper from a larger sheet of paper. Set the strip on the easel. In the diagram shown, imagine cardboard is placed over the first three blocks from the left and the far right section is exposed for 4 seconds. Then the cardboard is moved to permit exposure of the two right-hand blocks and another 4-second exposure is made. Again the cardboard is moved to the left and another 4-second exposure made. Finally, the last block is exposed for 4 seconds. As you can see, once the full strip is exposed, the left block has had 4 seconds of light; the next has had 8; the next, 12; and the right-hand block, 16 seconds. You may adjust the times and number of blocks to fit your own needs, but the times should always remain consistent for each exposure.

Development should extend for the full recommended time. It is not a good practice to "pull" a print before the time is up.

12. Close the lens to approximately midrange—f/5.6 or f/8.

13. Take a flat, opaque object—a sheet of cardboard will do—and cover all but one-sixth of the test strip. Set the timer for 60 seconds. During the first 10 seconds, expose the first one-sixth of the strip. During each additional 10 seconds, expose an additional sixth of the strip. When you are finished, one section will have been exposed for 60 seconds, one for 50 seconds, one for 40 seconds, and so on.

14. Develop the test strip for the recommended time. Fix it for at least one minute, then rinse. Turn on the room lights.

15. Examine the strip for the best exposure time. If two of the sections look acceptable, but one is slightly dark and the next slightly underexposed, take an average of the two times. Then set the timer for the exposure time you've selected. If the contrast is too high or too low, change filters and make another test strip. If you're using graded paper, simply change paper grades.

It is extravagant to make exposure tests on full sheets of paper. Without test strips, few photographers will make a good print three times out of four—and three out of four is the average you have to hit before it makes good economic sense not to use test strips.

16. You are now ready to make your first print. Turn off the room lights.

17. Draw a sheet of paper from the box and close the box.

18. Place the sheet in the easel.

19. Turn on the enlarger and make the exposure.

PROCESSING

The next step is to develop the paper for the recommended time.

1. Insert the paper into the developer, emulsion side down. This ensures that the total surface is immediately wetted with developer. You may then turn the paper face up.

SAFETY REMINDERS

When you're printing, you're usually working under safelights. Remember that safelights are dim and when you are working under an enlarger your vision may not be adjusted for the dim light, so all the precautions for working in the dark still apply.

- Review the safety reminders in Chapter 11.
- Use tongs or protective gloves when tray-processing prints. (Again, allergic reactions may occur if you handle prints by hand and you also risk contaminating the chemicals.)
- If you have a paper cutter, you are most likely to be using it to cut printing paper. In the dim light take special care to keep fingers out of the way of the blade.

Agitation of the print may be done by lifting and lowering the tray.

2. Gently agitate the print (move it back and forth) in the developer. Agitation may be done with the tongs or by slightly lifting and lowering the edge of the tray.

3. A full 10 seconds before the time is up, lift the paper by a corner with the tongs. Let excess developer drain back into the tray.

4. Transfer the paper into the stop bath. Return the developer tongs to the developer tray.

Contact sheets are made with the negatives "in contact" with the printing paper. When the negatives are cut in strips of 6 frames each, a 36-exposure roll can be printed on one 8 × 10 sheet. A contact sheet lets you preview a roll of film without having to make individual prints of each frame.

5. Agitate the print for the recommended time in the stop bath.

6. Transfer the print to the fixer for the recommended time. Agitate.

7. After double-checking to be sure your paper box is closed, you may turn on the room lights.

8. If you're using hypo clearing agent, use as directed.

9. Wash the print. Papers hold hypo more tenaciously than film and *must* be washed per directions for permanence.

DRYING

Compared to other papers, resin-coated papers dry easily. To speed drying, you may wipe these papers damp-dry with paper towels and set them on bath towels on any flat surface to finish drying. Some photographers hang resin-coated papers to dry, and some speed the process with warm air from a hairdryer.

Uncoated papers may be squeegeed and placed on a flat, glossy surface to reduce curling. Especially for uncoated glossy prints, you may want to use a print-flattening solution available at photography suppliers.

Storage

Storage of chemicals and equipment for printing is the same as storage for film chemicals and equipment. Remember the cautions and see Chapter 11 if you would like a review.

Prints should be stored in a dark, cool, dry place. Properly processed prints should last a long time even when displayed, but displayed prints do not last as long as stored prints.

CONTACT PRINTING

When you've finished shooting and processing a 36-exposure roll of film, you have to choose whether or not to obtain prints of all 36 negatives. Whether you order the prints from the photofinisher or make them yourself, the prints will cost money. Many photographers find that just a few of the pictures on

a roll are really worth having. Contact printing allows you to preview all the shots on a roll without having to make individual prints of each.

Contact printing is done with the negative "in contact" with the printing paper. The negatives are printed to size. They are not enlarged.

To contact print a 36-exposure roll of film, you cut the film into strips, usually of six negatives each. All the strips are then placed against an 8 × 10 sheet of printing paper. The paper is placed emulsion-side up. The negatives are place emulsion-side (dull-side) down on top of the paper. The emulsion sides of both negatives and paper touch each other. Then a sheet of plain glass is placed on top and holds the negatives flat against the paper. The glass should be a little larger than the paper, and its edges should be taped for safety.

Some manufacturers make contact printing frames. The frame has a place for the printing paper and slots of one sort or another for each of the negative strips.

The negatives and paper are then put on the enlarger base. The enlarger head must be high enough so that the whole sheet of printing paper will be exposed. With the enlarger head at a specific distance from the printing

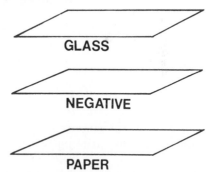

GLASS

NEGATIVE

PAPER

Contact sheets are made with the printing paper face up and the negatives emulsion-side down on top of the paper. A sheet of glass holds the negatives in place.

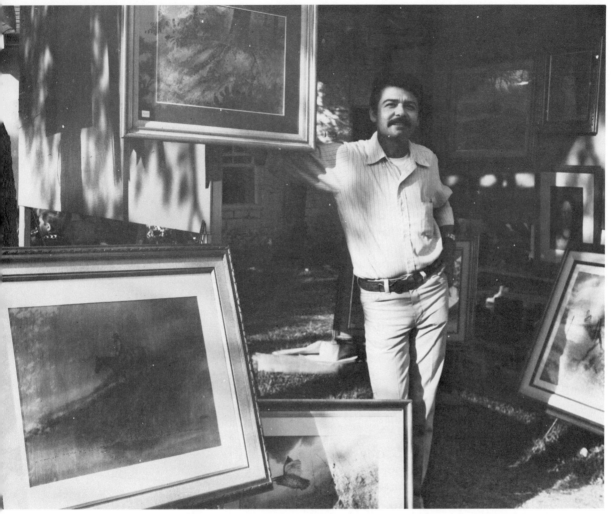

Texas Highways

A good print has white whites, black blacks, and a good range of tones in between.

paper, a workable f/stop and exposure time combination can be obtained using the test strips mentioned. The contact sheet is processed the same as any printing paper.

When the paper is processed, all 36 pictures are on a single sheet. From this sheet, you can select particular negatives for enlargement. The sheet is called a **contact sheet**. In addition to giving you a preview of

your pictures, a contact sheet helps you make decisions about which portions of a picture to print and sometimes helps you decide on print exposures as well. A contact sheet is also useful for filing purposes.

Making contact sheets does take time, and not all photographers use them. Some photographers just look at the negatives and make selections based on what they see. If

you would eventually like to avoid making contact sheets, try this: Look at the negatives. Select the ones you think you would like to print. Then make a contact sheet. If your choices haven't changed after you've seen the contact sheet, you can trust your judgment using just the negatives.

FINE-TUNING PRINTS

To obtain the best prints possible, start with good negatives that are well-exposed and properly processed. Good negatives generally maintain a wide range of tones with white whites, black blacks, and a full complement of tones in between. The highlights are not blocked up. The shadow areas retain details. Over- and underexposure, over- and underprocessing, over- and underfixing, and over- and underagitation all cause characteristic problems.

Usually for beginners, the most frustrating problem comes from underexposed and underdeveloped negatives. The results are muddy, hard-to-control negatives and prints. That is not to suggest that you overexpose and overdevelop everything. If you've fol-

lowed directions throughout and you still have problems, dig a little deeper into publications on film exposure and darkroom techniques. Most of the time, you have some latitude in exposure and processing. But you do need to know what a good print looks like, what the common problems are, and how to correct them. Take the opportunity to look at good prints in museums, art galleries, libraries, and commercial studios.

Whenever possible, problems should be corrected during shooting. Some adjustments may be made during the film processing, though this is usually less practical with 35 mm than with sheet-film processing. As you print, remember that you can make adjustments in contrast. There are other techniques as well.

Dodging and Burning-In

Dodging and burning, or burning in, involve selective exposure of the printing paper. **Dodging** is holding back exposure to parts of the paper. It makes a dark area lighter. **Burning-in** is adding exposure to parts of the print to make it darker. Because

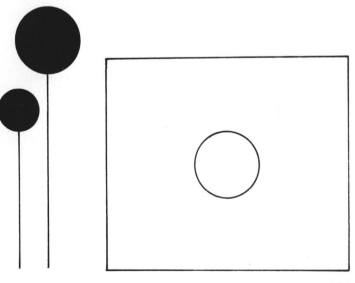

Dodging and burning tools are often homemade. The dodging paddles (left) can be made from cardboard circles taped to clothes-hanger wires. The burning tool (right) can be made from the cardboard sheet with a hole cut in it. On burning tools, some people prefer to cut jagged edges around the hole to help avoid telltale marks on the print. Both dodging and burning tools should be kept moving during exposure to blend the effect into the rest of the print.

These two prints were made from the same negative. The bottom picture was printed from the full negative. The top picture was enlarged to crop out most of the girders and emphasize the bird, the most interesting element in the picture.

photographers often make their own tools for these techniques, the equipment varies quite a bit. Common tools are shown in the illustration on page 199. Especially for burning-in, photographers may simply use their hands.

An uninteresting sky is an example of one problem that may be helped with burning-in techniques. The print is exposed normally—based on the correct exposure for the foreground. Then additional exposure is given to the sky. Remember that to increase exposure a full stop you must double exposure time. Thus, the enlarger is turned on a second time. All of the print but the sky is covered by an opaque object, such as a piece of cardboard or the photographer's hand. The top of the print is exposed throughout the time the enlarger is on. The opaque object is kept

moving, though, to avoid a sharp line in the print. By moving the opaque object during exposure, you blend that portion of the scene with the rest of the print.

Dodging is the opposite technique. Part of the print is covered to reduce exposure in that area.

Dodging and burning have their limitations. Because the tools must be kept moving, fine adjustments can be difficult to make.

Cropping

Cropping is the printing of only a portion of a negative. The remaining portions are cropped out of the final print.

The best cropping is done in the camera with careful composition before you press the shutter button. That way you can get full use of the small negative area available to 35 mm users. Sometimes, though, you will want a long, narrow horizontal or vertical picture and the top or side of the picture may be cropped. Cropping is also useful when you want a grainy print. All but a small portion of the negative is cropped, and the remaining portion is greatly enlarged.

The 35 mm negative does not exactly fit the 8 × 10 format, so whenever you make an 8 × 10 from a 35 mm negative, a portion of the picture is cropped.

Finally, it doesn't hurt to fine-tune your framing techniques by looking at different possibilities on the enlarging easel. You will occasionally want to print the pictures-within-pictures you see there.

SUMMARY

Negatives may be either contact printed or enlarged. Contact prints are made with the negative in contact with the paper. Under a safelight, printing paper is first exposed in the enlarger and then processed in at least three solutions: developer, stop bath, and fixer. The print is then washed and dried. Times, temperatures, the control of contrast, and cleanliness are important.

Printing papers vary as to degree of contrast, texture, size, tone, and coating. Filters are used with polycontrast paper. Grain magnifiers are used to enlarge the grain pattern of the negative for fine focusing.

Common problems for beginners are usually underexposed and underdeveloped negatives. Some problems may be corrected with dodging and burning-in, which involve over- or underexposing selected parts of the print. Cropping involves printing only the portions of the negative you want.

Discussion Questions

1. What are safelights?
2. How does the kind of paper affect the print?
3. How is printing paper stored?
4. What three chemicals are used to process printing papers?
5. When a print is "pulled" from the developer before the development time is up, it will tend to look _____.

6. What is one method used to test safelights?
7. What is the purpose of the easel?
8. Tell the steps for exposing the print.
9. Tell the steps for processing the print.
10. What is a contact sheet? Why is it used?
11. Describe dodging and burning-in.
12. What is cropping?

Assignment

1. Make at least three enlargements or one contact sheet and two enlargments. Use test strips.

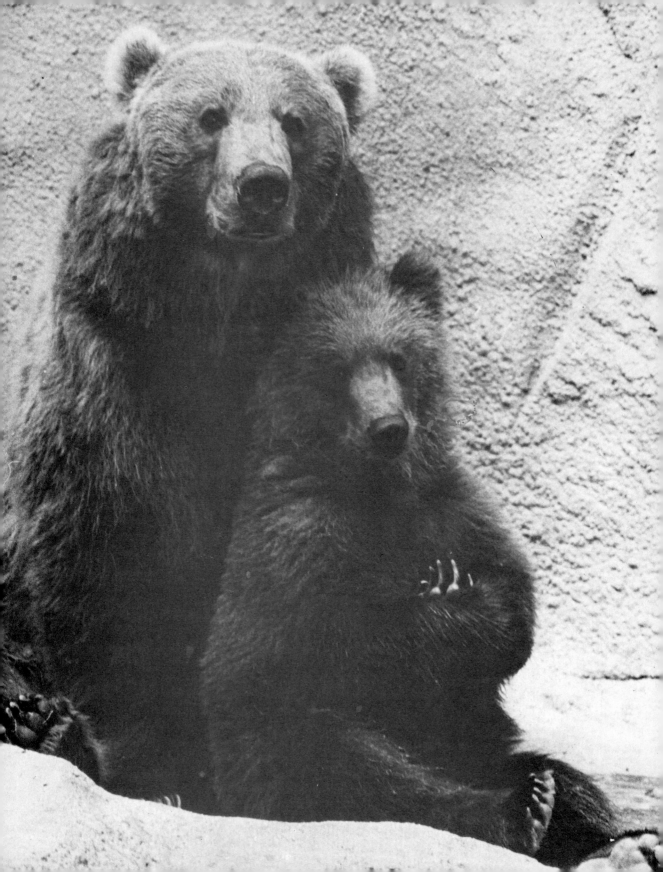

CHAPTER 13

Ways To Grow

It may seem strange, but your growth in photography depends less on adding to your knowledge than on getting back to basics. You'll continue to learn. That's a lifetime project. Making the most of what you learn, though, depends on how well you get back to the basics. Now more than ever is the time to remember that photography has one purpose. All the details we've covered, all the tools you've acquired, all the techniques you've mastered have a single purpose: good pictures.

Pictures are interesting subjects, well-presented. Sometimes it's easy to forget the subject, to get wrapped up in technique. However, the point of having a good technique is to be able to apply it to the most interesting subjects you can find.

Let's look specifically at how you might go about it.

203

A gentle daylight shot of a friend or family member becomes an important part of a family's history.
The Observer

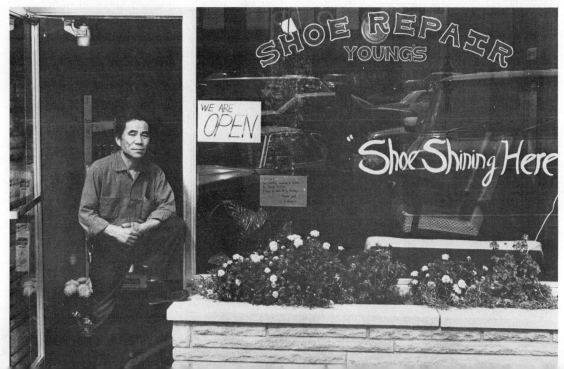

Terms to Learn

cued
keystoning
layouts
photogenic
portfolio
tear sheets
title slides

THINKING ABOUT POSSIBILITIES

Some people take a course in photography and learn more than they ever wanted to know about the subject. A few of these stick to amateur cameras and flashcubes. Where can they go from here? You might be surprised.

When you're shooting for the family album, and when you understand what a simple camera can do, the simple camera *will* do.

Even with a simple camera, you can find good subjects. Subjects can be well-framed. Backgrounds can be controlled. Just because you have a simple camera doesn't mean you can't look for good light. Simple cameras are hardly ever used to the fullest. You can move in and out with them, taking long shots, medium shots, and moderate close-ups for variety. When you know the limits of a flashcube, now and then you can even catch an important picture with one. When the subject

is interesting enough, a simple treatment works.

Some simple cameras have fairly good lenses. Use the cameras outdoors, order small prints, and you may be hard pressed to tell the results from those taken with a quality 35 mm. In 1982, Jim Alinder and Wright Morris published *Picture America*, an art book of photos and text. The photos, enlarged well beyond snapshot size, were all shot with a Kodak Instamatic.

If you're limited to an SLR, one lens, and, for subjects, a child and a dog, consider the possibilities. The most serious problem appears to be in the limited subjects at hand. You seem to have only three choices: child, dog, or child and dog.

To see what can be done, let's take the child alone. A child is a different subject a hundred times a day. Expressions and postures change. Backgrounds change. Light changes. Environments change. You have a choice of long shots, medium shots, and close-ups. You will probably include a silhouette or two in your collection. The child has friends. Moods change. Moreover, you have your choice of all the treatment methods you've learned. Review them and note how they might apply to the child.

The child does not have to be the emphasis of every picture you take. Once in a while, let his/her toys take over. The four seasons are part of the child's life. Show them and show him/her reacting to them.

A single subject presents problems, but it can present a delightful challenge, too. Your approach of showing your work may change. Instead of displaying every picture you take, you may begin to look for the few outstanding pictures on a roll. Go for those. Look for variety.

You can broaden your subject choices just by looking around. You have a life, friends, a home town, a school, or a place of business. Are pictures of these a part of your collection? Make the most of them. Show your

school classroom—and see what choices you might have. The choices include instructor at blackboard, instructor at podium or desk, instructor with a single student, instructor with a group of students, a wide angle shot from the back of the class with instructor in background, instructor gesturing, student responding to questions, and students watching. The list goes on. You should be able to easily imagine at least a dozen shots in this kind of setting.

Moreover, any one of these shots can be handled in many ways, such as by changing camera-to-subject angles, camera-to-subject distance, or waiting for expressions to change. You should be able to find from 30 to 50 noticeably different pictures in a classroom setting, any one of which could be used in a yearbook or similar collection of pictures.

Your shooting opportunities dramatically expand once you get to the machine shop, band room, gym, or any other place in the

Paul M. Schrock

Photos don't have to be complex to be successful. This one relies on an interesting subject and a simple treatment.

town at night. Look for the free activities. Notice the places you go. A church, synagogue, or any public meeting may offer opportunities you've never considered before.

Make a written or mental note of the pictures you must have. During most shooting sessions, you should be able to find a variety of picture possibilities, even when you're working with a single subject and a single activity. There is usually no one "right" angle, no one camera-to-subject distance. Let's take, for example, a somewhat drab location—a

You've seen at least two other shots of this same instructor at the blackboard. The point is that you could work in a single classroom several days in a row and not exhaust the possibilities for usable pictures.

school where more varied activities take place. Obviously, you'll seldom need 50 shots from any single location. Still, you should know in your bones that those pictures are there—ready to be taken—whenever you need them.

What you expect to find is important. It can prepare you to look for the kinds of pictures you need. It can also encourage you to look for the good-luck shots that you couldn't possibly plan on. When you look for the good-luck shots along with the must-have shots, you're likely to find both.

No matter what equipment you have, the trick is to avoid thinking about the limitations. Think instead about the possibilities. With a camera and normal lens, and with one or two subjects, the possibilities are limited only by your imagination and willingness to practice the basics.

With an SLR, three basic lenses, a 2X extender, close-up adapters, perhaps a few filters, a flash that can be bounced, a tripod, and something to carry it all in, you can tackle just about any assignment. As a matter of fact, you'd be well-advised on many assignments to leave some of that equipment at home. It takes a little experience and self-discipline to travel light. Too much equipment can often cost you as many good pictures as too little equipment. On many outdoor outings, you can do just about anything you need to do with a camera and three lenses.

Again, here's a classroom picture. It's not fancy, but it works, certainly well enough for a yearbook or school newspaper if you need a "classroom" picture.

Make an effort to show family members involved in activities that are important to them.

Four kinds of picture collections deserve brief, additional attention: the family album, the portfolio, the layout, and the slide show. An understanding of how these collections can be most effective will go a long way toward giving you a sense of direction and improving your work. The sections on the portfolio, layout, and slide show also suggest ways you can enter professional photography.

THE FAMILY ALBUM

The basic family album is a collection of all the pictures a family takes. Sometimes the over- and underexposed shots are discarded, and occasionally some selection is made of which pictures to include and which to edit out.

You're now in the position to go beyond the basic collection and make the most of an album. Turn it into a family history. Make it both a document and an experience pleasing to the eye. The methods are simple.

1. Look for the **photogenic**—the things that look good in pictures. Holidays and special occasions may still be your mainstay, but look for the quiet, special shots, too. Make an effort to show family members involved in activities that are important to them. Show them interacting with one another.

2. Provide an interesting treatment of your subjects. Make the most of light. Frame and compose carefully. Deal with backgrounds. Focus and expose carefully. Once in a while, make the most of the controls on your camera. Include an intentional blur occasionally. You don't have to take six rolls of film at a picnic, but do look for "professional" shots—the candid with the long lens, the well-framed and spirited discussion between two family members, the cook trying to avoid smoke at the grill.

3. Edit. There's nothing wrong with shooting three rolls of film at a cousin's wedding and picking three to five of the best shots for the album. As a matter of course—at least for practice—you should pick out the three best shots on each roll you take. If those three are truly good, you know you're on the right track. If they aren't, determine the problems and correct them. Discard flawed pictures, or at least store them away. Never put a whole roll of pictures in an album. The more heavily edited the album, the more attractive it will be.

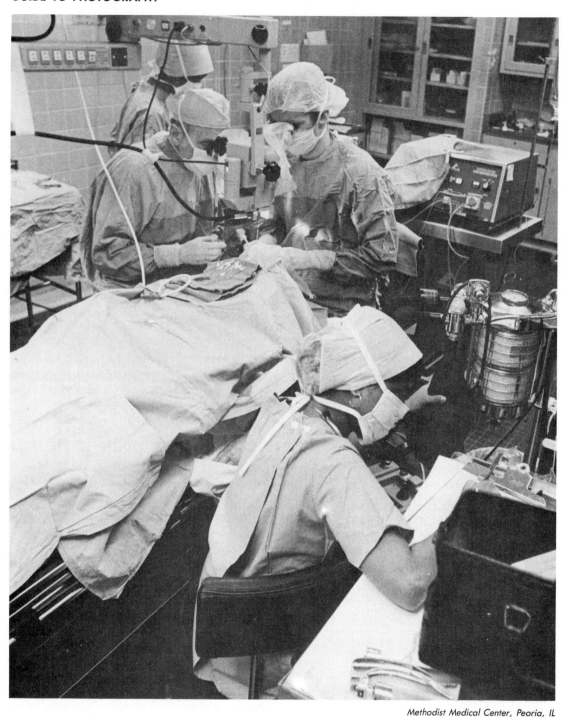

Methodist Medical Center, Peoria, IL

A portfolio is a collection of your best work, designed to show your skills to potential clients and employers.

Taken with a bounce flash in a hospital, this shot shows a nurse instructing a couple on baby care. It is a straightforward picture, but it could certainly be included in a portfolio to show that the photographer can handle on-location candids. At school, you have access to subject matter not easily available to other photographers. Take advantage of it.

4. Make or have made a few enlargements of the best pictures. If you're doing the work yourself, vary the print sizes. Consider using the techniques described in this chapter on layouts.

PORTFOLIOS

A **portfolio** is a collection of your best work, whether it be prints or slides or a combination of both. It is designed to show your skills to potential clients and employers. Some photographers show strong promise early in a career, and a portfolio may make a difference in whether or not you get your share of opportunities.

There are two kinds of portfolios, neither of which should ever be considered "complete." One is a master collection of your best work. The other is the specialized collection. The former provides material for the latter. Specialized collections are tailored for showing to specific kinds of clients. You wouldn't for instance, show industrial pictures to wedding clients, or for that matter, show wedding pictures to potential industrial clients.

Portfolios should grow as you grow, change as you change. Over time, weaker pictures should be removed in favor of newer, stronger ones. A portfolio should indicate the range of your abilities and show you at your best. Once your work is published, be prepared to show **tear sheets**, published samples of your work.

It is good practice, especially early in your career, to shoot specifically for your portfolio. You need shots that show off your technical abilities. You need to show that you can handle different subjects under a variety of conditions. In addition to being a selling tool, a good portfolio provides you with direction. You begin to think more about earning a living with your pictures.

As you assemble your portfolio, go for both quality and variety. It is much better to show 25 quality pictures than to show a larger mixture of quality mixed with only average

shots. Never put a poor picture in your portfolio. Show only your best, and keep the collection lean. Too little is better than too much. Although you'll tailor a specialized collection for a certain client, take the trouble to show off a range of skills within the given subject.

The form of the portfolio may vary and is not as important as the content. Some photographers show only mounted prints. Others show unmounted prints. Still others show their collections as slides. Their black and white work is duplicated on black and white film, processed into positives, and mounted in slide mounts.

At first you may not need a portfolio. Minor jobs may be obtained without one. Your work may already be known by a poten-

tial client because you've worked for someone the client knows or because the client has seen your work somewhere. However, if you plan on selling your photographs, today is not too soon to begin putting a portfolio together.

LAYOUTS

Layouts are the arrangements of pictures for a printed page. Layouts are used for brochures, books, magazines, yearbooks, and newspapers. Photo essays and picture stories are two forms of layouts. The pictures in an individual layout have a common theme, or message. They are united for a single purpose. Often, they appear with text related to the pictures. A layout may consist of three pictures on a single page or it may run many

Photo layouts begin with three or more pictures that work together for a single effect.

pages. Ideally, the elements of the printed page—headlines, the copy (the words in the text), captions, and pictures all work together for a pleasing effect.

Layouts today are perhaps less formal than they were several years ago. You might like to look at how the old *Life* magazine used to arrange pictures and compare the arrangements with those in modern magazines. Look also at how *National Geographic* has changed its presentations over the years.

For our purposes, we are primarily concerned with how the pictures are selected for a picture story and how they work together to give a single impression. A single picture usually tells a story in a single frame. In a layout, several pictures tell pieces of the story. One of the pictures often gives an overview of the story. This shot may be a long shot—perhaps even an aerial. Other pictures pick up the details and show the characters in action. Usually, long shots, medium shots, and close-ups will be juxtaposed. Often, you will see contrasting shots, such as vertical and horizontal shots, each adding something different to the total effect. Yet all the pictures have something in common—a noticeable style, approach, or set of characters—that carries the message.

For example, imagine two photographers, each working opposite sides of a football field during a big game. The photographer on the winning side captures the big plays and concentrates on the excitement on the bench, at the sidelines, and in the locker room. The photographer on the losing side also captures the big plays, but he concentrates on the disappointment on the bench, at the sidelines, and in the locker room. The two sets of pictures will tell two different stories.

Quite often, the few pictures presented in a layout will have been selected from many. Among those presented are the best of the lot, but less successful pictures, too, may be included for their storytelling value. The emphasis of the layout may or may not be on the qualities important to photographers. A layout of pictures is a mini-portfolio: quality and variety, trimmed to the bare bones.

Close-ups work with medium shots and long shots to provide variety to your layout. This picture, enlarged from a small portion of the negative to obtain the grainy effect, was shot to go with others you have seen in this chapter for a hospital brochure on maternal-child nursing.

SLIDE SHOWS

For slide shows, too, photographers seek quality and variety. Slide shows, though, have special needs of their own. They're almost always in full color. They may include **title slides**, which are slides of text or captions. The words emphasize points made in the program. The program may include narration and music. The length of time each slide appears on the screen can be controlled, as

To keep your audience happy, keep your slide show short and visually interesting.

well as the total time of the program. Groups of projectors may be combined and programmed for multimedia shows.

The simplest slide show is a collection of pictures presented to the audience using a manually controlled projector. The person showing the program pushes a button to advance each slide and may make comments on the pictures as they hit the screen. It takes very little to add music to the presentation, which may be taped. Modest equipment is available so that the program may be **cued**— programmed to advance automatically.

When two or more projectors are combined, the screen doesn't have to be dark between slides. As the light in one projector fades, the light in the next projector brightens and brings the next slide to the screen.

With two projectors, two slides may be shown at once. Let's say you have a set of title slides with white lettering on a black background. One projector puts a scenic picture on the screen. The second projector shows a title slide on top of the scenic slide. The audience sees the scene with a series of titles that fade in and fade out over the picture.

The worst crime in a slide show is to bore the audience. Dramatic presentation is essential. A good production begins with the preparation of the program. Even if you're mak-

ing a show for your family, the slides should be edited and put in order. Don't show over- and underexposures, accidental blurs, and other errors you've made. Even for the family, overly long slide shows are a mistake. Keep it short. For all but your family, limit your single-projector slide shows to a single tray of slides. With the family, limit it to two trays.

Generally, the slides should remain on the screen between 5 and 15 seconds. Keep up the pace. Remember that slides are presented in a sequence. You control which slide is seen first, which second, and so on. Put your slides in good order. Offer your audience a well-paced show. If you like, start off with a few terrific shots. Then level off to the main part of the program. Finish off with more terrific shots.

Prepare the room where the slides will be shown. Keep a spare bulb for the projector.

Have the projector focused before you seat the audience. Avoid keystoning. **Keystoning** occurs when the projector is not approximately level with the screen and the picture is wider at the top or bottom of the screen. Check all equipment before seating the audience.

Once you seat them and dim the lights, the show should be ready to go. Turn on the projector lamp after the first slide is in place. Don't blind the audience with a white screen. The show should run without a hitch. When it's over, shut off the projector lamp on the last slide. Again, don't blind the audience with a white screen.

As you probably know, slide shows have a bad reputation. Remember your purpose: To impress—not bore—your audience. It's hard to pull slides that don't work. It's hard not to linger on your favorites. It's hard to keep your shows short. That's why most photographers often fail miserably at slide shows. To keep your audience, leave them wanting more.

THE PHOTOGRAPHER AS A CITIZEN

Personal growth—whether in photography or any other field—doesn't occur in a vacuum. In many ways, photography is a social enterprise. Photographers are people,

The Observer
Slide show pictures may be more obviously theatrical than the pictures you take for other media. By now, you should be thoroughly familiar with the techniques used to make this shot.

United Way

In many ways, photography is a social enterprise. Photographers are people, they usually work with people, and their products are expected to appeal to people.

they usually work with people, and their products are expected to appeal to people. In its highest form, your growth in photography includes social growth.

That's not so obvious when your main concern is f/stops, shutter speeds, and guide numbers. At first, those details take precedence. Before long, though, you begin to grow more and more comfortable with the details. Then you start to notice your work has an effect on others.

Pictures become pictures again. They regain the magic they had before you knew how the magic was done. Pictures become more than the light and dark silver embedded in a paper's emulsion. The images regain their meaning—a meaning well beyond the little details underlying their creation. At this higher level, you become more than a technician.

In the next two sections, we will look at photography as a social enterprise and your involvement in more than the technical aspects. We will see the effects the photographer and photography can have on society.

The Photographer as a Member of the Community

Even as a student, you have reason to be aware of photography's power and your relationship to that power. Throughout the text, references have been made to photography's capacity to catch the eye, to communicate, to influence.

Photography is fascinating in its ability to change a subject from neutral to influential. As you have seen, as a photographer you are in a position to manipulate light, subjects, and camera positions. When you're taking a picture of a procedure in your school's metal

214

shop, no one—including yourself—is likely to question your motives.

But imagine what would happen if you snapped a picture of another student using a power tool when your subject was supposed to be wearing safety glasses and had failed to put them on. Would the picture be used? You could count on reshooting and you could also count on the instructor's strong reminder to the class about wearing safety glasses.

On another level, in an article called "Lessons of a Living Room War," Leonard Zeidenberg wrote about the 1968 Tet offensive during the Vietnam war, "Tet helped persuade the Johnson administration the war could not be won, and the uncompromising look the cameras presented to the American public of the fighting—including the bloody attack on the U.S. embassy in Saigon—is regarded by those who were in the American mission at the time as having played a major part in shaping the public's attitude toward the war."

Most people do not fully understand the possibilities for manipulation in a picture. People are used to trusting what they see. Therefore when a picture distorts reality (as, to a degree, it always does), the photographer needs to be aware of the distortion and needs to have some understanding of how the distortion is related to people's value systems.

Again, the camera's ability to modify reality

The Observer

That a subject has been chosen to be photographed implies that it is worthy of the viewer's attention.

It is permissible for an advertising photographer to present a product in an attractive light.

is more important in some instances than in others. In most circles, it is considered permissible for a food photographer to show a product steaming hot under the best light possible. It is not, however, permissible for extra meat to be added to a can of spaghetti or for half the peanuts to be removed from a can of mixed nuts just to make these products appear more appealing. The question is, "What's fair?"

Likewise, legal photographers take great pains to *avoid* special effects. It is not considered permissible for a legal photographer to make use of the telephoto lens's ability to compress foreground and background just to create an impression that would not be noticeable on location to the average naked eye.

On the positive side, this all may suggest to you a wide variety of ways that photography can be put to good use for any group with which you're associated.

At the very least, you can be the one in the group who "thinks pictures." (One sign that occasionally appears on darkroom doors says, "Think Negative." For photographers, that really can be a positive way of thinking.)

216

Paul M. Schrock

Whenever your group sponsors an activity, look for picture opportunities.

As a member of any group, you have many experiences from which you may draw on to make beneficial suggestions. Photography is now one of those experiences.

Ask, "When would a picture help?" In a school, most clubs are represented in yearbook pictures. For special promotions, pictures can make a big difference in brochures, displays, slide shows, or other presentations. Whenever your group is involved in a photogenic public service activity, coverage by the school paper or even your local newspaper is not out of the question. (You don't always have to be the one to take the pictures.)

You can, of course, be the one to take pictures for your group. Even when you're taking your own pictures, keep in the back of

your mind that good teen and young adult pictures are not easy to come by for adult photographers. Your best work may find itself in print on a national level—not only to your benefit but to the benefit of your group.

Finally, as a member of any group, you have the same responsibilities to the group as other group members, and the same rights. It is up to you, as it is to other group members, to contribute to the group—to contribute ideas, plans, time, and opinions.

The Photographer as a Leader

How, why, and when would a photographer be seen in a leadership role? Ordinarily, we think of photographers as providing services. Most of the time, our perceptions along those lines are accurate.

That does not mean, however, that photographers survive strictly in service to others. Even in the practice of their craft, they are often providing direction. They have to take charge of situations simply to get their work done.

217

The portrait photographer is responsible for putting clients at ease and getting the best expressions. The photographer directs the subject in such a way that the portrait looks natural. Corporate and agency photographers, especially when they head their own departments, become involved in administrative duties. This could include creating budgets, scheduling the time of other photographers, and influencing management so that the best use is made of the photographic resources available. In other words, they have to take charge.

Freelance photographers must often function in a consultant's role with the management structures they deal with. A freelancer, for instance, may become involved in influencing the outcome of a photographic presentation needed by a particular business. The freelancer may be expected to provide sound advice to those needing pictures.

The studio owner, of course, is an indepen-

Sandra Guzzo

A freelancer may become involved in influencing the outcome of a photographic presentation needed by a particular business.

Most photographers work squarely in the middle of modern life.

dent business person. As such, the studio owner is responsible for many of the same things any other small business owner is responsible for. Employees depend on the studio owner for their livelihoods, so the owner must meet payrolls, choose and fund advertising campaigns, steer the business in such a way that it remains profitable and grows, deal with clients, troubleshoot problems, pay taxes, and generally function as a productive and contributing member of the community.

A few photographers manage to live as hermits. They may work out of a mountain cabin, shoot spectacular scenery, and do all their marketing through the mail to faraway customers in exotic cities. Many more photographers, however, work squarely in the middle of modern life. They have to deal with people.

Those photographers learn to give a little, take a little, and work with their subjects, clients, and editors. Early on, they discover that part of what they like about photography is interaction with people, learning what people like, and finding ways to provide a little more than is expected. They delight in negotiating and eliciting from the people they work with the responses they need. These photographers assess what needs to be done, and they involve others in getting it done.

In that respect, photographers are leaders.

Your improvement depends on your application of the basics.

SUMMARY

There are ways each photographer can grow. Equipment is only part of the story. Improvement is determined by how well photographers apply the basics of subject and treatment.

It's important to make the most of subject material at hand. Even in an ordinary setting, many acceptable pictures may be obtained. An apparent lack of material should not stop a photographer.

A family album can be a lifetime shooting project, and it can be as good as one cares to make it. An interesting treatment should be given the subjects. Pictures should be edited, and print sizes should be varied if possible.

A portfolio is the prime sales tool of the photographer. Specialized versions are made for clients with special interests. Photographers who plan to sell their work should begin a portfolio soon.

Layouts are the arrangements of pictures

for print. The pictures give a single impression. The individual pictures are a variety of quality shots, and each tells a piece of the story.

Good slide shows depend on a well-done presentation. This involves consideration for the audience. Careful planning of the program leaves an audience wanting more.

Discussion Questions

1. What is the purpose of good photographic technique?
2. What is the purpose of a portfolio?
3. What four approaches can improve a family album?
4. What are tear sheets?
5. What kinds of things should a portfolio show?

6. What do the pictures in a layout have in common?
7. How can two or more projectors improve a slide show?
8. Why is a well-thought-out program essential to a slide show?

Assignment

1. Make 10 pictures, the best you possibly can, for either a family album or for a portfolio.

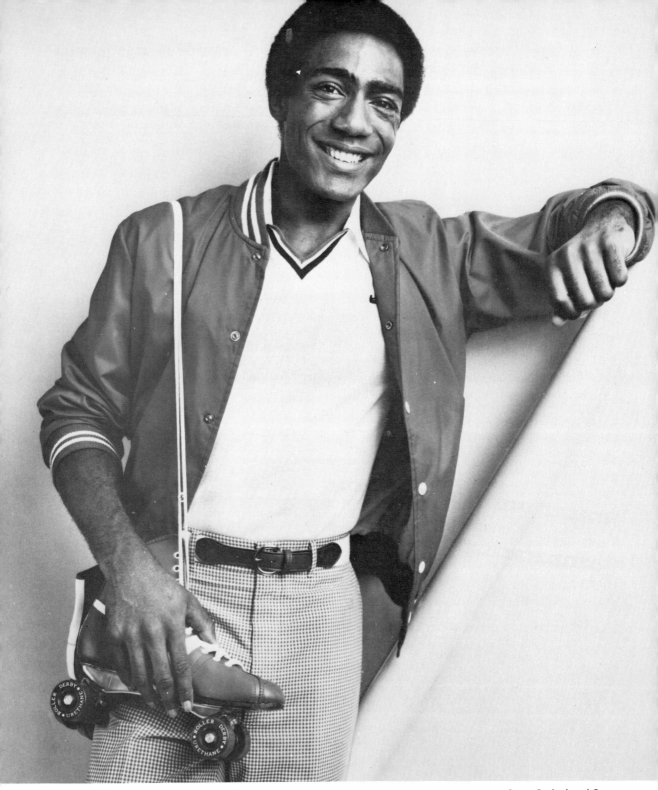

CHAPTER 14

Jobs in Photography

Photography is a competitive field, but every picture you see—in books, magazines, newspapers, ads, displays, in your own home, and in the homes of others—was taken by someone. Even among the pictures in your home, you will find many taken by professionals. These could include portraits, wedding pictures, and baby pictures, not to mention all the pictures in printed matter. By reading this text and practicing, you've learned enough to take many of the pictures in demand today.

In this chapter, you will be shown ways to put the techniques you've learned into practice. We will review the educational requirements for professional photography. We will look at two basic approaches to photography and see how choice of approach affects a photographer's career. We will cover a list of specialities. Finally, we will review ways you can make your equipment pay for itself. Students can and do earn money from photography, and we will look at several opportunities available to you today.

EDUCATIONAL REQUIREMENTS

Professional photography doesn't absolutely demand a formal education. Certain salaried positions may require it, but clients generally are more interested in ability than in formal education. Some photographers begin their careers with no formal training. Some continue to grow through nothing more than experience, reading, trial and error, and asking questions of other professionals. There are instances when skill with a camera takes second place—although an important second place—to business skills.

On the other hand, colleges and universities often provide courses in photography, both in their regular curricula and in their continuing education programs. A few offer advanced degrees. Princeton University in

New Jersey and Boston University in Massachusetts have both offered doctoral programs in still photography. Commercial photography is often done by photographers who have served apprenticeships at major studios, usually in urban areas. Seminars and workshops are offered through national and regional photography organizations. Certain private organizations also provide programs. Some photographers receive their training in the military. While no formal education may be required, special skills are needed in a wide variety of jobs. To be successful, photographers must develop the necessary skills in their chosen fields.

The most basic skill may be the ability to use specific equipment for a specific job. If your local Board of Realtors® needs pictures of houses for its multiple listings book and

Terms to Learn

aerial pictures
entrepreneur
field photography
murals
stock photographs
studio photography

you can take the pictures, even if it's with an automatic camera, you can be the Board of Realtors'® professional photographer. Obviously, your career is more likely to grow if you can take other pictures as well, but many small and simple opportunities exist. A few photographers do nothing more than take advantage of them.

A grasp of the business of photography is often necessary even for salaried photographers. Job security may depend on budget keeping, efficiency, and an understanding of how and why photography is cost-efficient for a business or agency. For instance, staff photographers may be called upon to recommend the purchase of photographic equipment and to make the most efficient use of equipment on hand. When cutting costs, businesses and agencies often look very close-

Colleges and universities offer
photography courses.

224

Business skills are as important for most photographers as photographic skills. As you progress, continue to learn.

ly at photography. To survive, photographers need to know how photography promotes profits.

An ability to work with other people is also important. Whether directing models or other subjects or showing clients and employers how photography may benefit them, the photographer should be able to communicate in words as well as in pictures. It is helpful to know why photography is wanted and needed and to be able to communicate this knowledge to others.

TWO APPROACHES TO PHOTOGRAPHY

Two approaches to photography affect both the cost of pictures and the photographer's way of working. These two are the field approach and the studio approach. They do overlap somewhat, but most pictures show the influence of one or the other.

Field Photography

This text has emphasized field photography. **Field photography** is characterized by minimal equipment and a high reliance on available light, natural surroundings, and natural action. Field photography includes much of the work done outdoors and, as the name implies, "on location." For its impact, it relies on real people, real action, and real places. It's informal. Because it is based on reality, it conveys an air of truthfulness. The fact that field photography costs relatively little to enter appeals to photographers. There usually are no buildings, utilities, or staff to pay for.

The best example of field photography is probably photojournalism. Field photography may also include forms of industrial photography, some advertising, informal portraits, legal and insurance photography, documentary work, and sports and stock (illustrative) photography, just to name a few.

Studio Photography

Studio photography emphasizes control—control of subject, light, and location. There is an emphasis on quality, so the larger format cameras are the rule rather than the

225

Tazewell Publications

Some pictures simply can't be done in a studio.

Texas Highways
Food photography is usually done
with a studio approach.

exception. Slower films are common. Studio photography usually assumes a larger investment, not only on the part of the photographer but on the part of the client as well. Studio photographers must meet the cost of buildings, staff, advertising, expensive lighting, and more expensive equipment. In return, studio photographers may compete in the more profitable markets and know that their good work shows.

Most advertising work, such as food, fashion, and product photography, is done with a studio approach. It is the same with most formal portraits. We looked at some elements of studio photography when we looked at multiple unit lighting. By reviewing ads in the more prestigious magazines, you can get an excellent feel for the studio approach.

Choosing an Approach

Why should the approach matter to you? For one thing, you may already prefer one approach over the other. It's helpful to identify that approach early. Some people prefer the freedom of the field approach. Others prefer the control of the studio approach.

Identifying your preferences should suggest how you want to spend your energy, time, and money. There is little sense in pursuing 35 mm work if your heart is really in studio photography. Instead, you may want to research apprenticeship opportunities in your area and look into inexpensive ways to enter studio photography. An excellent book to get you started is Larry Cribb's *How You Can Make $25,000 a Year with Your Camera No Matter Where You Live* from Writer's Digest Books (Cincinnati). For those who prefer the field approach, there is Rohn Engh's *Sell and Re-Sell Your Photos* from the same publisher. Engh's book describes stock photography in detail. It may be especially interesting to students because virtually all stock photography is marketed through the mail and the photographer's age is not an issue. (There will be more about stock photography later in this chapter.)

SPECIALTIES IN PHOTOGRAPHY

As you can imagine, many different kinds of jobs fall within the boundaries of photography. Even when you exclude darkroom personnel, lens designers, and motion picture editors, many quite varied specialties remain. Photographers often adapt themselves to work in several different specialties.

A comprehensive list of specialties could fill a book. The discussion that follows should give you an idea of the variety of work

227

Advertising and promotional pictures show a product in an appealing way.

Advertising

Ad photography is done primarily with a studio approach, even if it is done on location. Studio lighting, large-format cameras, and attention to detail are the rule. The advertising photographer may work under an art director with an advertising agency. Though ad photography is often seen as one of the glamour fields, it can include much routine work. Samples of the ad photographer's work may be found in brochures, catalogs, magazines, newspapers, and on posters, cereal boxes, and television. All advertising pictures are expected to attract buyers for products or services.

When the work is done under an art direc-
available and may spark an interest in an area you would like to pursue.

tor, the photographer may have little to say about how the picture is taken. The art director will probably dictate exactly how the picture is to be set up, framed, and lighted. Occasionally, agencies will ask top-flight photographers to design a picture. Staff advertising photographers, with newspapers or corporations, may have a say in how their work will look.

Aerials

Aerial pictures—those taken in flight—are mentioned not only because many photographers take them once in a while, but because they illustrate the variety of opportunities within a single category. Some aerials are interesting only to specialists. The military uses them for reconnaissance (studying enemy territory). Geologists use them when

Children have always been popular subjects for photographers—both on location and in the studio.

searching for oil. Cartographers use them to make maps. Probably more familiar to you are the aerials of scenery, local businesses, or sections of a town. Spectacular and demanding are the advertising aerials taken for airlines, such as pictures of jumbo jets breaking through clouds in the evening sky. Newspapers may try to get aerials of disasters—large fires, floods, or the aftermath of a tornado, blizzard, or volcanic eruption. Some aerials may be taken by anyone with a camera. Others demand highly specialized equipment.

Architecture

Architectural work involves pictures of buildings both indoors and out. It is usually done with large-format cameras because these cameras allow control of perspective. The pictures are used for legal records, sales promotion, and advertising. A few photographers specialize in architectural work. More often, the work is done by studio photographers who include architectural pictures among their offerings.

Audiovisuals

Audiovisual photography ranges from the shooting of a simple slide show to the production of a multimedia event. As a speciality, it may demand script writing, sound production, special effects (both audio and visual), the programming of projectors, special lab work, graphics, and slide copying. It may also require an acute awareness of presentation factors, such as the selection of special screens or the special setup of a theater, auditorium, or other showplace. In some cases, audiovisual production is more complex than motion picture production, and the audiovisual specialist can usually make good use of motion picture production techniques.

Children

Most photographers take pictures of children, and some specialize in this area. The specialists include school photographers and certain portrait photographers. Young children, especially, demand special techniques. The photographer must solve posing prob-

229

Decorative murals are found in a variety of locations. This one is in a hospital room for new mothers.

to make a profit. Many students are photographed. The setup usually consists of one stool, one background, and one light or set of lights. Once these variables are adjusted, they remain unchanged for pictures of perhaps hundreds of students. The photographer concentrates primarily on expressions and timing. Usually, the photographer makes use of a special camera designed to take large rolls of film, and the labs that process the film are set up to offer only a few standardized packages. Because the pictures are mass produced, they can be offered at quite attractive prices.

Displays and Decorative Murals

Displays—at conventions, trade shows, and in the entryways of office complexes—often make use of greatly enlarged pictures. **Murals** (photographic wall coverings) are also seen. Because of the enlargement involved, these pictures usually begin as large-format negatives or transparencies. Displays often have a commercial purpose and the pictures may portray the use of the sponsor's product. Decorative murals are usually pictures of scenery.

In displays you are more likely to see original prints. Decorative murals, on the other hand, are often pictures that have been re-

lems, sometimes behavior problems, and must be able to consistently produce pleasing pictures. As subjects, children can be effectively photographed using both field and studio approaches.

Besides the demand for studio portraits, there is a market for pictures of children in natural settings. A stock photographer, for example, may specialize in children's pictures: children at play, with their families, at school, or doing anything that children do.

In the studio approach, the techniques are usually standardized. The school photographer, for instance, must depend on volume

produced on a printing press. If you closely examine most murals, you will find the dot patterns characteristic of any pictures in print in newspapers, books, or magazines.

Displays are most often financed by businesses or agencies. Those who buy the pictures usually obtain them directly from staff or freelance photographers. The photographer may or may not be involved in the final creation of the display itself. Murals are sold through a variety of outlets, usually several steps removed from the photographer. The photographer or his/her agent sells the picture to the printer who in turn sells the copies to the outlet.

Fashion

Fashion photography is one of the more glamorous fields, but fashion work has news value as well. As photographer Richard Ave-

Sears, Roebuck and Co.
Fashion pictures have traditionally been done in a studio, but more and more are being done on location with small-format cameras.

don once put it, "A good fashion picture is an unusual approach to a usual garment." This applies whether the picture is for an ad or a magazine story on the newest clothing trends. In any event, the photographer's job is to make the clothes look good. Fashion photographers are usually adept in the studio approach, although more and more small-format work has appeared in recent years. The most profitable assignments, however, still regularly go to the well-known studio operators in large cities.

Food

Food photography is usually done for both the advertising and news media. In this respect, food and fashion work are similar. But the markets for food photography differ somewhat. Photographers who specialize in food must develop the ability to make products appear attractive without deceiving the public about the quality of the product. Here again, the studio approach is the more common one.

Legal and Insurance Work

This area may be either a specialty unto itself or part of the business handled by a small studio or a field photographer. The photographer takes pictures of evidence,

Medical photography has gone far beyond the simple x-ray, and yet doctors still depend on x-rays for important medical information. Medical photography contains a wide variety of subspecialties, all of which to some degree build on the information you have learned in this text.

such as fire damage to a house. He or she works primarily in the field and must be accurate and a good recordkeeper. The photographer may be called upon to testify in court. The clients who buy the pictures are less interested in pictorial qualities than they are in a clear, sharp rendition of the facts. Some of the work in this area is done by police officers and by claims agents for insurance companies. Certain varieties of the work are done with basic equipment—a small-format camera, normal lens, and perhaps a flash. However, the field also includes infrared work and photos taken under a microscope.

Medicine

Medical photography is a broad heading covering a wide variety of areas, some of them quite specialized. The work of x-ray technicians falls under this heading as well as the work of those who take pictures through special scopes that may be inserted—either surgically or through natural openings—into the human body. Again, accuracy rather than pictorial qualities may be stressed. The field of medicine requires pictures for illustration, education, analysis, research, and diagnosis. Some of the most exotic tools used for photography are found in this and other scientific areas.

Photojournalism

Photojournalism is perhaps the primary specialty within the field approach to photography. Small-format cameras and light, easy-to-carry equipment are the rule even for photographers who work with the major news agencies. On the whole, photojournalism is not particularly well-paying, but some of the work is the most exciting available. It may or may not involve travel. It may include some motion picture and videotape photography. Students can and often do find publishers for their early news pictures.

Sports is a speciality within news photography. In its own right, sports requires skills with long lenses and with low-level, available light.

Stock Photography

This area covers illustrations, primarily for books and magazines, but also for advertising. **Stock photographs** may be described as "generic" pictures—pictures that may be used for a variety of purposes. The same picture of a family at a dining table may be used to illustrate an article about family communication in a religious magazine or an article about rising food costs in a women's magazine. The pictures may be marketed either through stock photo agencies or by the

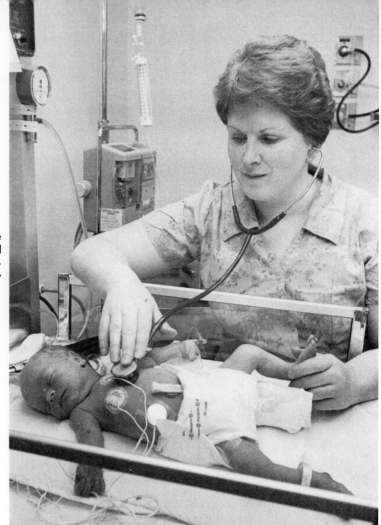

Photojournalism is perhaps the primary specialty within the field approach to photography. Small-format cameras and easy-to-carry equipment are the rule.

photographers themselves. Stock photo agencies usually retain a commission, often in the 50 percent range, for pictures sold through them.

Students are in a better position than even professional photographers to supply magazine and book publishers with stock pictures of other young people and school activities. Because color printing remains costly, the

Students are in an excellent position to provide stock photos of other students. Stock photos often show people involved in activities.

Students may provide their schools and, sometimes, their local newspapers with sports pictures.

publishing industry still buys quantities of black and white work. The primary requirement for pictures in this area is that they must be of people involved in an activity.

Weddings

This area is a common one, and those who enter it include the small studio operators and the photographers who work out of their homes. Traditionally, wedding photography is done with medium-format cameras, although some photographers do work in 35 mm.

Many photographers began their professional careers in wedding photography, and students who are thoroughly familiar with their equipment and with the requirements in this area may do the same.

OPPORTUNITIES FOR STUDENTS

Money-making photographic opportunities for students range from the sale of an occasional print to a full-fledged business, with all sorts of interesting variations in between. If you've completed the assignments in this text, you may already have the beginnings of a portfolio, and you should have an understanding of basic photographic techniques. For some purposes, that will be more than enough for you to start. A few opportunities can even give you access to the necessary equipment.

Photography as a Hobby

If you simply cover expenses, photography remains a hobby. You accept work that at least will cover your supplies and perhaps cover the use of your equipment as well.

In some schools, students are granted full use of film and darkroom supplies by shooting for the school yearbook or school paper. A few students may arrange to shoot for professional photographers who supply the school with yearbook and newspaper shots. Advisors for the yearbook and paper can tell you what the arrangements are at your own school. In any event, the yearbook and newspaper may present you with your first chance for publication. In some instances, this publication is a worthwhile addition to your portfolio.

Local newspapers may be interested in sports coverage they cannot obtain from staff photographers. A call to your local sports editor will tell you whether the paper lacks coverage, which sports may need photographing, and whether the paper will replace your film or pay for prints. Newspapers often want free or low-cost pictures. If your paper does not pay, you may want to see if your school administration or athletic department is willing to at least pay for your supplies.

Finally, local newspapers may or. may not have the ability to process and print your film. Deadlines for publication may follow an event by a few hours or less, and you may need access to a darkroom to meet a newspaper's needs. Again, a call to the sports editor should answer any questions you have.

In smaller communities, the newspaper may be interested in pictures of activities other than sports. In any community, you may find organizations that need pictures for any number of reasons. Let people know what you can do. The idea is to identify needs, make sure you can meet the needs for a reasonable cost, and ensure that you can more than cover your own costs.

As with all photographic opportunities for which you receive supplies or payment, your success will depend on your business-like manner and the quality of your work.

Photography as a Business

What about photography as a business? You have two choices: Go into business for yourself or work for someone else. Again, the possibilities are almost as varied as the field of photography itself.

Earlier you saw that apprenticeships are one way beginning photographers learn the trade. An apprenticeship may or may not be a formal arrangement. There is nothing wrong with calling on local photographers from time to time and asking if your assistance may be needed. Students who know the basics, want to learn more, and are willing to work

Tazewell Publications

When you produce quality work, your clients will be glad to hear from you.

should be able to find several possibilities in their own communities. Even if you initially have to do nonpaying work (and you should settle for nonpaying work only to gain experience), any experience you get will prove valuable later on.

With your own business, there are several factors to consider. In some cases, especially if you are selling locally, business and sales tax licenses may be necessary. A call to your Chamber of Commerce will tell you what you need. If the business is small and simple, basic accounting procedures will suffice. It is good, even when you are starting out, to keep records of income and expenses, and you

Two books for those interested in entering their own business are Larry Cribb's *How You Can Make $25,000 a Year with Your Camera* and Rohn Engh's *Sell and Resell Your Photos.*

The Observer

Many pictures sold today are taken with standard, readily available equipment. It is your treatment of the subject, such as this use of depth of field, that makes the real difference in quality.

have already learned methods for keeping track of your negatives and slides.

What kinds of opportunities can you find? The Cribb and Engh books, mentiond earlier in this chapter, describe only two of the many ways photographers enter self-employment. Both books, however, show how to get started with a limited investment. Both also show ways to make your investment grow. Cribb concentrates on markets you will find in your own community. Engh discusses national markets for stock photos.

What kinds of opportunities should you take? Don't be afraid to take any for which you're prepared. If you've been shooting pictures for your school, read Engh's book and, following his directions, submit prints to a book publisher who is looking for pictures of students. If you've worked with a wedding photographer or have practiced enough to know you can shoot a wedding properly, shoot a wedding. Don't, however, attempt to shoot a wedding without thorough preparation. Be prepared to turn down work you're not ready to handle.

As you grow as a photographer, continue to think about your subjects and your treatment.

As you set out to find paying work, remember the following points:

1. Your age doesn't have to make a difference. As you have already seen, age has nothing to do with how you frame a picture, make an exposure, process film, or make a print. By using commercial processing and printing, all you have to do is make the picture. If you can produce the work your clients need, your clients seldom care about your age. Students sell to national and local markets. If you market by mail, your clients don't even have to know your age.

2. Most pictures sold today are taken with relatively standard equipment. Costly equipment is necessary only for the more exotic pictures. To start, you can get by with one camera and one good lens. As you progress, add the equipment for which you feel the most pressing need. Too often, beginners fail to explore the market needs that can be met with limited equipment. Make the most of the equipment you have available. Learn all the possibilities of each piece you own. Add necessary equipment as your budget grows.

3. Avoid giving away your work. Customers value what they pay for. Learn what others charge and price your own work accordingly. Underpricing is perhaps more hazardous to your business than overpricing. When you undercharge, you face too many temptations to cut corners and to turn out less than professional work. Your reputation depends on the quality of your work, and no one has the right to ask you to jeopardize your reputation. Moreover, you must do more than meet expenses to stay in business.

4. Meet other photographers. The best will freely discuss their techniques and share what they know. Do, however, weigh what others say in terms of your own needs. Be sure the techniques of others meet your own purposes before adopting them for your use. In addition, don't be afraid to refer a client to another photographer when you cannot meet the client's needs. You can usually count on the favor being returned.

5. Know your limits and the limits within your market. One example: Because they are mass produced, school pictures are relatively low priced. Unless you can also mass produce, don't attempt to match the price for a similar package. Moreover, when you promise to do a job, your reputation depends on its

If you find you're good with informal portraits, approach the owners of small businesses.

delivery. Accept challenges you can meet, and refer demands you cannot meet to other photographers.

The Photographer as an Entrepreneur

In photography, entrepreneurship is making money with your camera—and doing it on your own rather than working for a salary.

An **entrepreneur** organizes, manages, and assumes the risks of a business. You can become an entrepreneur by setting up and running your own business.

The chapter discusses a variety of opportunities open to you, and if you sit down with a pen and paper, your imagination will point to many others. To help you get started, here are a few suggestions.

Check the costs of film, processing, and printing for a roll of color prints. Divide the total cost by the number of good pictures you can get from a roll. If, for instance, a roll of film, processing, and printing cost you $9.00 and you can get 36 good prints from a roll, each picture costs you $.25.

Talk to your friends and see how many might be interested in informal portraits—alone or with other friends—at $.75 apiece. Collect your fee at the time you shoot the pictures. If you think it will be difficult to find 36 customers, start with either a 12- or 24-exposure roll. Don't forget to recalculate your costs based on shorter rolls because they are likely to be slightly more expensive per picture.

Check the costs of slightly larger prints. Also check the costs of frames at department stores. Then offer the option of framed prints at slightly higher prices.

If you find you're good with informal portraits, you can add neighborhood families with small children to your potential-customers list. Try to have samples of your work to show early in your marketing efforts.

Try a similar approach with owners of small businesses. Photograph them at their places of business, perhaps in front of their stores or working at a desk.

If your friends respond to your first efforts, be available for pictures at special school events—dances, athletic events, etc. Some customers buy more than once.

Be prepared with price quotes for reprints. Sometimes a single reprint will be higher than regular prints, but you can almost al-

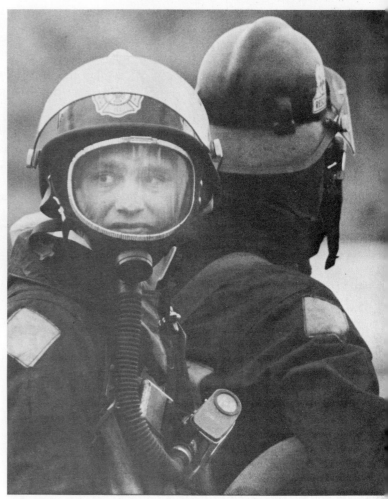

Tazewell Publications

Assess the kinds of pictures you want to take. If you want to be a photojournalist, make an effort to include news-style photos in your portfolio.

ways get price reductions for additional copies of pictures. If response is good, suggest additional copies of pictures before sending film to the lab. Shop around for good lab prices, but make sure the quality of work meets your standards.

The Photographer as an Employee

Suppose instead of working on your own you choose to gain experience working for someone else. In this chapter and the text, you have seen mention of photographic positions that might be open to students. Specifically, how does one go about looking for those positions?

It is best to begin by assessing three items.

1. What are you most interested in doing and what are you willing to do? If you're interested in serving as a staff photographer on a big-city magazine, you probably won't get what you want with a single telephone call and an interview. If you would like to shoot weddings, you will certainly want to approach photographers who do weddings to see how you may be of assistance.

Consider the contacts you already have. Who needs the kinds of pictures you want to take? What kinds of subject matter do you already have access to?

Identifying what you want to do is important, however, because you can begin now to work toward your goals. You must also decide what you are willing to do to reach your goals. Will you do darkroom work when you are primarily interested in shooting fashion? Would you work for a portrait studio when you would really rather be shooting sports?

Your answers to these questions will tell you something about the concessions you're willing to make and give you some idea of the difficulties you're likely to encounter in your job-hunting efforts.

The more flexible you are at first, the more

likely you are to find some kind of work in the field of photography. There are things to be said, though, for reaching first for what you want. If you want to shoot sports, try to find someone interested in your sports pictures—your school paper, your school yearbook, a rural newspaper's sports department. Try to think of anyone interested in sports pictures who would have difficulty getting them if it weren't for you.

2. How prepared are you? Do you have a portfolio? If you need your own equipment, do you have the minimum equipment necessary for the position? How much have you

learned about photography and how much more study and effort are you willing to put into it?

3. What kind of contacts do you already have and what kind of contacts are you willing to develop? As a student, you're likely to have better results if you already know a photographer or employer who needs pictures or if you know someone who is willing to introduce you to an employer. First explore the contacts you already have. Then go through the Yellow Pages and make a list of possible phone contacts.

After you have made your lists, check out books from a library on job-hunting, resumé preparation, and job interviews. (Richard Bolles's *What Color Is Your Parachute?* from Ten Speed Press gives an interesting perspective on the job-hunting process.) You may not need a resumé, but a typed list of the photography you've done could be useful. Be sure to include your name, address, and telephone number at the top. Make copies of the list to leave with potential employers. Include work you've done for your school or classmates.

Once you've done this background work, contact potential employers. Explain that you are a photography student looking for work, that you are taking a course, and that you are willing to learn and willing to work. Ask for an interview. If you get an interview, follow these points.
- Try to learn something about the employer before you arrive.
- For your own information, list five reasons why the employer should hire you.
- Be on time, preferably ten minutes early.
- Be neat.
- Be your best self.
- Relax and give direct, honest answers to questions asked.

If you get a job, make sure you are a good employee.
- Be on time for work.
- Dress as others do on the job.
- Take special care to do well.

- Keep busy. Look around for necessary work. Anticipate needs.
- Be pleasant to your employer, customers, and co-workers.
- Don't socialize on the job.
- Make a strong effort to learn as much as possible about your employer's business needs and learn to fill those needs. The more indispensible you are, the more likely you are to keep the job.

THE PHOTOGRAPHER OF THE FUTURE

As this book was being written, several significant changes occured in photo technology. The chromogenic films hit the market, thus changing the axiom, "the faster the film, the grainer the film." "T-grain" films likewise softened the old rule.

Polaroid came out with a 35 mm instant slide film. Programmed cameras that automatically set f/stops and shutter speeds became the norm rather than the exception. Auto-focus lenses gained ground over their manual counterparts. Nikon introduced Automatic Multi-Pattern light metering. This is a through-the-lens system that breaks a picture into five segments and compares exposure results with "100,000 photographs programmed into its memory."

The photography trade journals began to delve deeper into computer applications for small studio owners and audiovisual specialists. As you saw earlier in the text, computer-aided design has played an important part in the manufacture of camera lenses for several years.

Photography has always changed and will continue to change. We've come a long way since most cameras were made of wood, "film" was glass plates, and exposure times were measured in minutes rather than fractions of a second. If you continue to follow developments in photography in the coming years, you are likely to see changes you can hardly imagine now.

Paul M. Schrock
Some photography is timely; some is timeless.

nical improvements will continue. However, to get the best pictures possible, you will still have to know how to make pictures. And what does that mean to you?

You will need to know about technological advances as they are made. That includes not only cameras themselves, but accessories, the laboratory, films, and the business of photography. Computers already analyze negatives, run automated processing equipment, handle a multitude of photographic business needs (accounting, mailing lists, filing, billing) and, as mentioned several paragraphs earlier, compute exposure information within 35 mm cameras. They run multi-projector slide shows. The paragraph you're reading now was written on a home computer with a word-processing program and was prepared for printing with another computer at the publisher's office.

As a photographer, you will use the technological advances you encounter to make better pictures and to make them more easily —to communicate—a very basic, very human thing to do.

Bob Peterson, an audiovisual photographer, once said in a magazine interview, "It's easier nowadays to become a good photographer technically—but that's all, and that's less than half the battle. All the new techniques won't stop a telephone pole from coming out of a subject's head."

Peterson's assessments are accurate. Tech-

Discussion Questions

1. Where may you receive formal education in photography?
2. What is the highest academic degree that has been offered in still photograhy?
3. Name several types of photography using the field approach.
4. In what speciality is a photographer likely to work under an art director?

5. What specialty is likely to be important to a cartographer?
6. How does the work of a school photographer differ from that of a fashion photographer?
7. Why is it wise to get to know other photographers?
8. What are stock photographers?

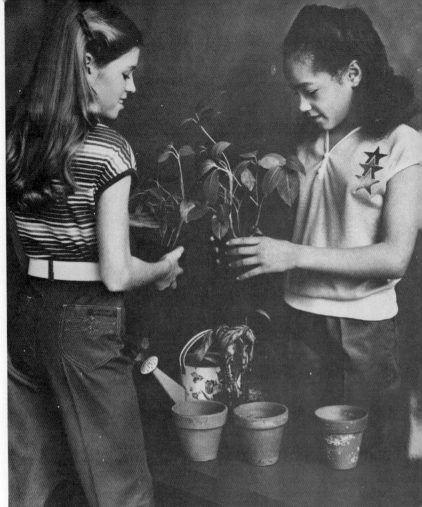

Sears, Roebuck and Co.

To get the best pictures, no matter what the technological advances in photography, you will still have to know how to make good pictures.

1. Assess the place of photography in your own life. Is it to be a hobby? A business? What will it be now? What will it be in the future? Do you prefer the field or the studio approach? Describe your plans.

Glossary

Adapter ring—a ring that attaches to a camera to allow the lens to be screwed backwards into the camera for close-up work

Aerial picture—a picture taken while the photographer is in flight

Angle of view—a measurement, in degrees, of the area in a scene that is taken in through the lens of a camera

Antihalation coating—a coating on the base of photographic film to prevent light from reflecting back through the emulsion and causing unwanted exposure

Aperture—the hole in a camera through which light enters to expose the film

ASA—the American Standards Association. An obsolete rating of film according to speed or sensitivity to light

Averaging meter—a light meter that measures light in several areas of a frame and averages the result

Background—that which is behind the subject of a photograph; the subject's surroundings

Background light—light placed behind the subject to illuminate the background rather than the subject

Backlighting—light that hits the subject from the back

Base—the flexible backing layer of photographic film which supports the emulsion layer

Bellows—an adjustable unit that fits between the camera and the lens to allow the lens position to be extended for close-up work

Bounce flash—flash reflected off a wall or ceiling onto the subject

Bracketing—taking several different exposures of a single subject to ensure a correct exposure

Bulk film—film packaged in 50- and 100-foot rolls to be loaded by the user into reusable film cassettes

Bulk loader—a device for loading bulk film into reusable cassettes

Burning-in—the process of selective exposure of printing paper whereby exposure is added to parts of the paper to make those parts darker

Cable release—a cable that attaches to the shutter button and allows the photographer to trip the shutter without touching the camera

Catadioptric lens—a telephoto lens that uses mirrors to reduce length and bulk of the lens

Center-weighted meter—a light meter that gives priority to the intensity of the light in the center of a frame

Chromogenic film—a film capable of being shot at a variety of speeds all on the same roll and still producing fine-grained enlargements

Close-up adapter—a glass that screws onto the front of a lens and magnifies the image for close-up photography

Color compensating filter—a special type of color correcting filter available in different strengths in each of the three primary and three complementary colors; also called "cc filters"

Color correcting filter—a filter designed to adapt the color of light to a particular type of film

Color meter—a light meter that reads light and suggests filtration for particular types of film

Color polarizing filter—a filter that, when combined with a polarizing filter, provides a range of colors in a single filter

Color shift—inaccurate color in color film due to reciprocity failure, heat, improper storage or development, or other factors

Color temperature—a scale to measure the color of light; based on the color at which

an inert substance would glow when heated to different temperatures; expressed in degrees kelvin

Composition—the arranging of material within the frame of a picture

Contact printing—printing done with the negative touching the printing paper so that the prints are the same size as the negatives

Contact sheet—a single sheet of paper on which all the negatives of a roll of film have been printed by means of contact printing

Contrast—the brightness range between highlights and shadows within a photograph

Copystand—a device for mounting a camera in order to photograph documents, artwork, or similar subjects

Cropping—the printing of only a part of a negative

Cues—inaudible pulses that automatically advance a slide projector

Data sheets—information sheets packaged with film that, among other things, recommend exposures for situations under different light levels

Dedicated flash—a flash unit that uses light sensors within the camera to control the duration of the flash

Depth of field—the distance in front of and behind the point where a lens is focused that will be reasonably sharp in the finished picture; also called "depth of focus," a less-used but more descriptive term

Developer—a solution that changes the silver bromide crystals on exposed film or paper into a visible image

Developing tank—a container into which exposed film and processing solutions can be loaded for developing

Developing trays—pans to hold the solutions in which printing paper is processed

Diffraction grating—a filter that makes points of light appear as multicolored stars

Diopter—a measure of the strength of a close-up adapter

Direction of light—the direction, in relation to the subject, from which light comes (such as frontlighting, sidelighting, backlighting, and overhead lighting)

Direct light—light which travels directly from the source to the subject

Dodging—the process of selective exposure of printing paper whereby exposure is held back from parts of the paper to make dark areas lighter

Easel—the adjustable printing paper holder used on the base of an enlarger

Emulsion layer—one of the top layers of photographic film; contains light sensitive silver bromide crystals which react to light and form the image when the film is developed

Enlarger—the equipment used to project the image from the negative to the printing paper

Entrepreneur—a person who owns, organizes, manages, and assumes the risks of a business

Expiration date—the date, marked on a film package, before which the film should generally be used

Extension ring—a ring that fits between the camera and the lens to increase the distance between the film and lens; used for close-up work

Fast film—a film with above average sensitivity to light

Field photography—photography of natural action in natural surroundings, usually done with available light and a minimum of equipment; the opposite of studio photography

Fill light—a supplement to the key light; fills in the shadows on a subject

Film advance lever—the lever on the outside of the camera that moves film forward after each exposure is made

Film chamber—the space inside a camera that holds the film cassette

Film rewind knob and crank—devices on the

camera that return exposed film into its cassette

Film speed—a measurement of a film's sensitivity to light

Film take-up spool—the spool onto which exposed film is wound after each picture has been taken

Filter—glass attached to the front of a lens for purposes such as light reduction, color correction, or polarization

Filter factor—a measure of the light reduction caused by a particular filter

Fisheye lens—a lens with an extremely wide angle of view, usually between 180 and 220 degrees

Fixer—a solution used during film and print processing to render the film or paper no longer sensitive to light; also called "hypo" and "fix"

Flash meter—a light meter designed to read electronic flash

Focal length—the effective distance between the lens of a camera and the film when the lens is focused on infinity

Focal plane—the plane on which light focuses on film in a camera

Focal plane shutter—a shutter located near the focal plane of a camera

Focusing ring—the control that encircles the lens and that is used to adjust the lens for a sharp image

Fog filter—a filter that introduces a mist or haze into a picture

Frame—the square or rectangle within which the picture exists

Frame counter—the indicator on a camera that shows how many pictures have been taken on a roll of film

Frontlighting—light that hits the subject from the front

F/stop—a number that indicates the size of the aperture, or hole, in the lens, different size holes admit different amounts of light; the larger the number, the smaller the hole

F/stop ring—the control that encircles the lens and allows the photographer to adjust the size of the f/stop

Grain—particles that form the image in film; the particles are more apparent in large prints and in prints made from fast film

Grain magnifier—a device for magnifying the grain pattern of a negative for accurate focus during the printing process

Gray card—a card of average reflectance used to help ensure a correct reading on a light meter

Guide number—a rating for a flash unit that allows the photographer to calculate the proper f/stop for any given film speed and flash-to-subject distance

Hard light—a light that comes from a point source and throws distinct shadows

Hypo—a solution used during film and print processing to render the film or paper no longer sensitive to light; also called "fixer" and "fix"

Hypo clearing agent—a solution used to neutralize the fixer, or hypo, on film or paper

Incident meter—a light meter that reads the light source instead of light reflected from the subject

Infinity—the mark on a focusing ring indicating that the lens is on maximum distance—as far as the eye can see

Infrared film—film capable of recording infrared light waves

Intensity—the brightness of light

Inverse square law—the principle that the intensity of light on a subject is inversely proportional to the square of the distance between the light source and the subject

ISO—the International Standards Organization; a rating of film according to its speed or sensitivity to light

Key light—the main or primary bright light illuminating the front of the subject in a studio lighting system

Keystoning—the distortion in the image of a projected slide that occurs when the projector and the screen are not on the same level

Latitude—the measure of a film's ability to record acceptable images at less than or greater than an ideal exposure

Layout—the arrangement of pictures for a printed page

Lens—curved, transparent material (usually glass) attached to a camera and used to focus light onto the film

Lens shade—a simple device attached to a lens to block unwanted light from the lens

Light meter—an instrument that measures the intensity (brightness) of light

Macro lens—a lens designed specifically for close-up work; also called "micro lens"

Modeling—creating the appearance of natural lighting through effective use of artificial light

Modeling light—a low-powered, incandescent light that burns continuously and simulates the effect of a flash

Monopod—a one-legged stand that supports and steadies a camera

Multiple image attachments—a special type of filter that makes a single subject appear as several identical images in a picture

Mural—a large wall covering

Negative—processed film containing an image opposite of the original scene in terms of light and dark areas

Neutral density filter—a filter designed simply to reduce the amount of light reaching the film

Orthochromatic—black and white film that records mainly blue and green light waves; now used primarily in high contrast copy work

Overexposure—a photograph in which too much light reached the film

Overhead lighting—light that hits the subject from overhead

Painting with light—firing a flash from several different places in a dark room while the shutter of the camera remains open

Pan—to move a camera horizontally in order to keep a moving object in the viewfinder

Panchromatic film—film that is sensitive to most visible light waves

Pan head—a feature on some tripods that allows the camera to be smoothly swung horizontally to follow a moving subject.

Paper safe—a container for storing printing paper and protecting it from light

PC cord—the line connecting a flash unit to a camera so the flash unit can be removed from the body of the camera.

Photogenic—a term describing anything that looks good in a picture

Photo umbrella—a reflector or diffuser that resembles an umbrella and that is used to soften the light on a subject

Polarized light—light waves that are vibrating only in one direction, such as the light reflected by water or glass

Polarizing filter—a filter that can be used to reduce haze, glare, and the reflection of light off of glass and water

Polycontrast paper—a photographic printing paper that allows for different levels of contrast through the use of filters in the enlarger

Portfolio—a collection of a photographer's best work, designed to be shown to potential clients and employers

Pose—the position of a subject's body

Positive—processed film containing an image with light and dark areas corresponding to those in the original scene; a slide or transparency; the opposite of a negative

Quality of light—the hardness or softness of light

Reciprocity failure—the altered reaction of film to light during abnormally long or short exposures

Red eye—a problem resulting from flash reflecting from the retina of the eye of a subject; occurs when the subject looks toward the camera and the flash is too near the lens

Reflected light—light that reaches a subject after bouncing off other surfaces

Reflected-light meter—a light meter that

reads the overall brightness of light reflected from a scene

Reversal film—film that is processed in such a way to produce a slide or transparency instead of a negative; film used to produce positive rather than negative images

Rim light—backlighting that brilliantly illuminates the edge of a subject

Ringlight—a flash that can be attached to the front of a lens

Rule of thirds—the principle of composition suggesting that the most important features of a photograph fall along two imaginary vertical lines that divide the length of the photograph into thirds and along two imaginary horizontal lines that divide the height of the photograph into thirds

Safelight—a light with a colored filter that provides light for a darkroom without exposing the printing paper

Scenics—pictures of landscapes

Shutter—the device between the aperture and the film that opens to let in light and closes to shut it out

Shutter release button—the button on a camera used to trip the shutter and take the picture

Shutter speed dial—the camera control by which the photographer adjusts the length of time the shutter remains open

Sidelighting—light that hits the subject from the side

Skylight filter—a slightly amber filter that can warm up the strong blue cast of open shade and overcast skies

Slow film—a film with below average sensitivity to light

Soft-focus filter—a filter that introduces a mist or haze into a picture

Soft light—light that comes reflected from a broad surface or through a diffusing material and that casts soft, indistinct shadows

Split-field filter—a filter that is divided into halves for two separate effects

Spot meter—a light meter that reads only a very small section of a frame or scene

Star filter—a filter that makes points of light appear as starlike bursts of light

Stock photographs—pictures that may be used for a variety of purposes

Stock solution—a mixture of processing chemicals minus the water that is added when the chemicals are to be used

Stop bath—a solution that stops the effects of the developer

Stop-down metering—taking light readings on a TTL meter with the aperture stopped down; used when the automatic metering system has been bypassed

Studio photography—photography in which the photographer carefully controls the location, subject, and lighting and usually uses a great deal of sophisticated equipment

Subject—a person or object that a photographer wishes to photograph

Sync speed—the fastest shutter speed at which the curtains of a shutter open completely; the fastest shutter speed at which electronic flash can be used

Tear sheets—published samples of a photographer's work, taken from the books, magazines, and newspapers in which they appeared

Telephoto lens—a lens with a long focal length and a narrow angle of view

Thyristor—an electronic switch that shuts off energy to an electronic flash, controlling the duration of the flash

Title slide—a slide containing written text or a caption

Tracing with light—moving a pinpoint light source in front of an open shutter in an otherwise dark room

Transparency—a picture on a piece of film designed to be viewed by shining a light through it; a slide

Treatment—the techniques used in photographing a subject, including framing, composition, timing, lighting, exposure, focus, handling of backgrounds, and depth of field

Tripod—a three-legged stand that supports and steadies a camera for long exposures

Ultraviolet filter—a colorless filter that absorbs ultraviolet light

Underexposure—too little light reaching the film

Variable contrast paper—a photographic printing paper that comes in different grades and provides for different levels of contrast in the finished print

Viewfinder—the opening on a camera through which the photographer frames the picture

Vignetting filter—a filter that introduces a haze around the edge of a picture while allowing the middle to remain sharp and clear

Wetting agent—a solution sometimes used after the washing of negatives so that the wash water will not leave spots on the negative

Wide angle lens—a lens with a short focal length and a wide angle of view

Zone—any one of the ten tonal values of the zone system, ranging from deep black to white

Zone system—a method for evaluating an exposure that depends on dividing the tonal range of a scene into ten values, or zones

Zoom lens—a lens with an adjustable focal length

Index